Shooting the curl: the best surfers, the best waves...by 15 of the best surf photographers

Chris Power

ISBN 978-0-9523646-8-9

PUBLISHED BY:
Orca Publications Ltd
Berry Road Studios
Berry Road
Newquay
TR7 1AT
United Kingdom
(+44) 01637 878074

www.orcasurf.co.uk
www.shootingthecurl.com

PROJECT DIRECTOR **Chris Power**
DESIGNERS **David Alcock, Mike Searle**
PRODUCTION CO-ORDINATORS **Mike Searle, Louise Searle**
STUDIO PHOTOGRAPHY **Mike Searle**
EDITORIAL SERVICES **Alex Hapgood**
PROOFREADER **Rob Barber**

Printed and bound by Great Wall Printing, Hong Kong

SHOOTING THE CURL

THE BEST SURFERS, THE BEST WAVES
BY 15 OF THE BEST SURF PHOTOGRAPHERS

CHRIS POWER

//CONTENTS

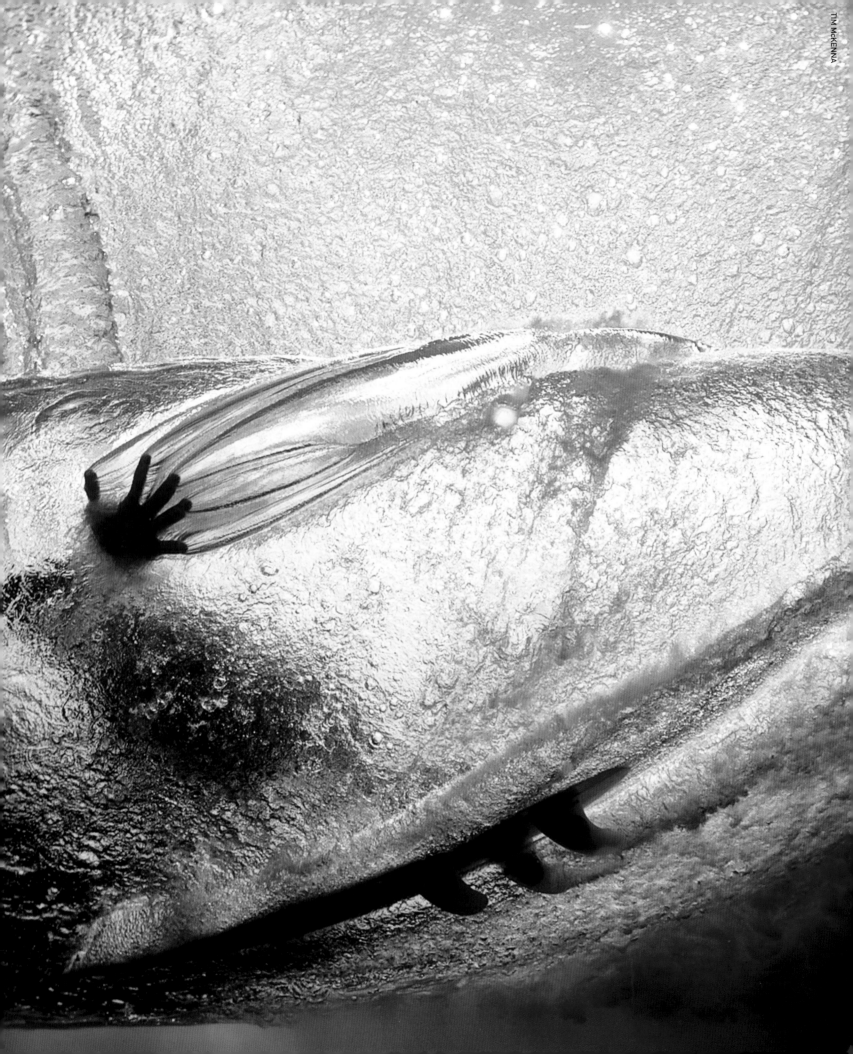

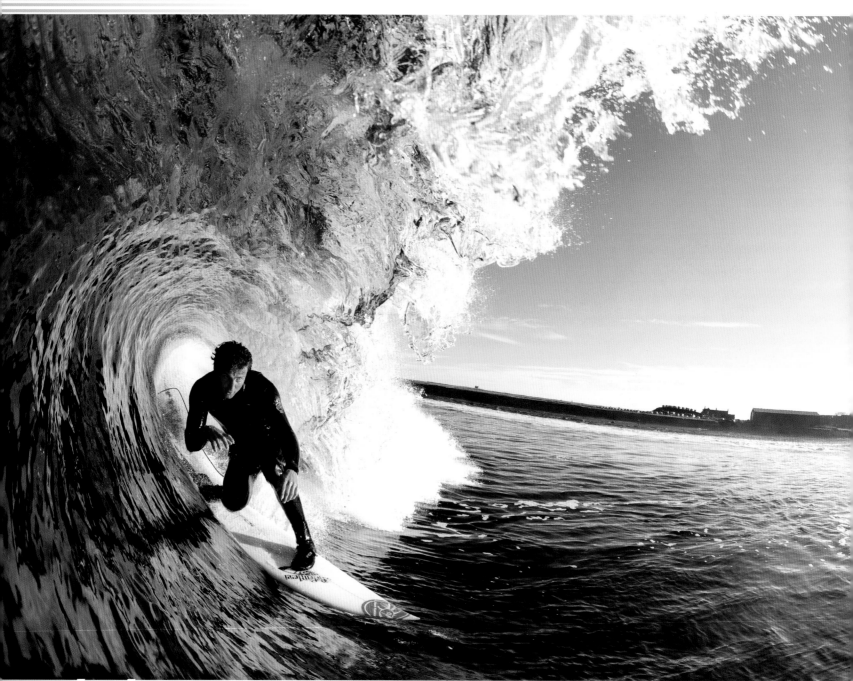

//INTRODUCTION

There are several million surfers on this blue planet of ours and one thing we all have in common is a love and appreciation of great surf photos. We just can't stop ourselves looking at shots of amazing waves and spectacular surfing. Count the number of surf magazines on the newsagent's shelves in any self-respecting surf town and I bet you'll see at least half a dozen. Or flip open your laptop and peruse the latest visual offerings on the myriad of surfing websites – dozens of new shots from sessions around the world are being posted every day.

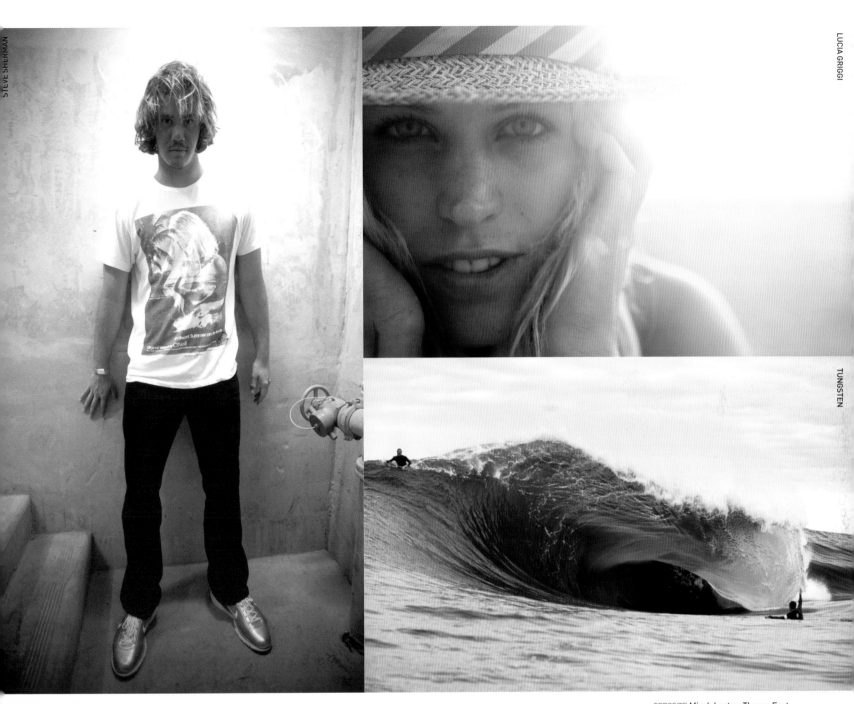

OPPOSITE **Micah Lester, Thurso East**
ABOVE LEFT **Jordy Smith**
ABOVE RIGHT **Rosie Hodge**
ABOVE **Cyclops, Western Australia**

Great surf photos can have quite an effect on surfers like you and me. They inspire us to travel. They psyche us to push our own surfing and try to emulate the pro's. They amaze and astonish us by capturing the power and beauty of the ocean.

Surf mags, understandably, tend to put the spotlight on pro surfers and it's they who always rack up the most column inches. When epic sessions go down or new discoveries are made, we usually hear about them from the surfers' perspective. They get the glory, the interviews, the fame and fortune. Yet the photographers who shot those epic sessions or led the way to those new breaks also have stories to tell, opinions to offer and knowledge to share. This book, while showcasing some awesome images, also sets out to hear the photographers' stories and offer an insight into their world.

So who are these web-footed freaks who swim fearlessly in the gnarliest lineups, these 21st century alchemists who mix light and waves to produce photographic gold? Thankfully, when you meet them, you realise they're not musclebound hulks or techno geeks who babble on about Raw files and shutter speeds all day. Most are fairly ordinary guys who are simply passionate about surfing, and who dig being involved with it at the very highest level.

What makes a successful surf photographer? Well, there's a whole lot more to it than just knowing how to use cameras and lenses. Physically, you need the

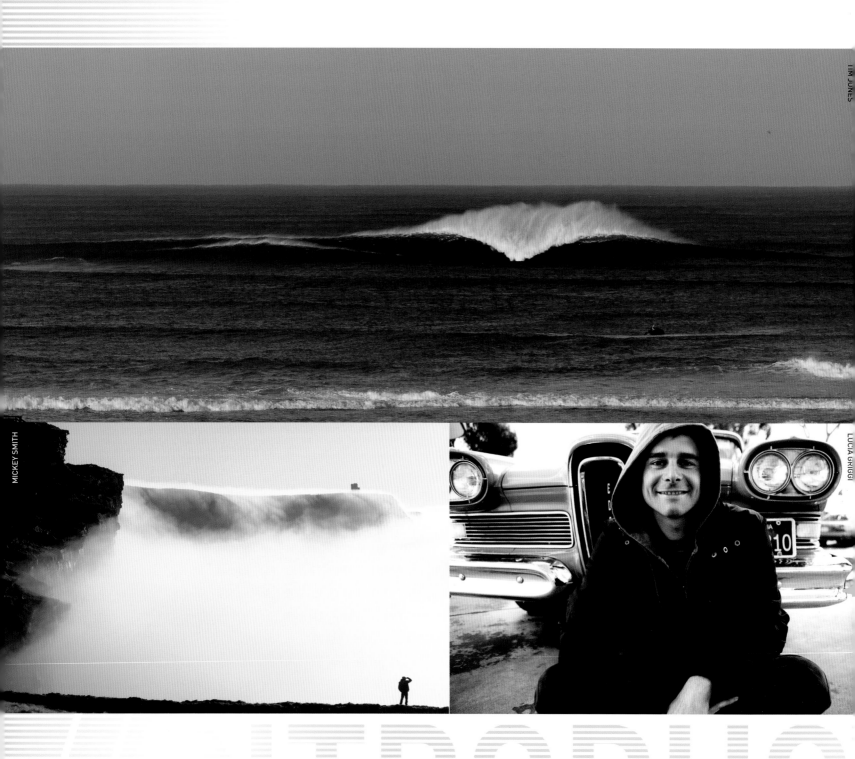

MICKEY SMITH

LUCIA GRIGGI

strength of a packhorse to lug around heavy equipment, and the swimming skills of a conger eel to negotiate the turbulence of the impact zone. Lightening-fast reflexes and perfect hand-to-eye coordination are essential to nail the shot at the critical moment. Mentally, you need creativity and imagination to plan shots, as well as an eye for composition, a sound technical knowledge of your equipment, and (crucially) a head for business.

The very best photographers possess all those attributes and then go one step further. They get involved, bringing us an insider's view of every aspect of the surfing experience. Specialist water photogs like Scott Aichner and Tim Jones

power their way through the turbulence to bring us incredible views of grinding spots like Pipeline and The Zone. Clark Little hits his turbo button and (somehow) makes it in and out of the most ludicrously heavy shoreys imaginable. Steve Sherman hangs out with the top pro's and quietly captures behind-the-scenes moments that no contest webcast cameraman would ever notice. Adventurers like Yazzy Ouhilal and Alan van Gysen go the distance and score pristine lineups, empty and untouched.

The 15 photographers featured in this book include some of the best lensmen in the business. The intention from the start was to feature a wide range of

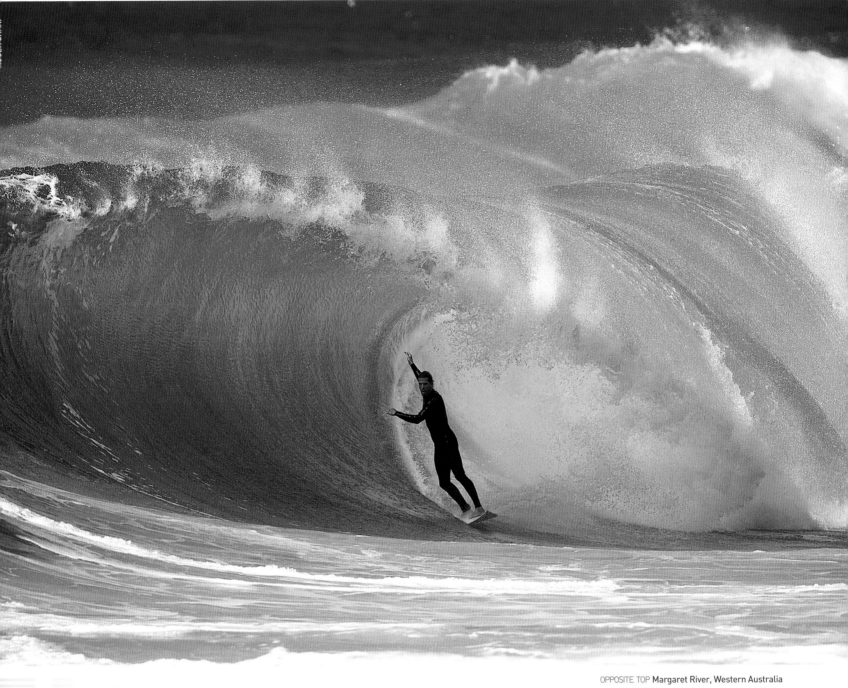

OPPOSITE TOP Margaret River, Western Australia
OPPOSITE BOTTOM LEFT Dawn mist, County Clare
OPPOSITE BOTTOM RIGHT Gabe Davies
ABOVE Andy Irons, Hossegor

photographers with different specialities and geographical bases. Some are old hands, veterans with decades of experience who learnt their trade using film. Some are comparative youngsters, guys in their twenties who've only ever used digital cameras. Some hail from Australia, some from the States, some from Europe, some from other parts of the world. There are easily 40 or 50 other surf photographers whose brilliant work we could have included in this book; but there are only so many profiles you can fit into 160 pages. To all you guys: sit tight, we might do Volume Two sometime!

Young or old, specialist or all-rounder, successful or just starting out, I have a huge amount of respect for all the photographers in this book. They, and the legions of other top surf photographers around the world, are heroes to me, just as much as the surfers they shoot. Because you have to be pretty bloody dedicated to work your ass off taking shots while all the guys around you are having the time of their life surfing. Of course the payback comes after the session is over. If you took some truly great shots there's an enormous sense of pride and accomplishment. South African shooter Alan van Gysen sums it up pretty neatly: "Getting a good shot is like getting barrelled – you get one and you just want to get more."

– Chris Power

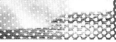

//TIM JONES
WATER PHOTOG WHO'S ALWAYS IN THE ZONE

There's a certain breed of surf photographer who feels right at home in heavy impact zones while sledgehammer lips rain down left, right and centre. Aussie watershot specialist Tim Jones is one such guy. TJ hails from the Central Coast of New South Wales and he was a top bodyboarder in his teens, a standout at psycho spots like Crackneck and The Zone. He turned pro at 18, began travelling to Hawaii and Indo on a regular basis, and around the same time became interested in photography. Spotting a gap in the market, he invested in a decent water housing and began taking photos of his mates, selling the shots to bodyboard mags like *RipTide*, *Bodyboarding* and *ThreeSixty*. It was common sense to broaden his horizons, and by the mid '90s he was a regular contributor to a range of top international surf mags including *Tracks*, *Waves*, *Transworld Surf*, *CARVE* and *Surf Session*. Today, TJ's base is still the Central Coast but he spends several months each year chasing waves at his favourite photo studios – the North Shore, Western Australia and Tahiti.

What's your favourite place to shoot anywhere in the world?
I reckon my favourite place is Western Australia. There's just such a variety of quality waves... reefs, beaches, wedges, big thick slabs. You can just get so much work done. As soon as the sun comes up in the morning you've got beautiful front-lit waves. In fact you've got incredible light for a good three-quarters of the day. Yeah, WA would be my pick, for sure.

You've done a lot of work with Ry Craike, in the northwest. What's the scene like up there?
Well, it's quite a guarded area, very localised. I've been going there for 13 or 14 years and I'm in with the boys, so there's no problem me being there with a camera. But you've gotta respect the boys. You can't just rock up with eight or ten people and expect to do a shoot. If I'm shooting with Ry, I just go with him.

I guess the other locals understand that it's his livelihood...
Yeah, I think Johnny Craike, Ry's old man, has had a few words with the boys over the years, saying, "Look, this is what my son's chosen to do, this is his path and I have to support him.

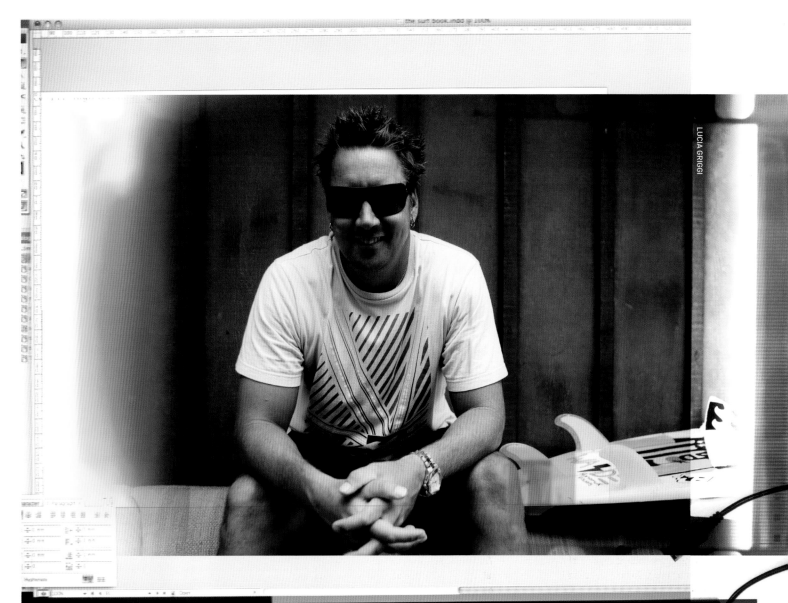

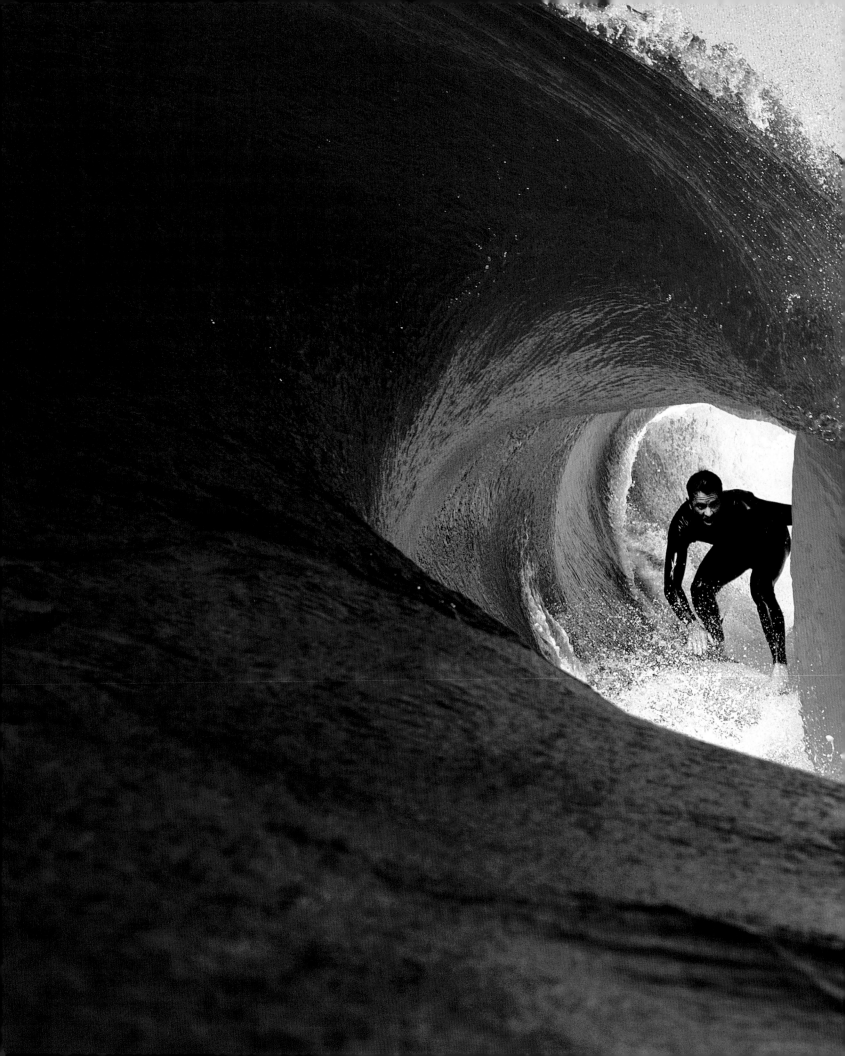

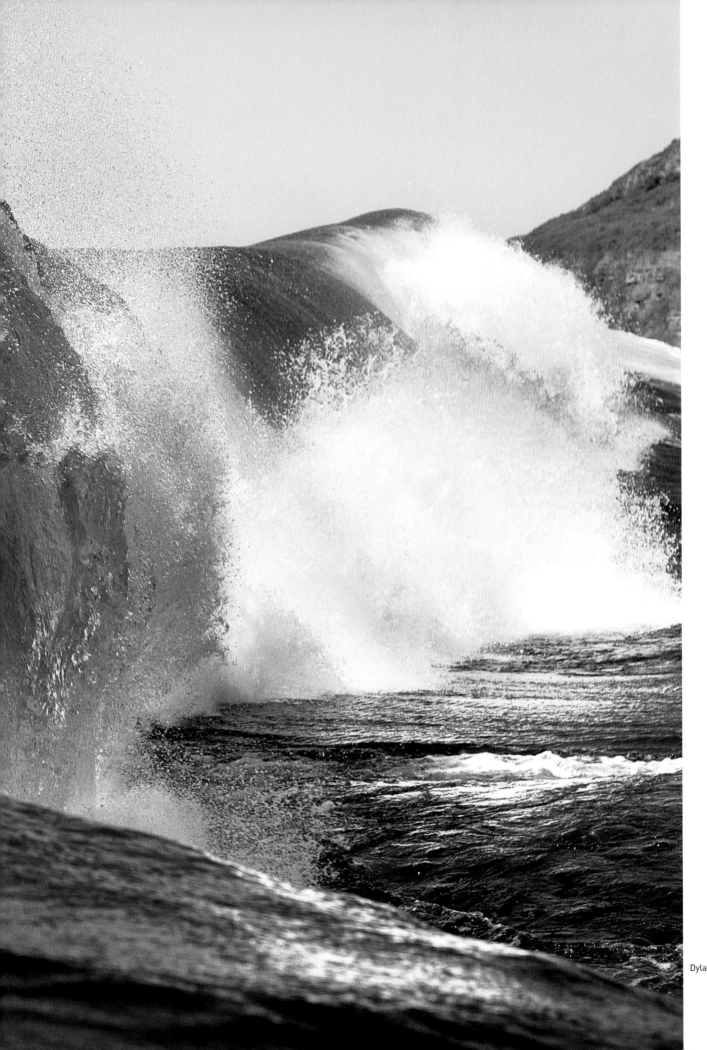

Dylan Longbottom, The Zone

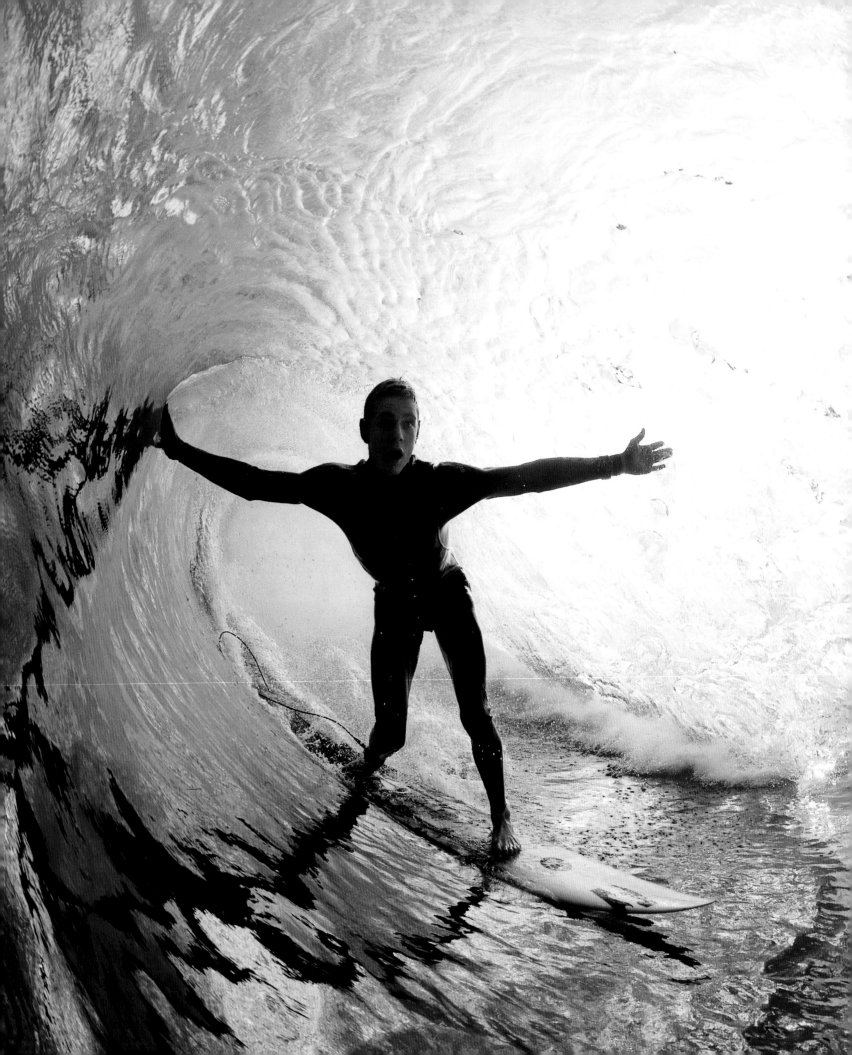

"WHEN THE WATER DRAINS OFF THE REEF AT CHOPES IT'S LIKE SOMEONE'S PULLED THE PLUG IN A BATH AND YOU'RE AN ANT TRYING TO ESCAPE THE WHIRLPOOL. ALL OF A SUDDEN IT'S LIKE, 'SHIT, I'M IN A LOT OF TROUBLE HERE...' THEN YOU DIVE DOWN AND REALISE YOU'RE IN THREE FOOT OF WATER."

If that means that photographers come up and shoot around here, then so be it." Johnny's a fisherman, a hardcore man from back in the day, so...yeah, it's all cool, there's no animosity whatsoever. You just gotta be respectful.

Ry seems to be one of those guys who always comes up with the goods. He's got to be one of the most explosive freesurfers around...
Aw, yeah. He's got so much natural flair. And he works hard too, he surfs for hours. He runs around the point, jumps off...runs around the point, jumps off...all morning. When he's on, I know we're gonna get good shots and the mags are gonna be real happy.

You obviously get on with him.
Yeah, he's an unreal guy. Loves a beer, loves a barbecue...he's just a good kid. He recently got married, and he and his wife live in a real nice house just, like, 30 seconds drive to the point at Jakes. It's a real nice environment. I love it there, it's beautiful.

Any sharks up there?
Yeah, plenty...but I haven't seen any when I've been in the water. There's worse places. I mean, they're everywhere, sharks. They're in South Australia, they're on the Gold Coast, they're in Hawaii, they're in Cape Town...they're everywhere.

Had any close calls?
Yeah, one or two. Closest I've had was at Teahupoo when a tiger shark swam through the lineup, at dusk. That was pretty heavy.

A big one?
Big enough. Like, three metres or something.

What happened?
Well, it was late afternoon. I was in the water shooting with a couple of other guys. We just saw this huge fin out the back, about 10 or 15 metres away from us. It's a long paddle from the lineup to the channel so we weren't going anywhere. I was like, "Right boys, we're all staying here together, we'll make a move when that thing goes." It was nerve-wracking. But that's life. You've gotta just get on with it. You don't hear racing car drivers going, "I'm not gonna get in my car today because it's too dangerous and I might kill myself." Things like sharks are always in the back of your mind whenever you go in the ocean, but you've got to forget about them. If you don't, you're gonna lose the plot and not be able to do ya job. Simple as that.

Tiger sharks aside, Teahupoo is a phenomenal place. I guess it's right up there as one of the most perfect waves you've photographed.
Yeah, for sure. It's just mechanical. I don't think there's a wave in the world like it.

What's the biggest you've shot it from the water?
I'd say about eight foot. Not much bigger...you can't hold your position out there if it's any bigger. It's impossible, there's too much current. When the water drains off the reef at Chopes it's like someone's pulled the plug in a bath and you're an ant trying to escape the whirlpool. You can't escape. You think you're safe, but all of a sudden it's like, 'Shit, I'm in a lot of trouble here...' Then you dive down and realise you're in three foot of water. It's crazy.

And you had first hand experience of a nightmare situation like that a few years ago...
Yeah I did, back in 2003. I got caught inside and worked. I was out there shooting, just after the contest had finished, and it was all good...about four- to six-foot. But then the swell jumped

Creed McTaggart, The Box

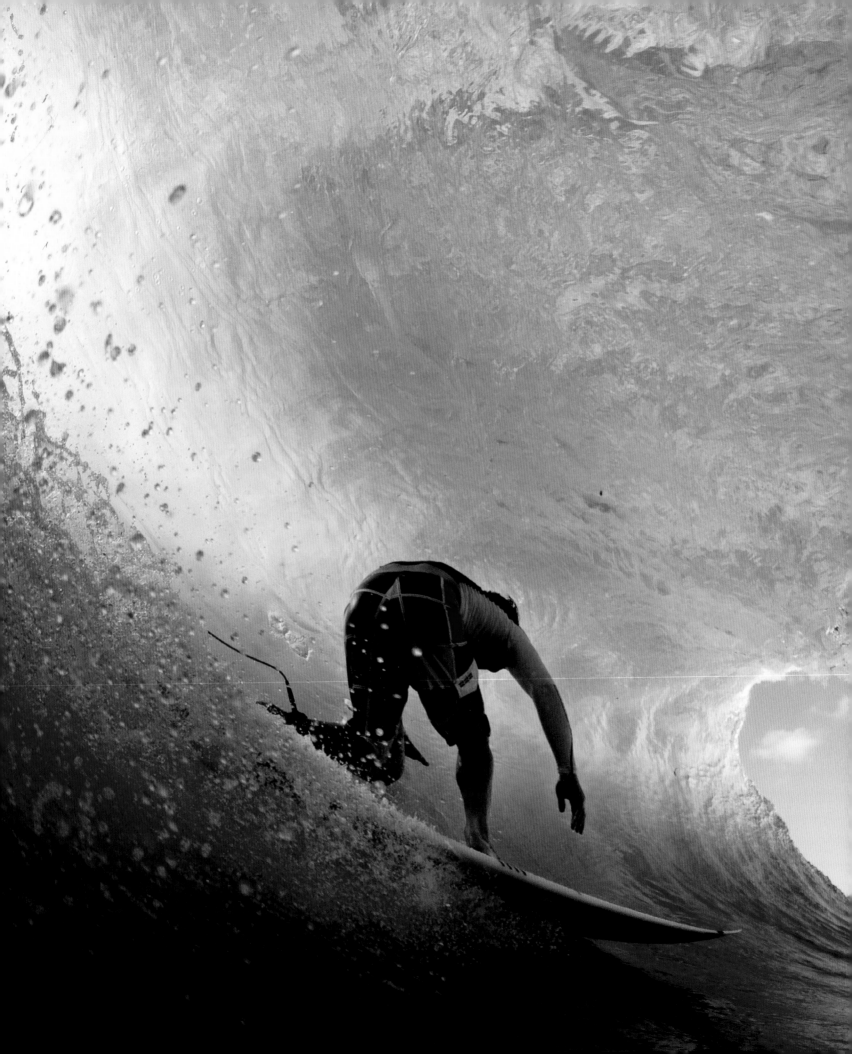

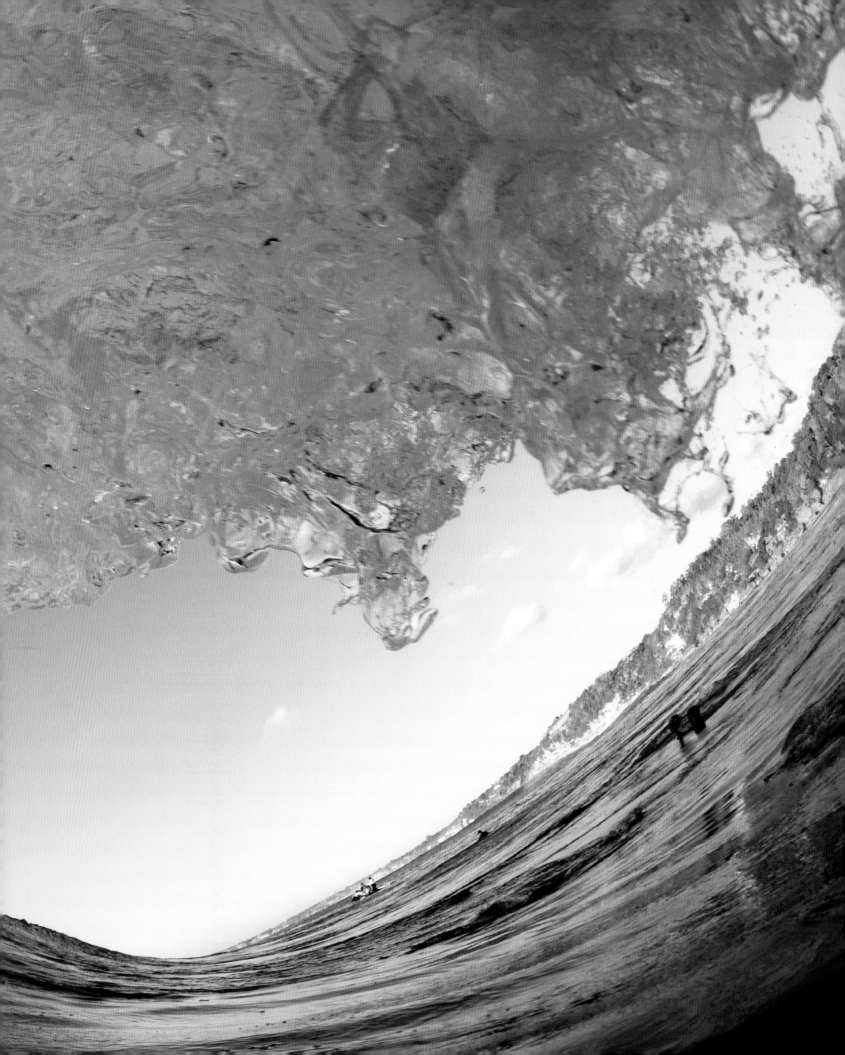

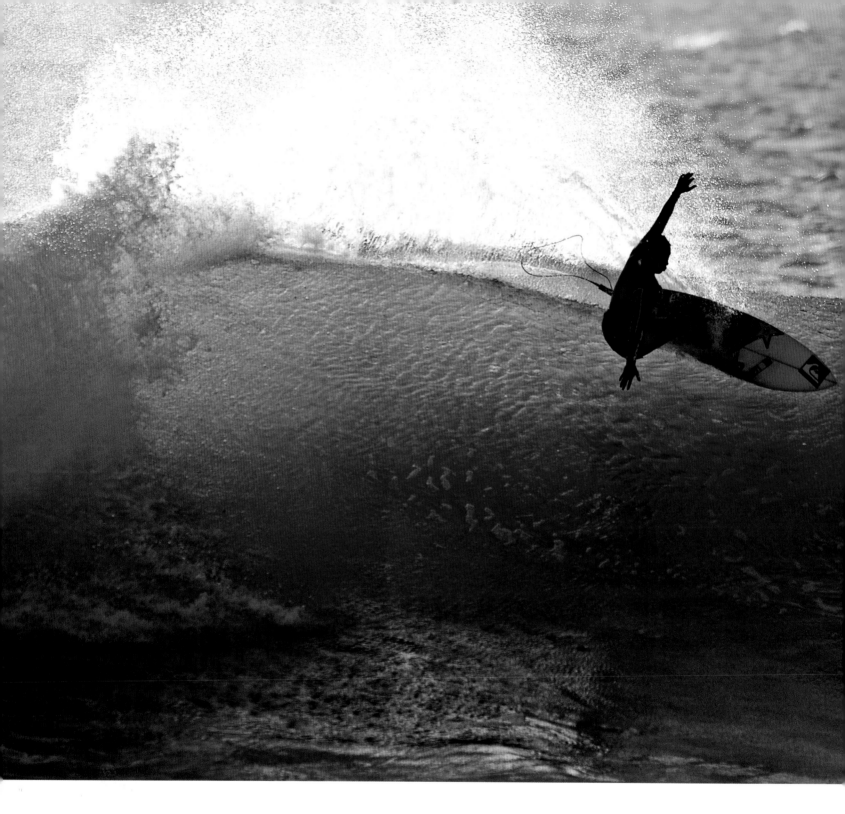

up to solid eight-foot in about 10 minutes and I got caught inside by a clean-up set. I got picked up and driven headfirst into the reef. Cracked my skull open, got concussion, dislodged my C1 and C2 vertebrae, bent my pelvis the wrong way...I was in a bad way. Yeah, that was the heaviest situation I've been in. I had a big cut in my head, blood pouring out all over the place. That was the closest I've come to dying.

Did someone come and haul you out?
Yeah, one of the Tahitian guys picked me up on the back of a jetski. I was concussed and pretty shaken up. I ended up having four internal and eight external staples...came out the hospital with bandages all around my head. I didn't tell my wife 'til I got home. But that's life, I lived to see another day, ha!

ABOVE Ry Craike, Jakes Point
PREVIOUS SPREAD Nick Vasicek, Padang Padang

Okay, let's talk about the waves you shoot at home on the Central Coast. The Zone is probably the spot that gets you the most fired up, right?
Yeah, I like The Zone 'cos it's right in my backyard and it's always a challenge. Back in the early '90s, when I used to ride it, it was just a bodyboarder's wave. No-one rode it on a surfboard back then. But nowadays you get guys like Jughead [Justin Allport], Dylan Longbottom, Adrian Buchan and [Andrew] Mooney out there, and sometimes a few of the Maroubra boys will come up. So sometimes you get a really good crew of guys who wanna give it a go. On its day it's such a heaving, unforgiving wave. I love it when it's like that...it's great being out there yelling at the boys to go! (Laughs)

I love that shot of Dylan Longbottom – the expression on his face is priceless.
Yeah! (Laughs). That wave has so many moods, it's always a little bit different depending on the swell direction, the wind, the tide. I love it, it's so photogenic. The shots I've taken there have probably paid for a quarter of my house!

And what about all the Shipstern's sessions you've shot – they must have paid for a fair few roof tiles...
Yeah, that's true.

How many times have you been down there?
Um...probably about 10 or 12 times. I don't go down there every single time there's a swell. I usually wait 'til I know it's gonna be at least 12- to 15-foot. It's good 'cos you can shoot all sorts of different angles there. I usually shoot from the water but sometimes I'll sit on a bodyboard and shoot it pulled back a bit, that looks good. Or you can shoot it fisheye

and get the cliffs in too. Yeah, Shippies is good, and it definitely gets your adrenaline going. It's sharky, it's cold...it's a crazy place. You just don't know what you're gonna get when you go out there...

Shipstern's always seems to deal out some spectacular beatings. You must have seen a few guys get pretty shaken up...
Aw yeah, there's always fear. Definitely. I've seen some horrendous wipeouts. You sorta think to yourself, 'How can the human body take that?' But only the very best of the best surf there, and they're prepared for it. They're real fit and they train for it.

Who's copped the heaviest beatings you've seen out there?
Um, I've seen Marty Paradisis and Mark Mathews take a few heavy ones...and Richie Vas [Vaculik]. He's a crazy guy. He's a cage fighter too – six fights and six wins. So Shipstern's...that's nothing for him!

A lot of the guys who charge really heavy waves seem to have that kind of mentality...
Well, some do...like Richie and the 'Bra boys. You've gotta have that mentality – a certain amount of aggressiveness – to wanna ride those kinda waves. But then you've also got the quiet focused guys like Kieren Perrow. He wouldn't hurt a fly, but he charges. So I think you're either born to surf big waves or you're not.

Okay, let's get back to photography, and where it's going. There seem to be loads more freelance photographers around these days. Is it harder to make a living now than it was five years ago?
Well, at the moment, it's tough. There are a lot of kids on the scene now who've bought cameras and big lenses and just jumped on the bandwagon thinking they're gonna make a quick buck. The way I see it though...well, hopefully the cream will rise to the top.

Fair enough. And do you have any new projects in the pipeline? What's the plan?
The plan is just to keep doing what I'm doing really...work hard and try to stay ahead of the pack. I've got a few other things going on too. Like, I've got involved with a new gallery in WA, The Sitting Room Gallery [in Cowaramup]. It's my mate Russ Ord's gallery and he asked me to be a part of it. So I've got a load of shots in there, and setting that up was really fun. We had a big opening party the other week and it all went really well. So doing other things, things like that, I think that's the way to stay ahead and keep moving forward.

"I'VE SEEN SOME HORRENDOUS WIPEOUTS AT SHIPPIES. YOU SORTA THINK TO YOURSELF, 'HOW CAN THE HUMAN BODY TAKE THAT?' BUT ONLY THE VERY BEST OF THE BEST SURF THERE. THEY'RE REAL FIT AND THEY TRAIN FOR IT."

//ALAN VAN GYSEN
SOUTH AFRICAN SHARP SHOOTER

IN HIS QUEST TO SHOOT PERFECT WAVES RIGHT AROUND AFRICA, ALAN VAN GYSEN HAS ALREADY SCOURED THE COASTS OF HALF-A-DOZEN COUNTRIES. ONLY ANOTHER 24 TO GO THEN.

Wedged into their overladen 4x4, photographer Alan van Gysen and South African mates Cheyne Cottrell, Dave Richards and Brendon Bosworth had been bumping along a pothole-riddled dirt track looking for waves all day. There was a decent swell hitting the coast, but despite checking bay after bay they hadn't found any spots to get excited about. So far their hopes of finding good waves in southern Angola had borne little fruit. Since leaving Cape Town the boys had been on the road for four days; they'd travelled more than 3,500 kilometres, fixed two punctures, and blagged their way through seven army checkpoints. Their rate of progress was painfully slow and they were beginning to wonder whether the whole trip had been such a great idea. But just then their fortunes changed. "It was quite late in the evening and we were almost done looking for waves," remembers Alan. "We were like, 'Let's jack it in and camp.' But then we rocked up at this little fishing village of circular mud huts, and off in the distance we saw this perfect left point..."

Frothing, the boys piled out of the wagon and squinted into the twilight, trying to gauge the size of the emerald-green waves peeling down the point. Cheyne volunteered to paddle out

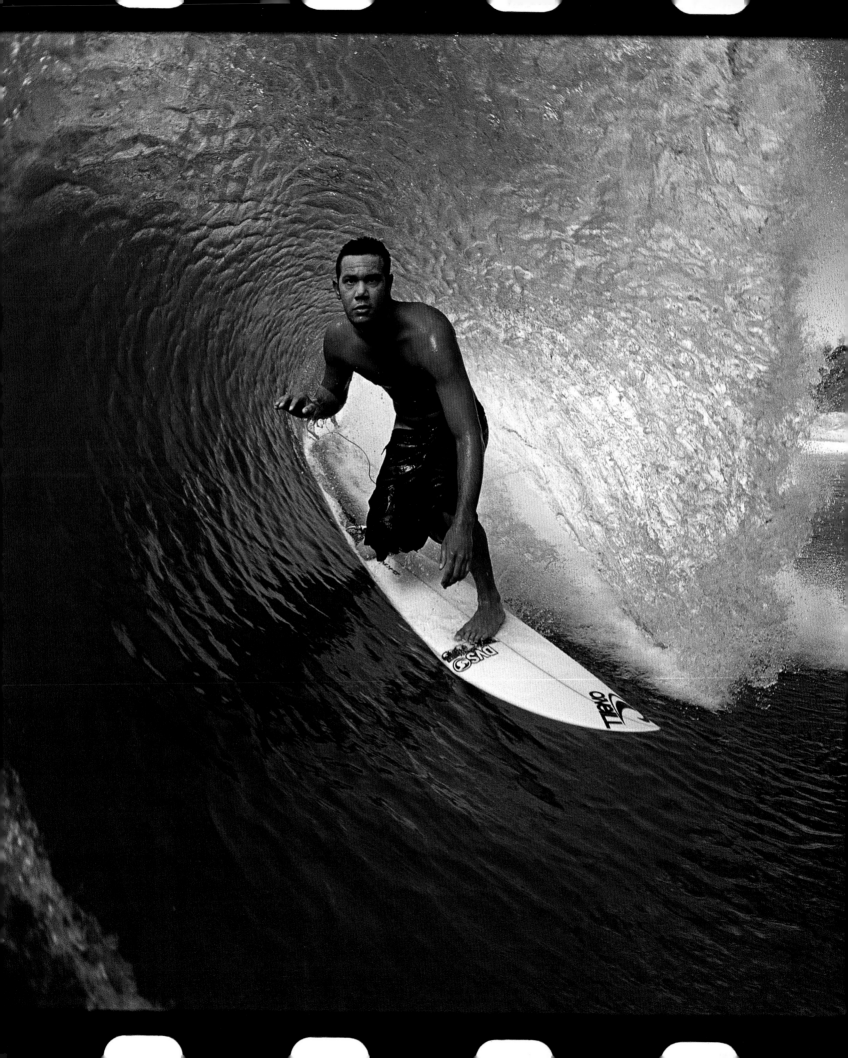

and ride a couple before darkness fell. Alan reached for his camera bag while Cheyne hurriedly pulled out a board and started looking for wax. Already the crew's arrival had created quite a stir in the village. "All the kids and young guys had run out of their huts and they were standing there in a big semi-circle. Cheyne was screwing his fins in while this whole mob of guys were staring at him, inching closer, trying to figure out what he was doing. They were looking at his board, saying something in Portuguese. *"Propulsor? Propulsor?"* [Propellor? Propellor?] I don't think they'd seen a surfboard before...they were trying to figure out how it was going to propel itself in the water. So then we headed down to the point with the whole crowd of about 30 villagers following us. Cheyne paddled out and caught a wave, and the villagers watched him, absolutely captivated. He did a few turns and the kids started mimicking the manoeuvres, bending their knees and waving their arms in the air. When he finished the ride and came into the beach they just went crazy, cheering and shouting. It was phenomenal. It's amazing to see people's first reactions to surfing, people who haven't seen it before. Ya, that was just an incredible moment."

The next day the crew gorged themselves on barrelling four- to six-foot lefts while Alan

busied himself shooting the action from all angles. The blazing sunshine and crystal clear water made the smile on his face even broader. He knew ZigZag photo editor Barry Tuck would love the shots (he did – the mag ran a 10-page article about the trip and used a shot of Cheyne blasting a sick air on the cover). This was the gold they'd travelled thousands of kilometres for. "Ya, Angola was the best trip of my life. For years we'd talked about driving up Africa's west coast as far as we could, and at last we were actually doing it. We took all our own supplies, camped in the wild...just lost ourselves for a month. The whole experience was amazing, unforgettable."

Angola, Namibia, Zambia, Mozambique, Madagascar, the Maldives, Morocco, Indonesia, Hawaii, Mexico, the Philippines...given the number of countries he's visited (some several times), it's perhaps surprising to learn that van Gysen is still only in his twenties. Born and raised in South Africa, he's lived in the Cape Town suburb of Kommetjie most of his life. Playing music was a family tradition and at an early age he took up the oboe. It might not have earned him much street cred but it won him a scholarship to a decent high school where he studied music and arts. Photography was a natural progression. A keen surfer, he combined his two prime interests in his late teens and had his first

On the right track, Angola

shots published in *ZigZag* at the tender age of 17.

A couple of years later Alan was invited on a boat trip to the Mentawai Islands by veteran American photographer John Callahan, who'd seen his impressive watershots in the magazine. John's novel idea was to recruit a multi-national crew of surfers, and double the productivity of the trip by using two photographers. It worked. The trip was a huge success and John sold the story to the leading surf mags in four European countries.

As his shots gained international exposure, Alan took on more and more assignments and put himself into ever heavier situations. Most times he managed to stay out of trouble, which isn't too hard when you're half man, half conger eel. If he found himself caught inside at some grinding reef he'd avoid a flogging by holding onto a coral head or swimming into a crevice. But some spots simply don't have an emergency exit...as he discovered at Hollow Trees in the Mentawais. "I was on another boat trip with John, this time for *Surfing* magazine. On board we had Travis Potter, Timmy Turner, Cheyne Cottrell and Brett Schwartz. We pulled up at HT's and it was perfect: eight- to ten-feet and as perfect as I'd ever seen it. Koby Abberton and a couple of other Aussie guys were also there, on another boat. The Aussies were frothing that I was shooting from the water 'cos their photographer had opted not to swim and was shooting from the boat. I soon found out why! I had to swim as hard as I'd ever swam out there."

After a couple of hours Alan had some killer shots in the bag, but his calf muscles were beginning to ache. Unexpectedly, a big set swung wide and he got caught inside. He took three on the head and was unceremoniously dragged onto the inside ledge, the infamous Surgeon's Table. As the water drained off the reef, he clambered to his feet and realised the predicament he was in. "I was standing in knee-deep water with a ten-foot wave breaking top to bottom right in front of me. There wasn't much I could do. I just turned my back to the whitewater, launched myself into it, and tried to play starfish. Somehow, thank the Lord, I didn't get badly hurt...I got a few cuts on my arms and knees, but that was about it. I think I was lucky."

Happily Alan's buddy Cheyne was on hand to administer the lime juice. "Oh ya, those things burn...AWWW!" laughs Alan, remembering the torture inflicted by his sadistic friend. "It's funny how your close friends always volunteer to help you with the pain. They seem to enjoy doing that."

Like most South Africans, van Gysen is a patriotic bloke and he's stoked that Saffa surfers have been making an impact on the ASP World Tour in recent years. Leading the charge is Durban phenom Jordy Smith, whose career Alan has followed closely.

"He's just unbelievably talented. And from a photographer's point of view he's great to have on a trip because he's a hard worker. I did a trip to Mozambique with him for *Surfer* magazine and I was really surprised how hard he was willing to work to get the shots. One day we were out for hours at this point [a grinding sand-bottom right which *Surfer* dubbed 'Africa's new J-Bay'], but it was hard for me to get in position because the waves were shifty and the current was really strong. I got some okay shots but I knew I didn't have anything exceptional. The other guys got tired and went in one by one, but me and Jordy stayed out. We ended up drifting for hundreds of metres down the beach... and this was at a spot which is known for its

sharks. I asked Jordy if he wanted to call it a day, but he was like, "No, no, let's try to get one more." So we drifted and drifted, and he stayed with me the whole time trying to get the shot. Eventually a set came through and we got a good hook-up. Perfect light, perfect water colour...I knew it was the best shot I'd got all day. *Surfer* eventually ran it as a covershot. But it took us about three hours to get it!"

When asked which wave in southern Africa he'd pick out as the best and most flawless on a perfect day, Alan doesn't opt for familiar spots like J-Bay or Cave Rock, instead choosing a desolate point miles from anywhere in the desert wastelands of Namibia. "It's impossible to single out one wave as the best, but I'd say that Skeleton Bay is certainly the most phenomenal. It's unmatchable in perfection, heavily hollow and just freakishly long."

Crowds are never a problem at Skeleton Bay, says Alan. The wave is a gruelling drive

"ANGOLA WAS THE BEST TRIP OF MY LIFE. WE TOOK ALL OUR OWN SUPPLIES, CAMPED IN THE WILD...JUST LOST OURSELVES FOR A MONTH. THE WHOLE EXPERIENCE WAS AMAZING."

Cheyne Cottrell and Angolan villagers

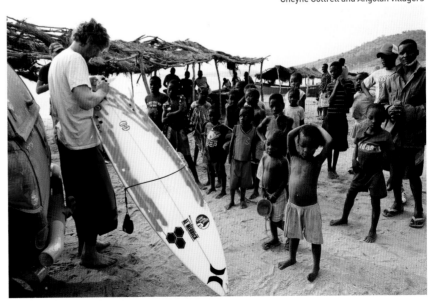

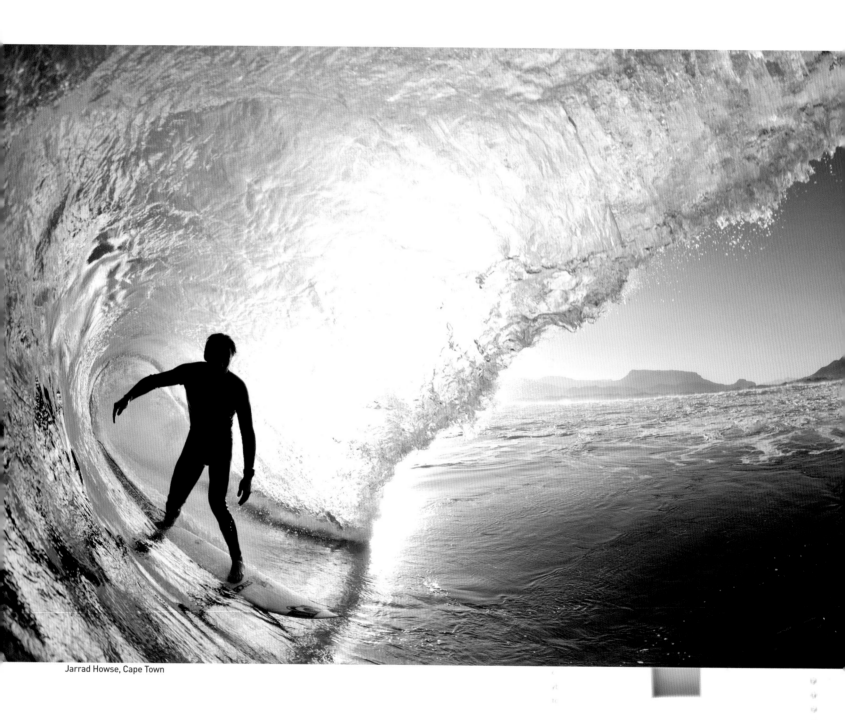

Jarrad Howse, Cape Town

"LONG DRIVES, REMOTE BREAKS, SHALLOW REEFS, POWERFUL SWELLS...PHOTOGRAPHERS IN SOUTHERN AFRICA HAVE PLENTY OF THINGS TO DEAL WITH, AND THAT'S BEFORE YOU EVEN CONSIDER THE POSSIBILITY OF BEING CHEWED BY SOMETHING UNFRIENDLY."

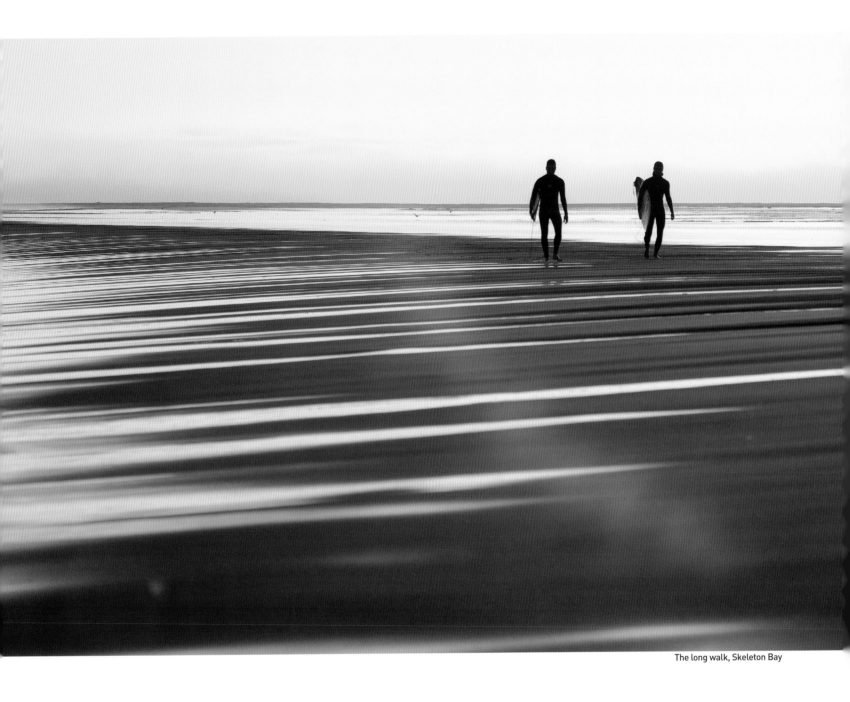

The long walk, Skeleton Bay

from Cape Town and only a handful of surfers make it there on the rare occasions that it breaks. It's not exactly a luxury destination either. "The whole place is just completely desolate. The wave breaks down a long sandspit with this abandoned lighthouse at the end, and the beach is littered with seal skeletons and bones. You see quite a few jackals skulking around, picking bits of flesh off the bones. It has a very eerie desolate feel. But when you're in the water you forget all that because the wave is so phenomenal. Basically your mind switches off and you just

focus on trying to surf it."

"The craziest thing is the current. It's unbelievable...like the current at Pipe on a big day. You jump off the point and if you don't get the first wave that comes through you find yourself halfway down the beach. And it's a two-kilometre beach! So by the end of the day, whether you're surfing or shooting, you're totally wasted."

An image from Alan's most recent trip to Skeleton Bay sums it up perfectly. Three guys huddle around the back of their 4x4 after a session. You can see they're exhausted, and

frozen to the core by the icy wind, but at the same time totally amped.

Long drives, remote breaks, shallow reefs, powerful swells...photographers in southern Africa have plenty of things to deal with, and that's before you even consider the possibility of being chewed by something unfriendly. Alan's closest call with a toothy ocean predator was during the O'Neill Coldwater Classic contest in 2008. "We were out at The Kom [a big-wave left near Cape Town] and the contest director had just called off the final heat because the

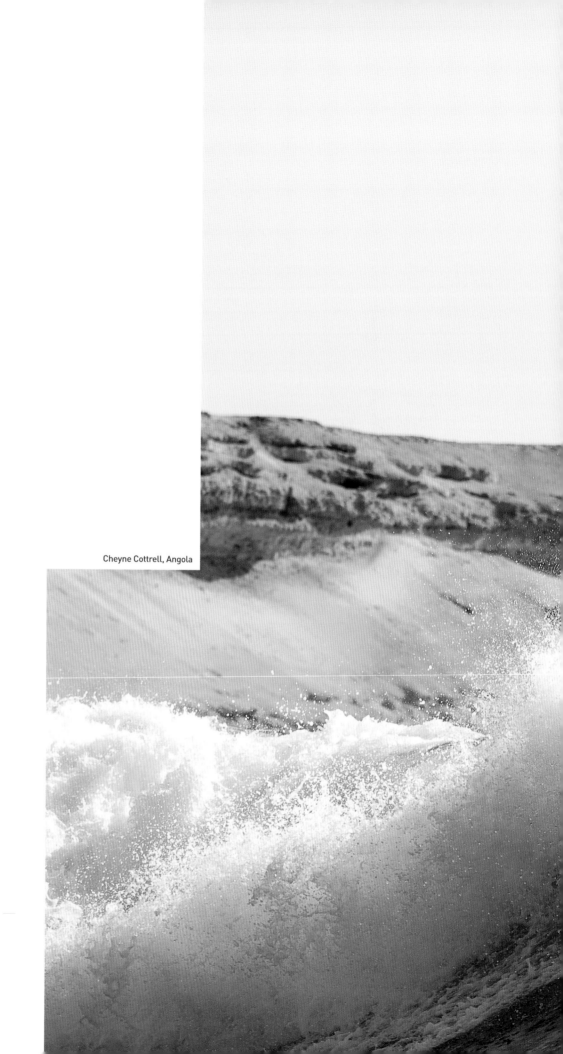

Cheyne Cottrell, Angola

weather was starting to get stormy. I was in a rubber duck with a couple of other media guys and surfers. It had been a long day, I'd been shooting for about six hours. We were waiting for the last two guys to paddle in, so I was taking it easy sitting on the side of the rubber duck with one leg dangling in the water. Just then this massive shark broke the water right next to our boat. It came up really slowly, without a sound, about a metre from my outstretched leg...I could've put my hand out and touched it. Then it rolled onto its side with its fin sticking out and just kinda stared at me. It was one of those moments when time sort of slows down...we were just looking at each other. It was terrifying but at the same time incredible."

The shark was the same length as the four-metre dinghy Alan was perched on, and he instantly knew it was a great white. "So then it turned and started making its way towards the two surfers in the water. We tried to buzz it and get in front of it to deter it from going towards the guys but it just keep swimming. So we had to get the guys into the boat pretty quickly. And luckily the shark just kept on swimming and went out to sea. Maybe it was just curious about us and what we were doing out there...but all the same it was quite scary!"

Adventurous, talented, hard-working... and not too fazed by massive sharks, Alan van Gysen certainly has a lot going for him. While the surf media looks likely to turn itself upside down in the next five to ten years, you get the feeling this young man will still be doing his thing, and doing it damn well. "Surf photography is my passion, I love it. Getting a good shot is like getting barrelled – you get one and you just want to get more." ❑

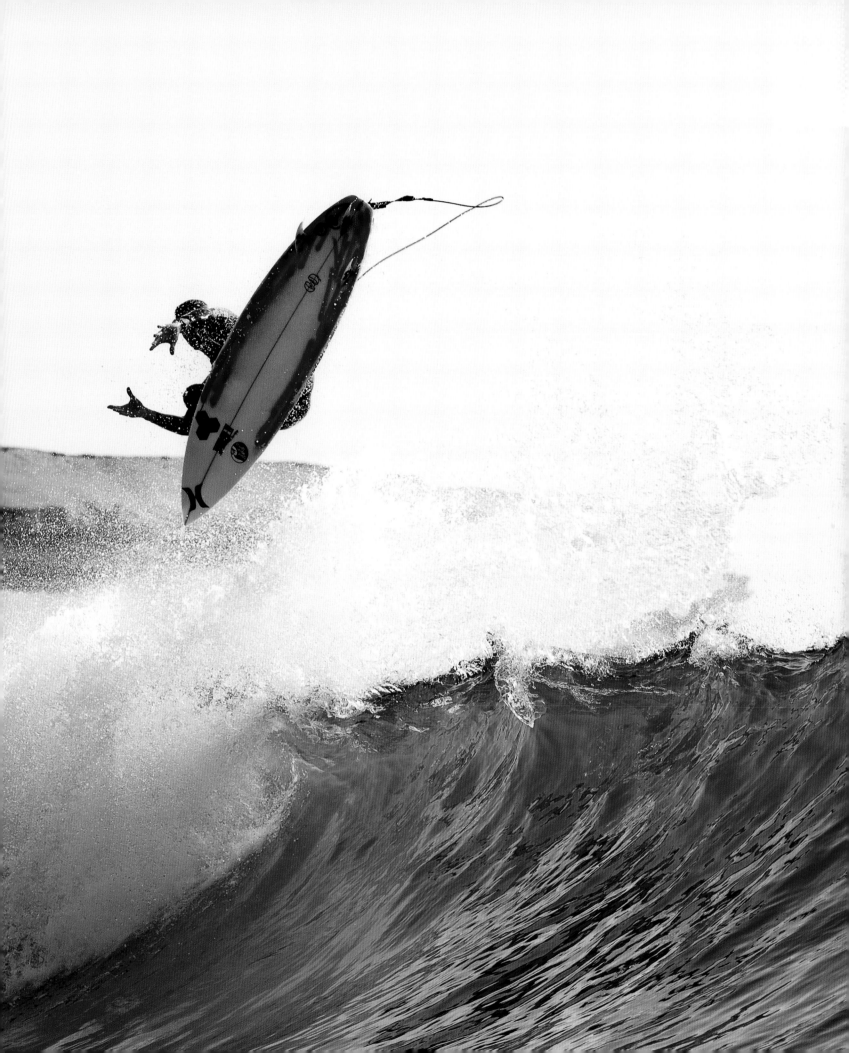

//SCOTT AICHNER

FEARLESS FISHEYE SUPREMO

From a young age, Scott Aichner has always loved being in the water, and in the thick of the action. In his teens he was a fanatical bodyboarder and a star waterpolo player at his high school in Ventura, California. By 19 he'd worked his way up through the bodyboarding ranks to become one of the top boogers in California; but it was next to impossible to make a living as a pro, so he settled for a job working at an upmarket hotel in the hills above the town. In his spare time he made surf and bodyboard videos, initially shooting footage of the local scene in Ventura, then later travelling to Hawaii and Mexico to shoot beefier barrels. His forte was in-the-tube water footage; the heavier the waves, the better. In the winter of '96, Scott and his wife Sandy moved to the North Shore of Oahu. They paid the rent by finding jobs at the Turtle Bay Resort, and Scott devoted his free time to shooting high-speed 16mm film for surf and bodyboard videos. Then, in '98 he decided to try his hand at stills photography. Keen to standout from the slavering pack of North Shore water photogs, he began shooting radical fisheye images using a medium-format camera. *Surfer* magazine loved his shots and signed him up as a staff photog a few months later. By the mid '00s, Aichner was widely acknowledged as the best fisheye lensman in the business. He's since racked up more than 80 covershots for titles such as *Surfer, Waves, Tracks, Stab, Japan's Surfin' Life, Fluir, Surf Europe* and *The Surfer's Journal*. From the very beginning, Scott's ethos has always been about involvement. "I didn't wanna shoot from a distance. I wanted to be right there in the action."

When you started shooting watershots you were using a Pentax 6x7 medium-format camera, something no one else was doing. It seemed like you had a game plan from the start...
Yeah, I wanted to do something different. I wanted to set myself apart from what everyone else was doing, 'cos everyone was shooting 35mm and there was just so much competition. So I started thinking about medium format. I wanted to blow the editors away by showing them a bunch of 6x7 slides, which are about four times larger than normal slides. The camera was heavy but it wasn't as heavy as the 16mm cine camera I'd been using. So the weight of the camera wasn't an issue, it was all about the timing. 'Cos it was one shot at a time.

Really, no motor-drive?
One shot at a time...the housing had a hand crank [to wind the film on]. So timing was the real

challenge. I had to wait for the exact right moment and then fire. Most times my head and body would be underwater as the lip came over, so I'd do it by feel. I'd see the moment happening and then it was all about feel. Working like that taught me how to shoot...I really had to think what I was doing before I fired the shutter.

And I guess you didn't get too many frames on a roll...
Yeah, only ten. But it still took me a couple of hours to shoot a roll 'cos I was really really picky about what I was shooting. I just took my time and waited for the moment. That was the key. And it still is. It's all about waiting and waiting for that moment, and then shooting it. I always tried to raise the bar. I didn't wanna just shoot a bunch of standard shots. I wanted to wait for those special moments.

How long did you use that camera?
Just for a season and a half. Then I realised I needed to make a living, so I caved in and started shooting 35mm. Film at first, then digital around 2006 when they got the frame rate with a fisheye up to 10 frames per second.

When you were starting out, were there any particular photographers you looked up to?
Yeah, quite a few, guys like Chris van Lennep and Aaron Lloyd especially. Back in the day I was a pro bodyboarder and I'd go on trips with Aaron to places like Cabo San Lucas [in Mexico]. So I was familiar with being on the other side of the lens and I learned a lot from him. And then I met Chris when I moved to the North Shore in '96. He was the man. His shots just had the best colours, and he really had a feel for what he was doing. All the photographers wanted to be like Chris. He was a total perfectionist. And he made his own housings too, which was really cool.

"I ALWAYS TRY TO WATCH THE SURFERS' EYES – 'COS WHERE THEY'RE LOOKING IS WHERE THEY'RE GONNA GO. IF A GUY IS LOOKING AT THE BEACH, THEN HE'S STRAIGHTENING OUT AND YOU'VE GOTTA GET OUTTA THERE. BUT IF HE'S LOOKING DOWN THE LINE, THAT'S WHERE HE'S HEADED."

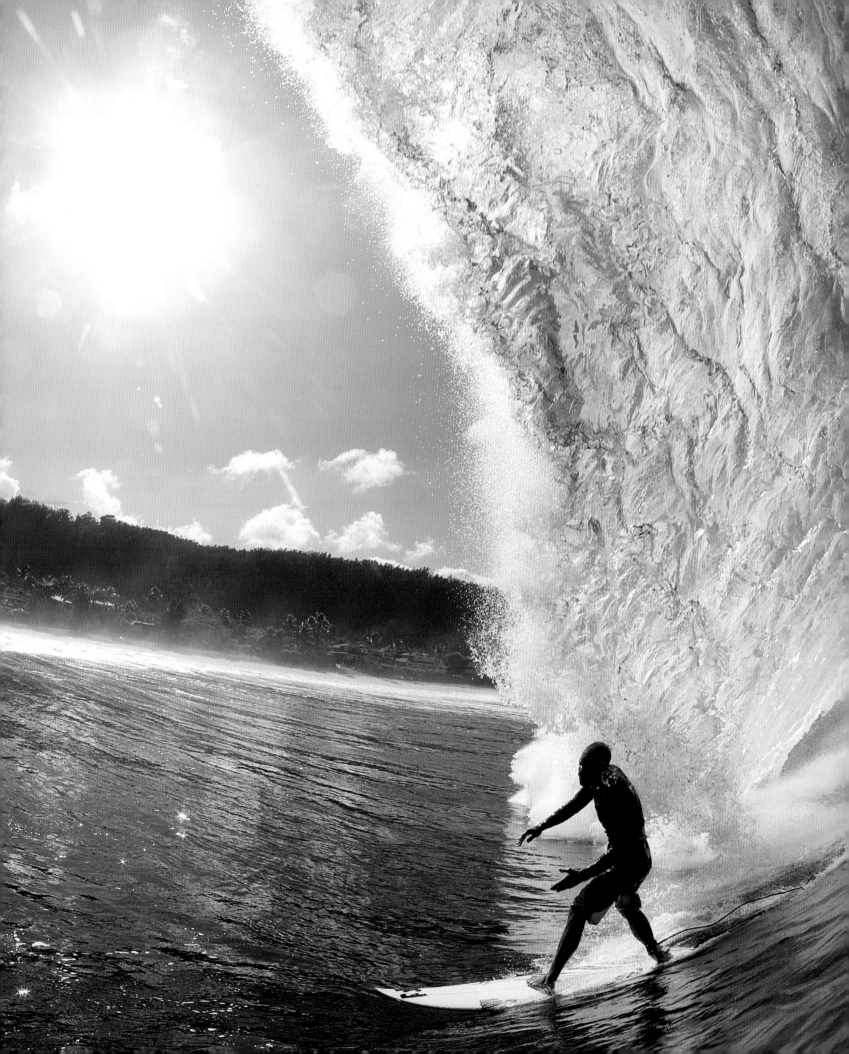

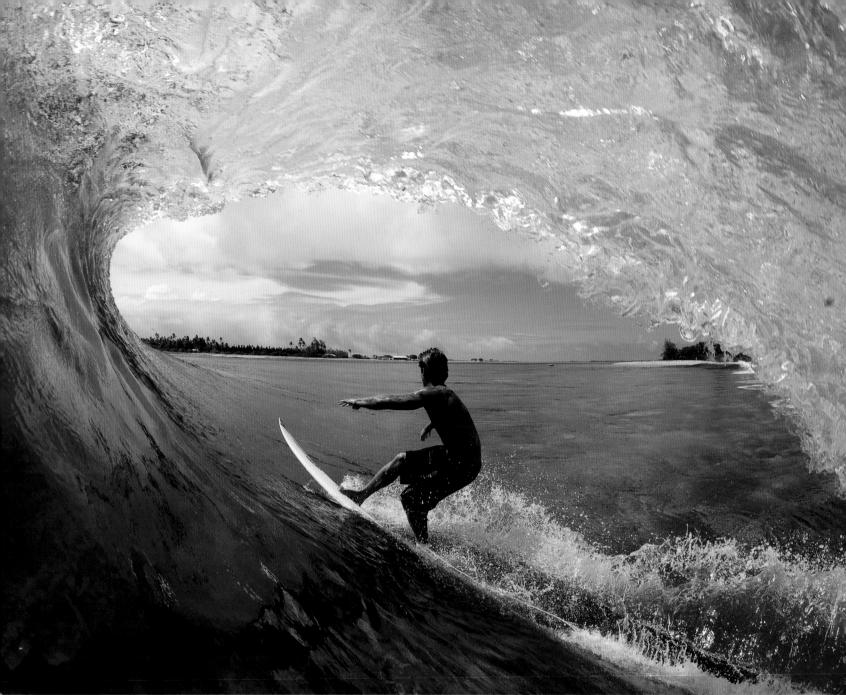

Kekoa Cazimero, Micronesia

"I ALWAYS TRIED TO RAISE THE BAR. I DIDN'T WANNA JUST SHOOT A BUNCH OF STANDARD SHOTS. I WANTED TO WAIT FOR THOSE SPECIAL MOMENTS."

this! What else are we gonna do today?" So we went out, and then this crazy double-up closeout came through and Rob took it...

Were you looking through the viewfinder when you got that shot?

No, I just shot it hand-held. With a bit of experience you figure how to hold the camera so you get your subject at the bottom of the frame. I wasn't really looking at Rob, I was looking at the lip. I always find the lip so interesting...in fact sometimes I've had a problem clipping guys off the bottom, you know, cutting their boards off, 'cos I just get so enthralled with what's happening. I'm watching the lip and I forget about the surfer. It's like, 'Oh yeah, there's a surfer in there!' (Laughs)

When you're swimming around in the impact zone at Pipeline, what's the most dangerous thing – the surfers coming at you or the waves?

Um, actually the most dangerous thing is an inexperienced surfer. Just some guy throwing himself over...that's really dangerous. But, yeah, it all comes down to reading the surfers and the waves. I always try to watch the surfers' eyes – 'cos where they're looking is where they're gonna go. If a guy is looking at the beach, then he's straightening out and you've gotta get outta there. But if he's looking down the line, that's where he's headed. So that's how to tell.

How would you compare Pipe and Puerto Escondido in terms of difficulty of shooting?

Well, Puerto's pretty gnarly. When it's big you have house-sized rips taking you out to sea. But they're manageable...and you always have the safety net of the harbour. Like, if it got really big really quickly you could always swim to the harbour. Whereas at Pipe, you can't do that. At Pipe you're out there, and your two fins have gotta get you in! (Laughs) Which is heavy. You can have some heavy moments out there and panicking is the worst thing you can do. I've found myself doing that once or twice. One time, when I'd been out for about three hours, I got caught inside and got stuck in the sweep moving towards Ehukai. I wanted to swim in, but I wasn't really close enough to the shore. I made the mistake of hesitating for a few seconds...and then I really had no choice. So I had to swim all the way back out and do another lap. And that was pretty heavy 'cos I was so tired. Although while I was swimming back out I got an amazing shot of Makua Rothman in a double-up pit, so at least I got that! Anyway...to get back to the question, yeah, I'd say Pipe and Puerto can both be real challenging places

Kekoa and crustacean chum

The year before last you won *Surfer's* Photo Of The Year for that shot of Rob Hennessy at Puerto Escondido. It's an incredible image, it looks as though the lip is about to land square on your head, but I read somewhere that you just got under it...

Yeah, I guess the lip missed me by about six inches! There are actually three more frames after that one where I'm in the barrel and the lip goes right over. And the funny thing is, we weren't even gonna go out that day. We were sitting on the beach looking at it, and it didn't really look that good. It was only four or five feet and most of the waves were closeouts. Nothing too special. Then we saw another surfer and a photographer walking down the beach, so we were like, "Yeah, let's go do

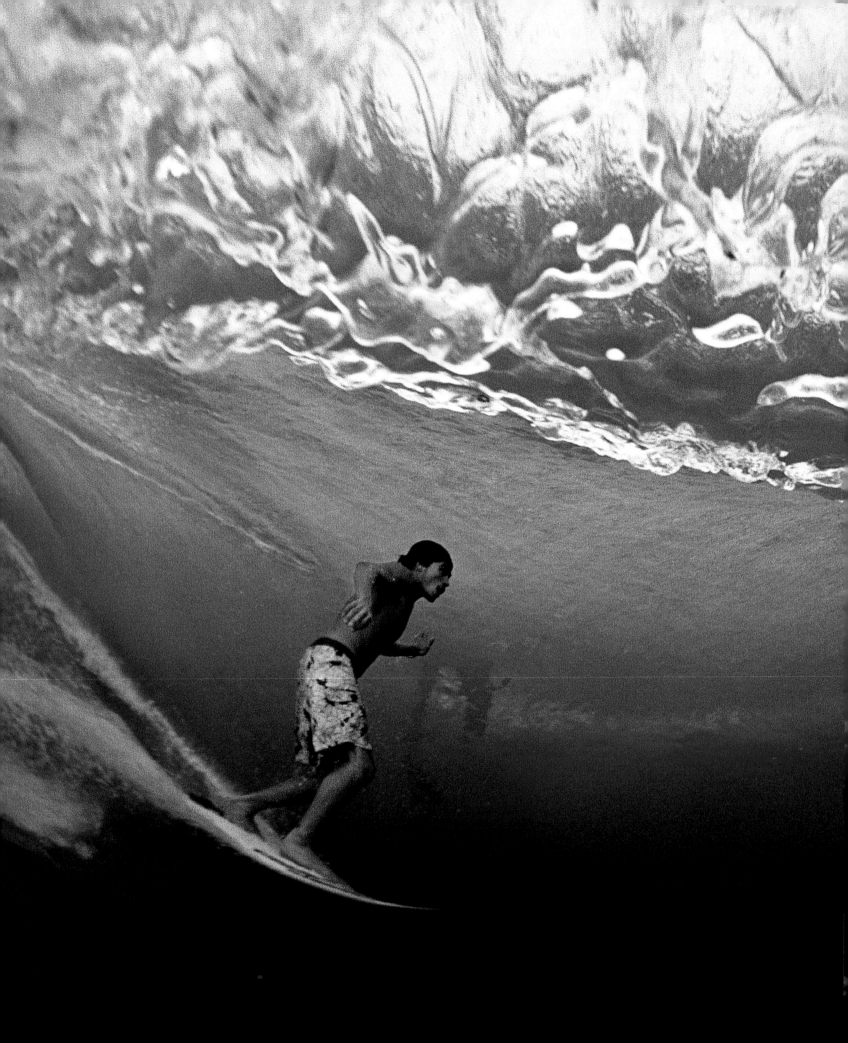

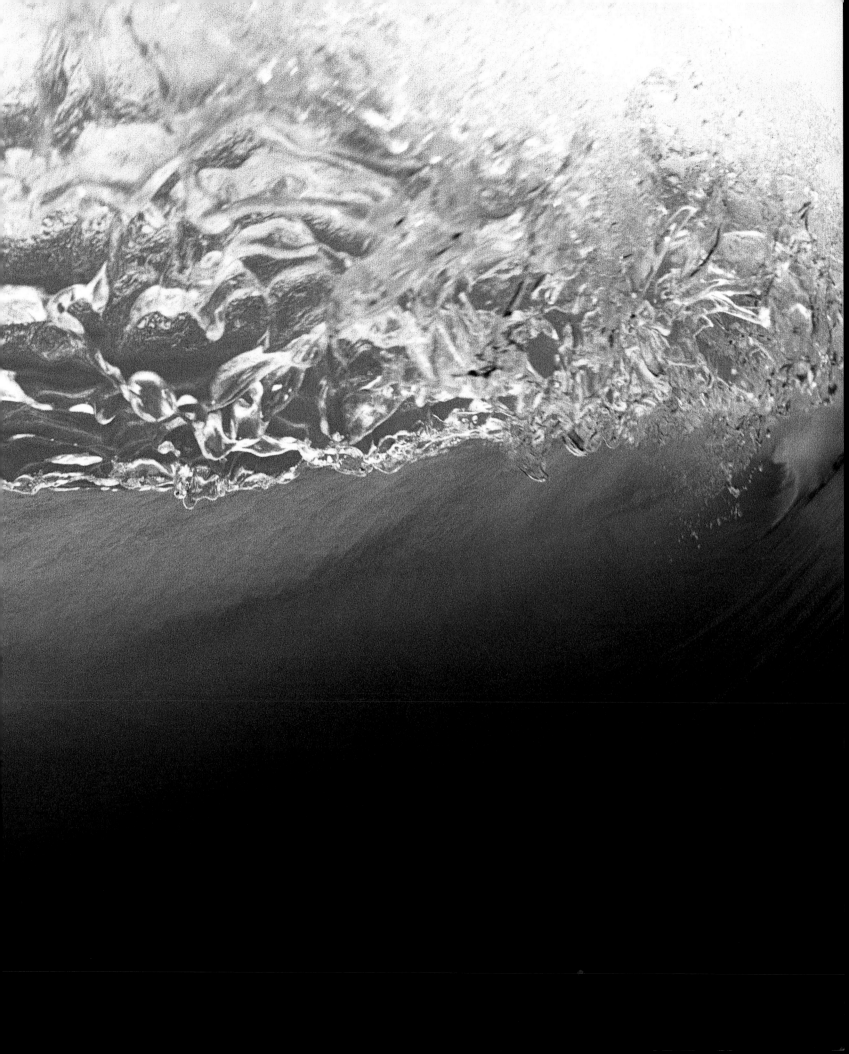

to shoot. I'd put them toe to toe in terms of difficulty of shooting.

You were a waterpolo player when you were at school so I guess you did a lot of training back then. Since then have you found that you needed to train to stay in shape to shoot places like Pipe and Puerto Escondido?
Oh yeah, definitely. You need to hit the gym, like, three times a week. You need to do a lot of cardiovascular stuff like running and cycling, maybe a little weightlifting... Yeah, training gives you the confidence to get out there and do it. Training and rolling around in the shorebreak! (Laughs)

For the last 12 years you were based in Hawaii, but you've just moved back to California. What were the reasons for that?
I was just ready for a change. I wanted to get into a few other things...and I wanted to go surfing again, 'cos I really missed actually riding waves. Whenever the waves were good I'd go and shoot, but I'd be like, "Aw, I'd love to go surfing...". So I was ready for a break. This winter was my first winter off in ten years, and we just had the most amazing season here in California. I was surfing all the pointbreaks around Ventura, from Ventura up to Rincon, and I really got back into it. I was doing laps out there! Yeah, it was good to get back in the water and just devote myself to surfing.

So are you just going to do occasional trips now? What's the plan?
Yeah, I'll shoot here and there when the opportunity arises. I'll go on some specific trips. But right now I'm just enjoying being back in California. And surfing...a lot! ❑

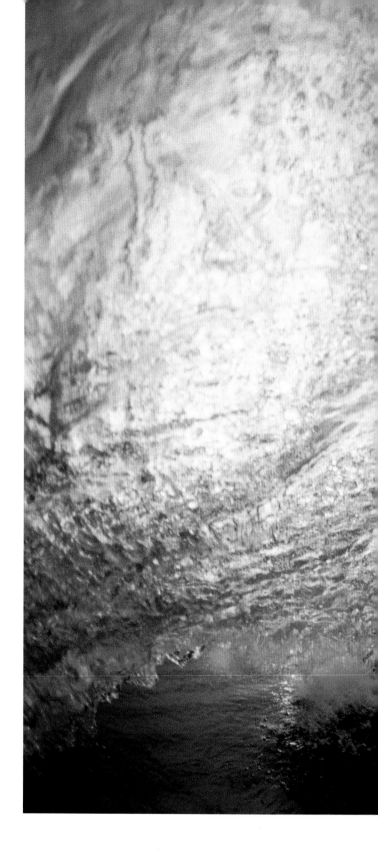

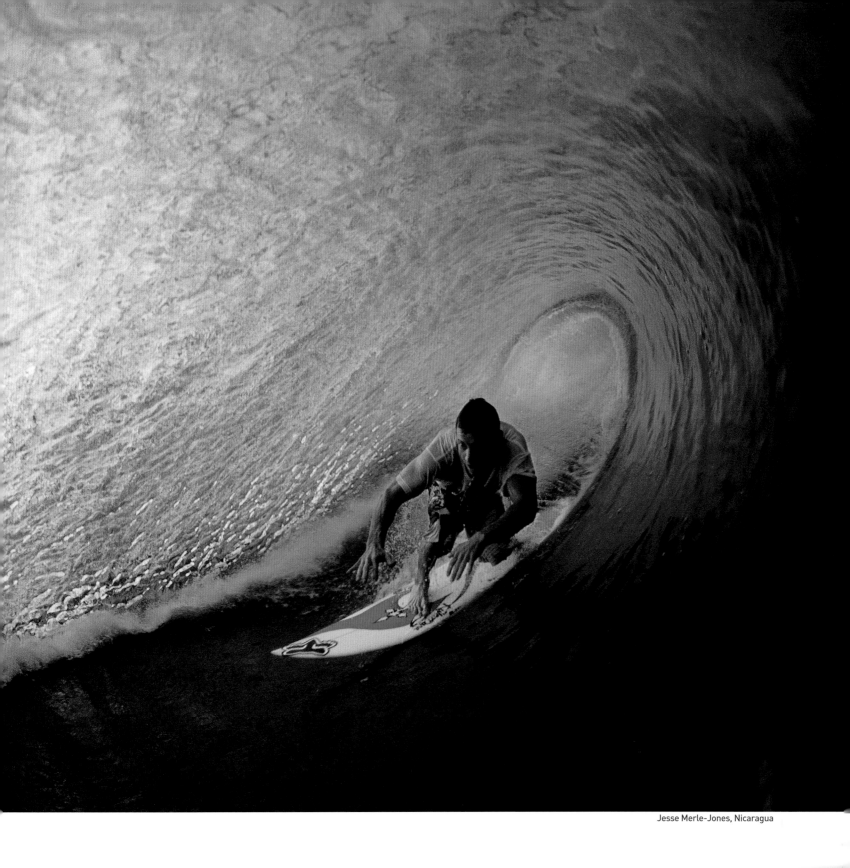

Jesse Merle-Jones, Nicaragua

//ERICK AND IAN REGNARD

[TUNGSTEN]

MAURITIUS-BORN TWINS WITH A PASSION FOR THE OCEAN

SURF PHOTOGRAPHY, COMMERCIAL PHOTOGRAPHY, FINE ART PHOTOGRAPHY...
ERICK AND IAN REGNARD (ALIAS TUNGSTEN) HAVE SO MANY PROJECTS ON THE
GO THAT YOU ALMOST SUSPECT THEY COMMUNICATE TELEPATHICALLY.

The first time photographer Erick Regnard saw The Right he was blown away. It was 15 to 20 feet, miraculously free of steps, and throwing barrels the size of train tunnels. But the finer points of the wave weren't what caught his attention. "Actually my first reaction was, 'Shit, I hope we don't get caught inside!'" he laughs, speaking with a thick French accent. "Because it was massive and we were only about 20 metres in front of the rocks. It's one of those spots where you really don't want to go overboard!"

Erick reckons The Right is the best big-wave break in Western Australia, if not the country. "I think it's better than Shipstern's actually. Shipstern's tends to warp and make all those steps, it's amazingly ugly in a way, while The Right grows and just throws perfectly."

The downside is that The Right is not the easiest place to get to. "The jetski ride there is awful, it's rough as guts. You have to go about 20 k's up the coast with all this backwash coming off the cliffs and big waves breaking all over the place. When the swell is 15 to 20 feet it's really scary getting out there. But once you're there it's okay...the channel's very deep so it's pretty safe."

Erick has shot The Right at least a dozen times and he's seen some serious charging out

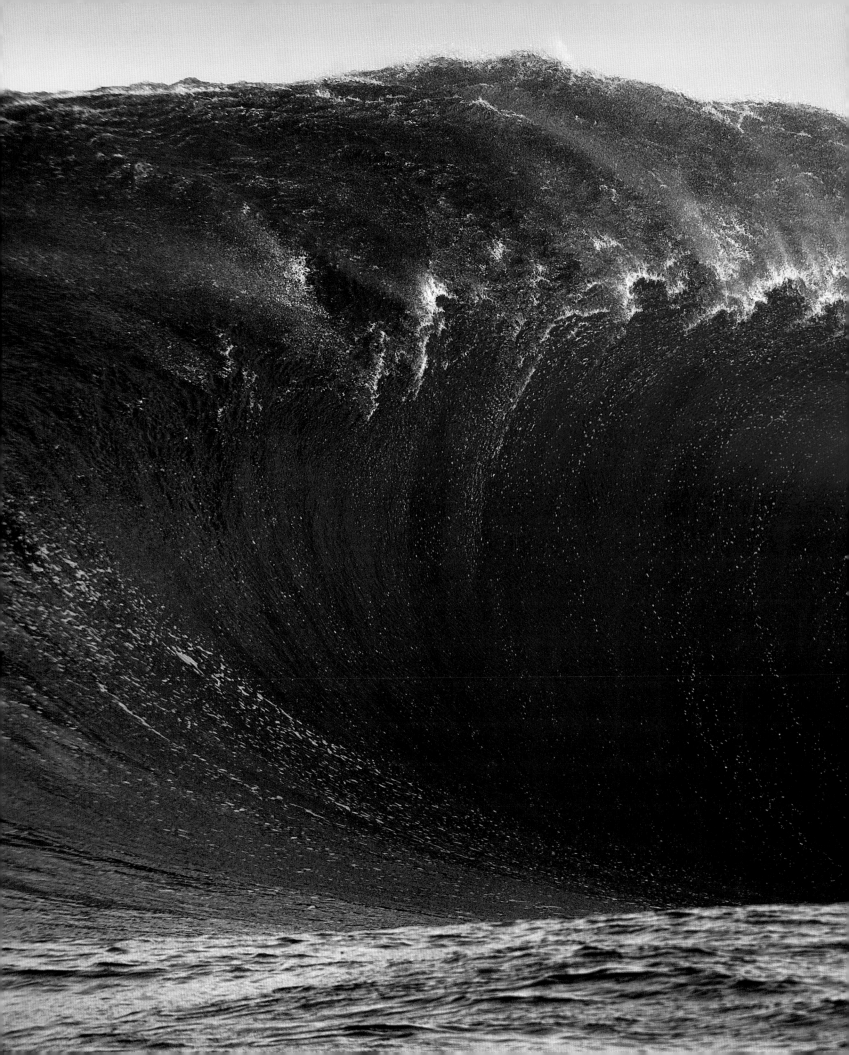

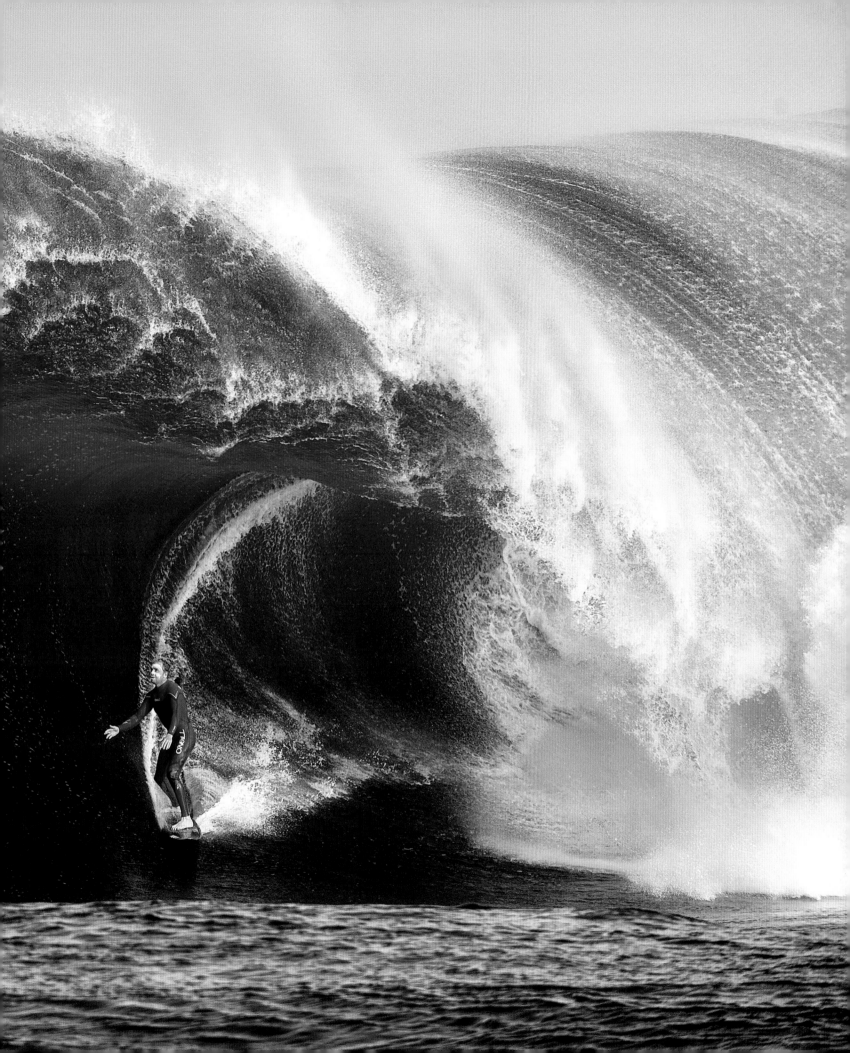

there, not always for reasons of pure bravado. "One time Koby [Abberton] was out there and there weren't really enough jetskis so everyone had to wait their turn. But Koby didn't want to sit in the water 'cos he was afraid a white pointer would take him. He didn't want to dangle his feet. When it was his turn to tow he was backdooring everything, just absolutely charging. Most of the waves were staying open but a few were shutting down on the end section. I remember him getting one which started to shut down but since he had so much momentum I guess he thought he could get through. So he just went straight for it, and he made it. Crazy!"

Together, Erick and his twin brother Ian make up Tungsten Photography, a West Oz-based outfit that uniquely combines surf photography, commercial photography and fine art photography. Erick does most of the on-location work, while Ian handles the admin side of things as well as local shoots and some of the commercial work.

The brothers grew up on Mauritius, the French-speaking island in the Indian Ocean, home to the legendary Tamarin Bay. Due to political instability in the country, their parents decided the family should emigrate to Australia in 1983, when the boys were 15. In their teens the boys were huge fans of undersea explorer Jacques Cousteau. Their dad sparked their interest in photography when he gave them a Minolta Weathermatic underwater compact camera. Later, after taking photography classes at school in Perth and subsequently gaining diving certificates, the boys hoped to get into diving photography. They earned $10 a week working part-time at their dad's petrol station and eventually saved up enough to buy a Nikonos IV underwater 35mm camera. Erick worked as a diving instructor for a while, but the plan to incorporate photography didn't work out as the gear was expensive to hire and Aussie diving mags only paid peanuts for shots. So the brothers turned their attention to sailing and windsurfing photography and videography, investing in better gear whenever they could. Then, in 1992, a dedicated West Oz surfing magazine was launched, *Westside News.*

"KOBY WAS BACKDOORING EVERYTHING, JUST ABSOLUTELY CHARGING. ONE WAVE STARTED TO SHUT DOWN BUT SINCE HE HAD SO MUCH MOMENTUM I GUESS HE THOUGHT HE COULD GET THROUGH. SO HE JUST WENT STRAIGHT FOR IT, AND HE MADE IT. CRAZY!"

PREVIOUS SPREAD Mark Mathews, The Right
LEFT "Can't catch me..."
RIGHT Luke Munro, West Oz beachie

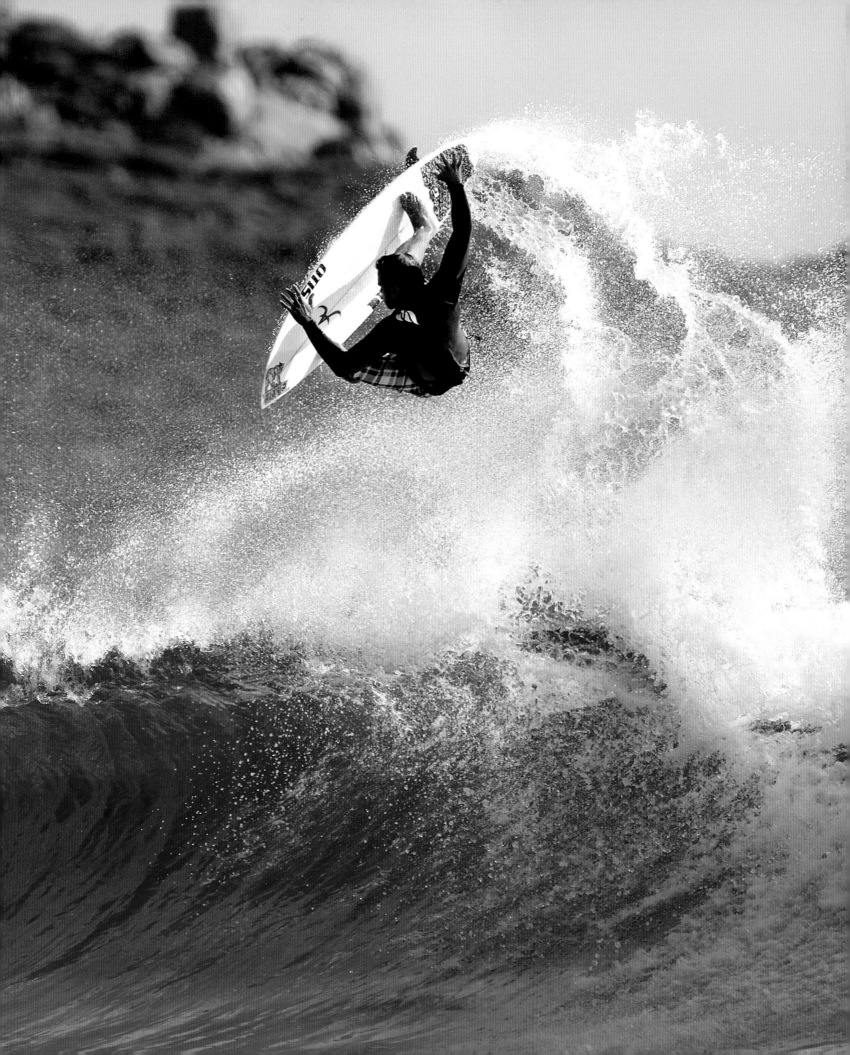

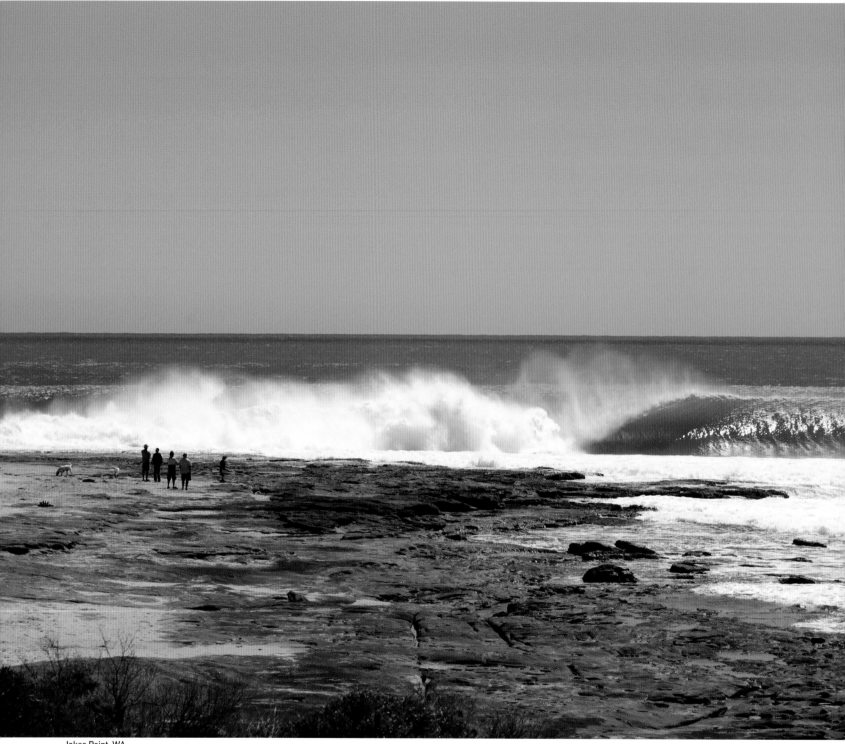

Jakes Point, WA

Overnight a whole new market opened up and the Regnard boys (by this time Tungsten) jumped at the chance to supply the new mag with surf shots. The Margaret River area was Erick's main focus to begin with, but it wasn't long before he was making forays into the desert regions to score sessions at remote and usually empty spots like Gnaraloo and The Bluff.

Two decades on, Erick says he still enjoys spending time out in the desert. "Camping out at Gnaraloo is fantastic, I just love it. It's going back to basics. You're there with your tent, you go fishing, there's dirt everywhere...I love the rawness of it all. Everybody's really friendly – sitting around campfires, talking about the surf, grilling whatever fish they've caught. If you spend 10 days there it's perfect. You drive up when you see a big swell coming and shoot Gnaraloo. Then when the swell drops a bit you go to Monuments or Slater's Right. There are a few different breaks that people can surf, so it's pretty cool."

WA tends to be relatively quiet from December to March, but it's prime time for waves in the North Pacific so that's when Erick sets off on his annual pilgrimage to Hawaii. For the last three winters, as well as shooting action shots, he's shot a series of portraits of heavyweight Hawaiian locals for a forthcoming book project. Erick says he's not trying to glamourise the bad boys among them, he's just trying to show them as they are. "I find guys like Kala [Alexander] make really interesting subjects for portraits. He's a heavy guy, a Wolf Pak guy, a bad boy you could say. But having a bad boy image has brought him a lot of good things – roles in

Kerby and Cortney Brown, WA

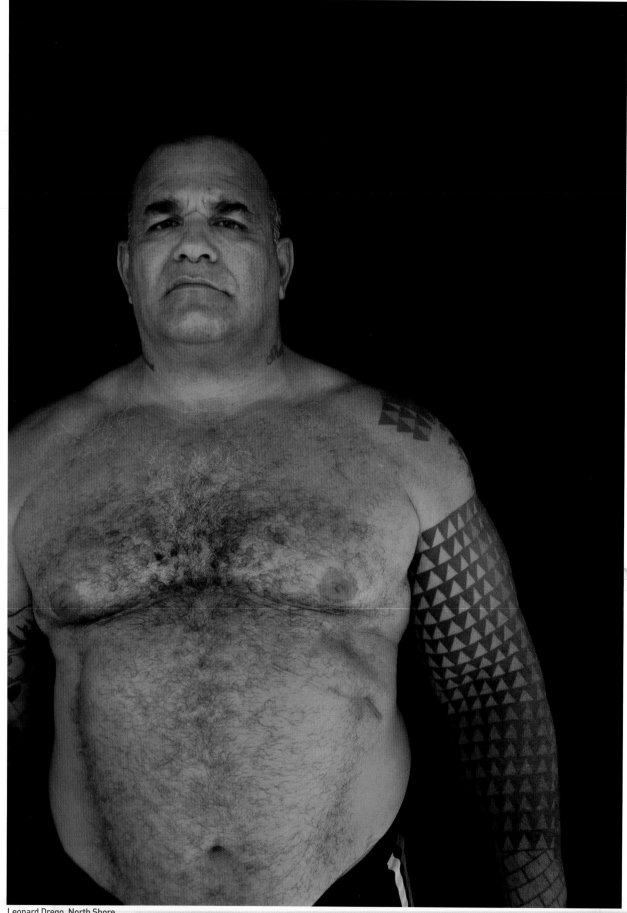

Leonard Drego, North Shore

movies, reality TV, girls, sponsorship...all that kind of stuff."

Erick didn't have any trouble locating Kala Alexander, Braden Dias, Dustin Barca and the other guys who control the lineup at Pipe, and once he'd shot portraits of them he hooked up with some of the Hui veterans like Eddie Rothman and Leonard Drego.

But there was one man on Erick's list who remained elusive, a big-wave surf star from back in the day – Marvin Foster. Since his heyday as a pro surfer in the the late '80s and early '90s, Foster had fallen on hard times and he'd had numerous run-ins with the law. He'd got involved with drugs, been arrested on a weapons charge, spent time in jail, then broken his parole upon being released. "I'd been trying to track him down for three years. The first year he was in jail, the second year he was in hiding, but this year I was determined to find him. I figured I had to go to the top so I went to see Eddie Rothman. He helped me out by making some calls and getting a message to Marvin. Eddie told me to go to a meeting point near Haleiwa but to keep a real low profile – drive a shitty car, wear old clothes... take only the one camera I needed. I went to the meeting point and waited, but Marvin didn't show up. Anyway, I kept asking around and looking for him, and a week or so later I spotted him hanging around in the car park down at the beach. I introduced myself, told him what I was doing and asked him if I could take some portraits. It was raining but I knew I had to do it then and there. He said, 'Sure, let's do it now.' We started talking, and I found him to be a really nice person. He was interested in what I was trying to do, asking genuine questions...he was just a real gentleman, truly one of the best guys to shoot for the book. I remember him saying, 'If only I could have been a surfer in this day and age...' because back then there wasn't much money around and it was hard to make it as a professional...you had to have another job and as soon as your performance level went down a bit you were history. So hearing him say that was kind of touching because I could tell he had a lot of regrets about getting involved with drugs, getting into trouble and

ending up homeless."

Erick could never have realised it at the time but he was the last person to take a photograph of this deeply troubled man, and perhaps the last to sit down and listen to him talking about his life. Tragically, three months later Marvin Foster was found dead in a derelict house in Pupukea. The pain of living had become too much.

Perhaps in an attempt to put that sad episode behind him, Erick has re-immersed himself in an entirely different venture, an ambitious fine art photography project which has already attracted international recognition. Erick's astonishing photos of a girl swimming underwater with stingrays were recently shortlisted for the highly prestigious International Photography Awards. The photos – taken at a secret location in the South Pacific – were shot one frame at a time on a large format film camera. This labour of aquatic love involved Erick and his model, Emily, being in the water for up to eight hours a day for three weeks. When the project is complete, the photos will make up an exhibition which will set off on a world tour starting in Monaco and going on to cities like Sydney, Tokyo, Beijing, Moscow, Berlin, Paris and New York.

Whether he's shooting terrifying 20-foot waves or beautiful girls cavorting with stingrays, Erick's love of the ocean is clearly the dominant theme in his work. "Yes, I'd say that, for sure. Whenever I go away somewhere, to New York or London, I get this feeling that I need to head back to the ocean. It's my life. So, yes, I think my work will always be connected to the waves and the ocean in one way or another." ❏

"WHENEVER I GO AWAY SOMEWHERE, TO NEW YORK OR LONDON, I GET THIS FEELING THAT I NEED TO HEAD BACK TO THE OCEAN. IT'S MY LIFE. SO I THINK MY WORK WILL ALWAYS BE CONNECTED TO THE WAVES AND THE OCEAN."

//STEVE SHERMAN
MR PORTRAITURE

He works fast. He talks fast too. For a guy who's been a boardsports photographer for two decades you'd think Steve Sherman might start to slow down a bit, but he can't – at heart he's still a stoked kid, buzzing about the scene he's immersed in. "I'm a surfer, I'm a fan of pro surfing," he declares happily, as if this was some sudden revelation. "I do this 'cos I just really love surfing."

Born in Indiana, Sherman's parents moved to California when he was 11 and he grew up and learnt to surf at Solana Beach. He became interested in photography while at high school, where he worked on the school paper; he covered events and shot portraits of his classmates, then printed them up in the darkroom. Later, after a stint at college and series of surf trips to Mexico, he got a job as a darkroom technician at *TransWorld Skateboard* magazine. Encouraged by influential photo editor Grant Brittain, Sherm hit the streets as often as he could, shooting kerb-view action shots and gritty black-and-white portraits of the local pro skaters. He gradually worked his way up the ranks to become a senior staff photographer, forging a reputation as one of the best portrait photographers on the scene. In 1999 TransWorld Media launched a new surfing title, *TransWorld Surf*, and Sherman was appointed photo editor. During his tenure there the mag established itself as America's most visually exciting surfing title, and Sherm's behind-the-scenes work and moody portraits gave it a unique identity. Later, in 2004, he joined *Surfing* magazine where he's worked ever since, both as photo editor and roving staffer.

He currently lives in Cardiff, just north of San Diego, with his wife, two children and quiver of 18 surfboards.

One of the iconic shots you took while working at *TransWorld Surf* was that lineup at Oceanside with the board graveyard in the foreground. Is that someone's backyard?
It's an empty lot on the beach at Oceanside. This guy living next door started collecting all the broken boards off the beach and made this little art project, with the boards looking like tombstones. I was shooting there one day, walking around taking lineup shots, and I just stumbled upon it. The waves were firing so I jumped the fence, got out my Hasselblad [medium-format film camera] and shot about 12 frames. And I happened to get that shot with the two guys in the barrel.

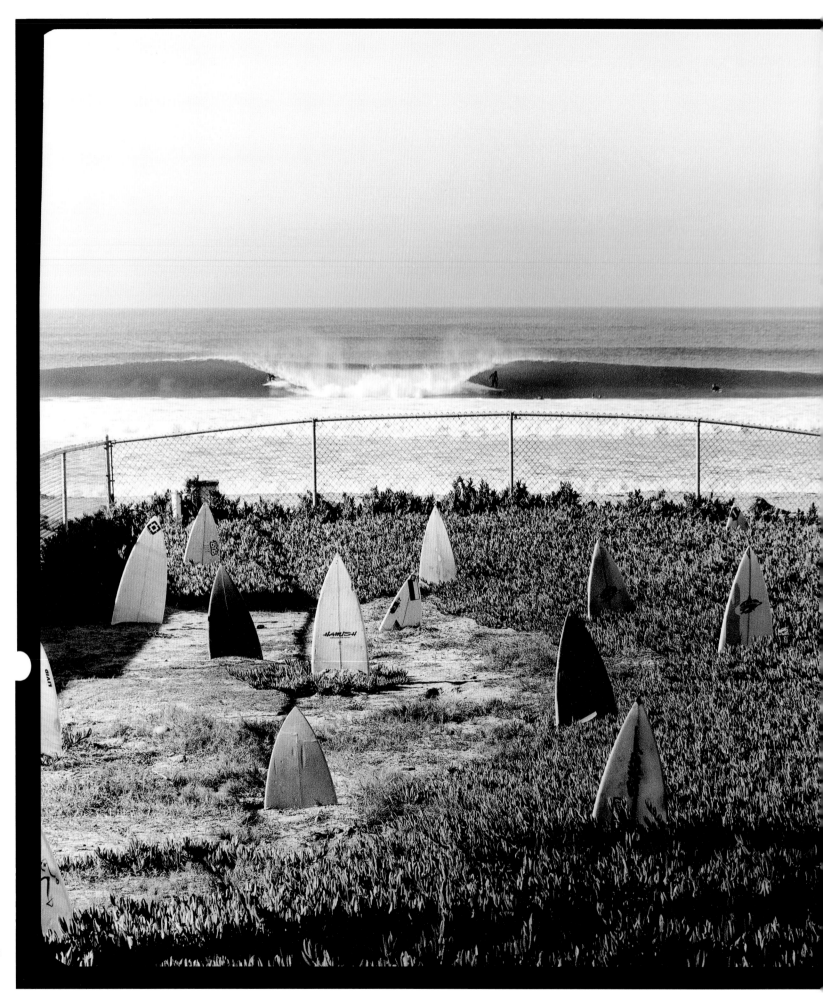

Board graveyard, Oceanside

These days what camera do you use most of the time?
I have a Canon 5D mk II, I use it all the time. It's great, I love it – full frame [sensor], great for portraits, and 21 megapixels so you get really big files. Wherever I go it's round my neck.

You're known for your behind-the-scenes shots, and to magazine readers it must seem like you become invisible to get those. But in fact it's about knowing the guys, being friends with them, gaining their trust...
Yeah it is. Most of the guys know me and they know what I do. And the way I work is pretty low-key...I just kinda sneak photos, or shoot a coupla photos and stop. I think that's the main reason those guys let me in...I'm kinda like a friend hangin' out. Kelly's girlfriend Kalani told me one time, "He likes to hang around with you 'cos you know when to take the photo, and when *not* to take the photo." Because sometimes photographers will be around famous people and they'll just keep taking photos all the time...boom, boom, boom. Instead of choosing a moment, shooting it and then stopping. I don't over-shoot. I tend to go for the moment and stop. And when I take portraits of people, I do it very quickly. I just don't like taking a lot of time. I find a lot of the photographers out there are kinda into the show...they're like, "Hey everybody, look! I'm taking a photo!" I'm just the opposite. I tend to be low-key. I'd rather people not even know that I'm taking photos. No bells and whistles, that's my thing.

Bruce Irons once commented that you and Brian Bielmann were "the only two non-creepy photographers on the tour." That says something about the respect the surfers have for you.
When he said that I just went, "Alright." Bruce is super-critical of people, he's very honest, and that was about the biggest compliment he'd ever given me. It's true though, I think a lot of the photographers on the tour are a bit creepy...you know, the guys who hang around all day waiting for the bikini contest, waiting to shoot the girls. I think a lot of them do it 'cos they just

"I DON'T OVER-SHOOT. I TEND TO GO FOR THE MOMENT AND STOP. I'D RATHER PEOPLE NOT EVEN KNOW THAT I'M TAKING PHOTOS. NO BELLS AND WHISTLES, THAT'S MY THING."

" I WAS FLYING DOWN THE LINE AND I HEARD BRUCE YELLING, "THAT'S SHERMAN!", AND THEN HE AND ANDY WERE BOTH SCREAMING MY NAME, HECKLING ME THE WHOLE WAY 'COS I'D STOLEN A SET WAVE OFF 'EM. "

wanna get laid! And when I see all those photographers on the beach, I kinda wonder, 'What's your motivation?' I'm always judging photographers that way. My own motivation is that I'm just a fan of surfing. I enjoy being around surfers. I love surfing, I'm a surfer. I wanna show the readers something I experience that they don't – the other moments, the moments you don't see on the webcasts. I think that's what comes across in my work, intimacy. And another reason I get on with the guys is 'cos they know that I'm a hardcore surfer too. I think that gives me some credibility with them. Like, in Australia, I was surfing Snapper Rocks and I grabbed a set wave from behind the rock in front of everyone. So I was flying down the line and I heard Bruce yelling, "THAT'S SHERMAN!", and then he and Andy were both screaming my name, heckling me the whole way 'cos I'd stolen a set wave off 'em. (Laughs) Yeah, I vividly remember that moment. I was thinking, 'This is *so* great! I love this!' That's the priceless stuff.

You've done a lot of trips to Mexico over the years, how much has it changed since you started going down there?
It's changed a lot. Yeah. I've been to Mexico a lot of times over the years, but to be honest I haven't been too many times lately 'cos it's pretty dangerous there right now. The economy's really bad, there are drug wars going on, and it's super violent…right there, just across the border in Tijuana. And when you get down to the coast there's a lot of crime. All in all the people seem pretty desperate right now. So I haven't been down there too many times lately. The last time was last spring when I flew down to Isla Natividad with Dane Reynolds and Dan Malloy for a few days. It was just a hit 'n run trip but we got it real good. Yeah, it's such a shame Mexico's changed so much. It's a beautiful place and the waves are great. But it's not like it used to be.

ABOVE LEFT **Eddie Vedder, San Diego**
ABOVE MIDDLE **Kelly and Andy, Gold Coast**
ABOVE RIGHT **Sean Taylor, Isla Natividad**

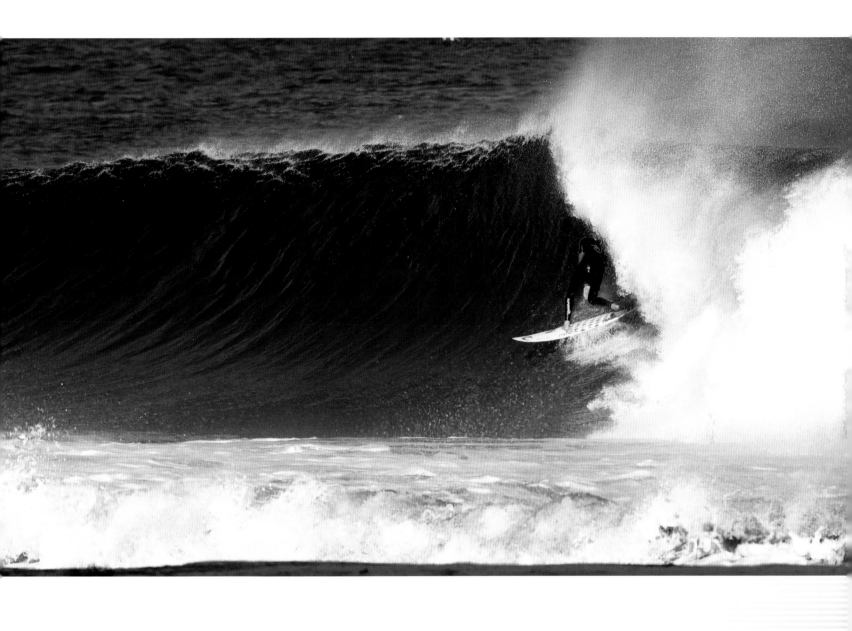

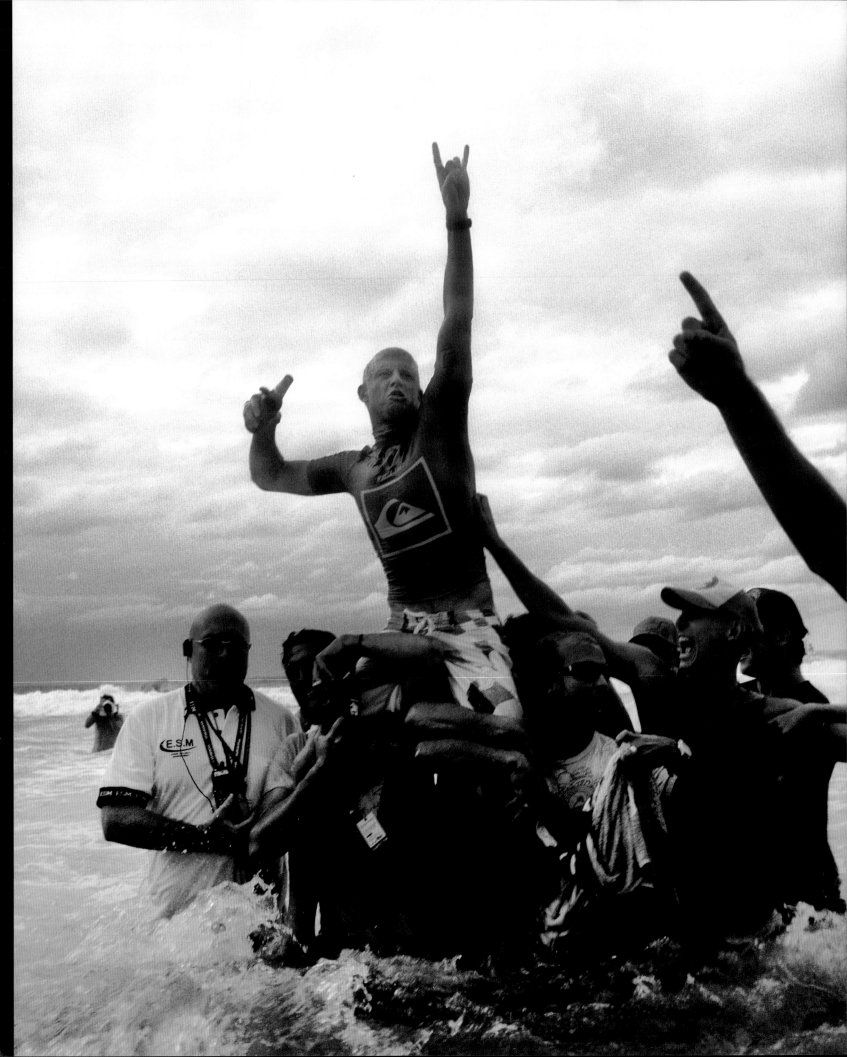

So, California is where you shoot most of the time.
Yeah.

I guess you know a lot of the top Cali guys from living in Cardiff, guys like Rob Machado...
Yeah, I know Rob really well. He lives just down the street from me, and he's a father with two kids like me. He's a great guy. Very mild mannered, good with kids, non egotistical...I like hangin' out with Rob.

I remember him quitting the World Tour in 2001 after being in the top five for years and I always wondered if he regretted that.
No, I think he was happy to do that. He'd done the tour for so long...he was kinda over it. Then he broke his wrist and the ASP wouldn't give him a wildcard for the following year, so he just quit. He wasn't happy about the way the ASP treated him though, he took it really personally. Yeah, he was very hurt by that. But it worked out. Since then he's had the time of his life. He does tons of travelling, he does films, he does charitable work in Indo, he does an annual contest for the locals here...all sorts of stuff. He's influenced a whole generation. Like, Cardiff has pretty much become the world headquarters for alternative craft! (Laughs) When you go across the railroad track to drive down [Highway] 101, you see people walking by with so many different surfboards. Fish, single-fins, quads, eggs...everything under the sun. And a lot of that is down to Rob's influence. It's a cool era to be surfing, I love it.

Okay, final question. Every other surfer now has a digital camera, the internet is awash with shots, and mag sales seem to have hit a ceiling. Against that background, where do you think surf photography is going?
Well, the problem is there's so many people doing it. There was a time when you could say, "Okay, I'm gonna get a 600mm, sit on the beach and make a living from shooting surf photos." But those days are gone. So many guys have cameras now, and the learning curve is so fast. With digital, anyone can buy a camera and do it. That's what's crazy about photography right now. Everyone's a photographer, everyone! So there's this glut of imagery, this kinda lacklustre imagery...run-of-the-mill action shots and lineups. People put all this stuff up on the internet, and most of it's crap. So, these days, if you're a pro photographer, I think you have to have a niche. You have to bring something to the table that no-one else has. And I'm lucky 'cos no-one really does what I do in the surf world. So I can keep working, keep doing my thing, do my photojournalism, and try to do what I do well. And I'm just so stoked that I've had the opportunity to do that. I love it.

Mick Fanning, Snapper Rocks

❑

//MICKEY SMITH

PROSPECTOR WHO STRUCK GOLD IN IRELAND

Cornish lensman Mickey Smith is widely recognised as the top water photographer in Britain, if not Europe. He's notched up 17 CARVE and Tonnta covershots in the last five years and has produced a stream of stunning shots from trips to the Canaries, the Azores, Madeira, Tahiti and Western Australia. But it's his recent pioneering efforts at spots like Riley's and Aileen's on the west coast of Ireland that have captured the attention of surfers around the world.

You, Fergal Smith and Tom Lowe only started surfing Riley's in 2007 but it's had a massive amount of media coverage since. How has the scene there changed?

It's gone from being our quiet little sanctuary to the talk of the county at times, among surfers anyway. I knew people would see my photographs and want to check the place out, but the way it's changed has been a bit weird for me. It's a kind of double-edged sword situation. When I first saw the wave I knew it was everything I'd been looking for. The stuff we were doing that first season was so heavy it had to be documented, and I tried to go about it sensitively. But secrets aren't safe for long once photos get published. Last autumn, every time we had good waves at Riley's there were dozens of people down there lining the rocks – half of them with cameras and camcorders. And every time it was clean and sunny a few more people paddled out...which was cool and to be expected, but some of them honestly had no idea what they were getting into. 'Cos even when it's three- to four-foot, Riley's is still a f---ing heavy wave. And last year we had to deal with *so* many injuries. Even some of the very best guys got hurt. Peter Conroy [a top local surfer] broke his back and Dan Skajarowski [a top Cornish bodyboarder] smashed his kneecap into five pieces. Riley's is a violent wave of consequence, and people will inevitably get hurt riding it. So there's definitely some negatives about it getting more exposure...and, for me, a feeling of responsibility at times. But on the flip side, there's positives too. It's been rad seeing some of

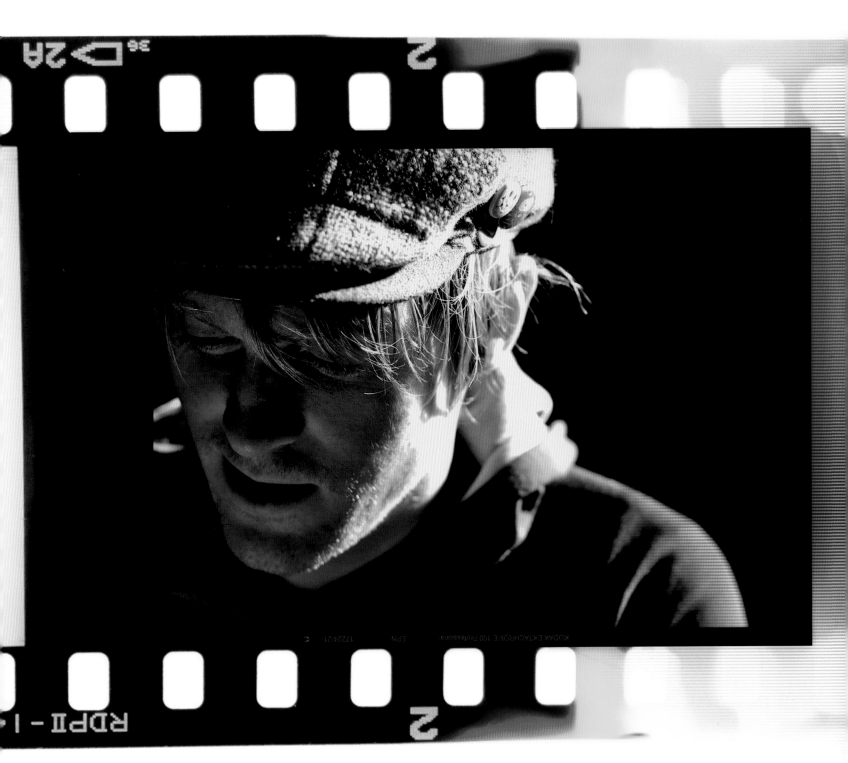

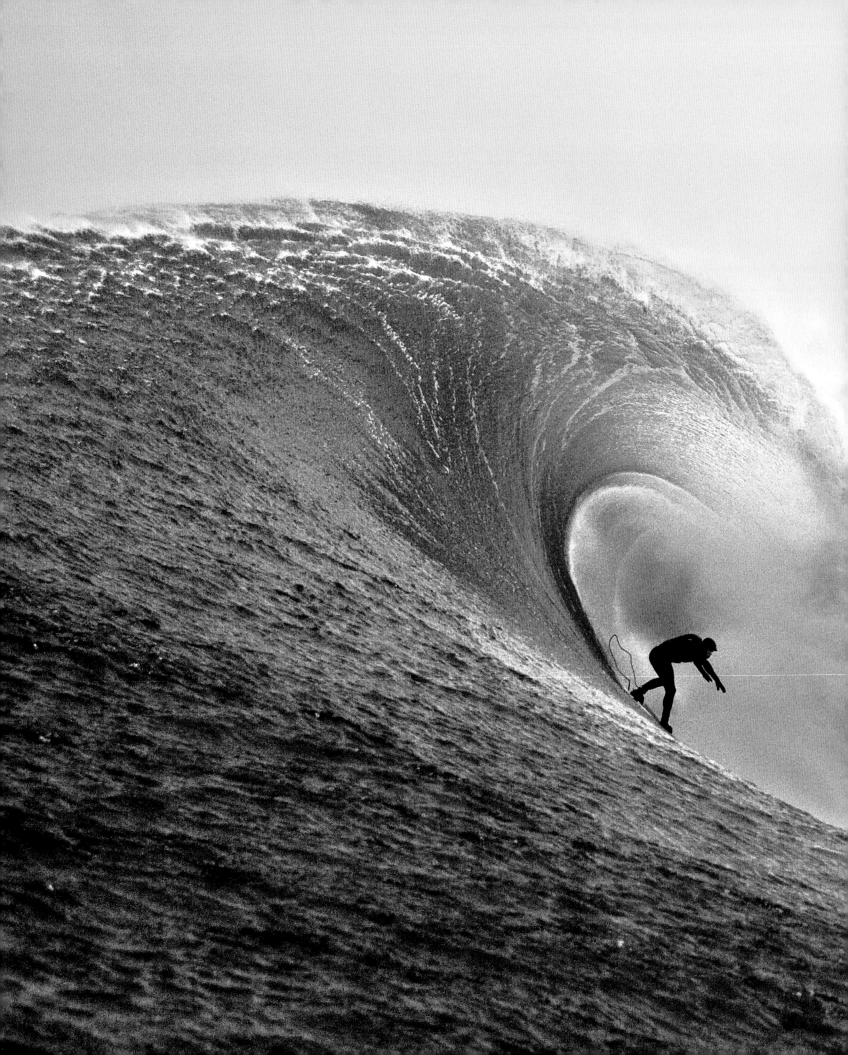

the younger lads throwing themselves into a few heavy ones recently...Hugh Galloway and Tom Gillespie for example. And just being out there on an epic day, seeing all your mates in the lineup with everyone pushing each other and sharing amazing heavy waves...that's pretty cool, it's the best feeling ever.

You guys took some serious risks pioneering spots like Riley's and Aileen's...

Yeah, totally. The thing that's interesting is that five years ago a lot of the people who were charging heavy waves didn't really have the technical skills, although they were taking gnarly risks. But now a lot of people – like the guys in WA, and Ferg and Tom – they're taking a whole different approach and using a whole different set of skills to ride those waves. You also need a different mental attitude to go over the ledge at those places. People assume that it's all about just charging, as if there's no thought process. But to find the gems amongst all the chaos, to ride the wave in the most critical place and ride out safely, that's where it's at. It's a whole different type of surfing.

Some of the backlit images you've shot in the last couple of years have been really beautiful. Five years ago very few photographers would shoot in those kind of conditions...

Well, when you get one of those epic sessions you've got a choice. You can take the safe

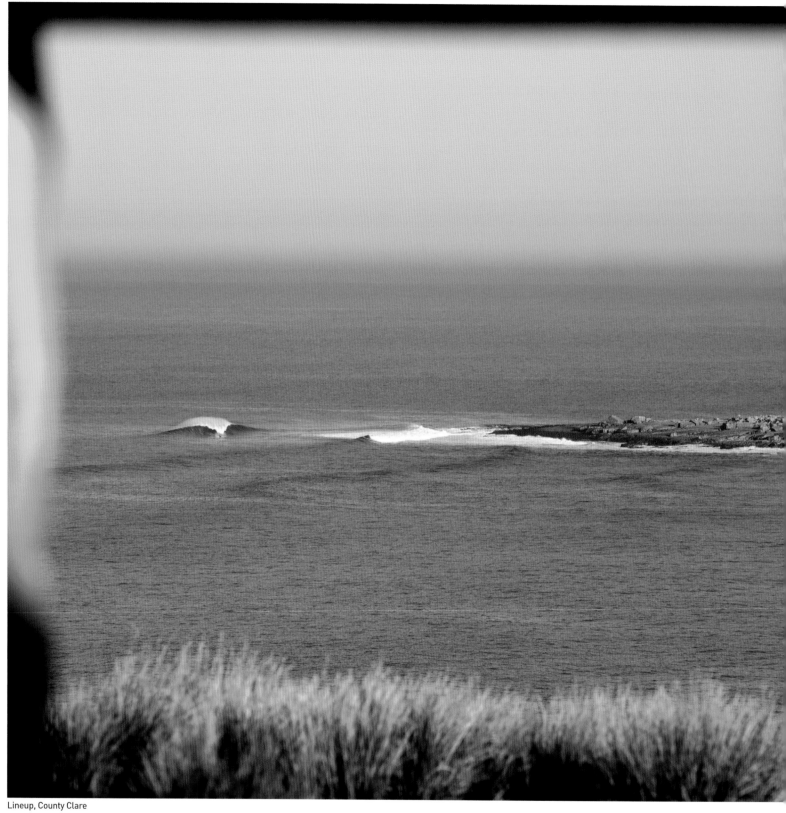

Lineup, County Clare

"BEING OUT THERE ON AN EPIC DAY, SEEING ALL YOUR MATES IN THE LINEUP WITH EVERYONE PUSHING EACH OTHER AND SHARING AMAZING HEAVY WAVES...THAT'S PRETTY COOL, IT'S THE BEST FEELING EVER."

option, or you can try to do something that might turn out really special. To do that you've gotta learn all these little tricks...like ways of tricking the camera into holding focus when you've got spray going all over the place and big flares of light. You can only figure those things out through experience.

Where do you see surf photography going in the next few years?
My take on surf photography is that you have to be constantly getting more tech with what you can do. When I started it was like, 'Yeah! Got me fisheye, got me fins...let's see who can go deepest!' But over my career I've realised that's kind of the stupidest way to go about taking photos! (Laughs) You might get a cool angle, but if you do that every session your stuff gets boring real quick. And you don't do justice to the waves. What I'm into now is trying to get tight shots with bigger lenses...still putting myself in heavy positions in heavy waves, but trying to get a different perspective. And that means focusing and composing under pressure.

How do you see the surf media changing in the coming years?
Well, I think it's pretty inevitable that there'll be more web-based stuff. People seem so hungry for instant gratification. A session goes down and the surfing public want to see it the next day. But the way I look at it, you can't beat actually holding a magazine in your hands...picking it up and gazing at the shots for ages. In the future, I think only the very very best stuff will make it into print though...the stuff people will want to have as a mag or a book, to keep and go back to.

65

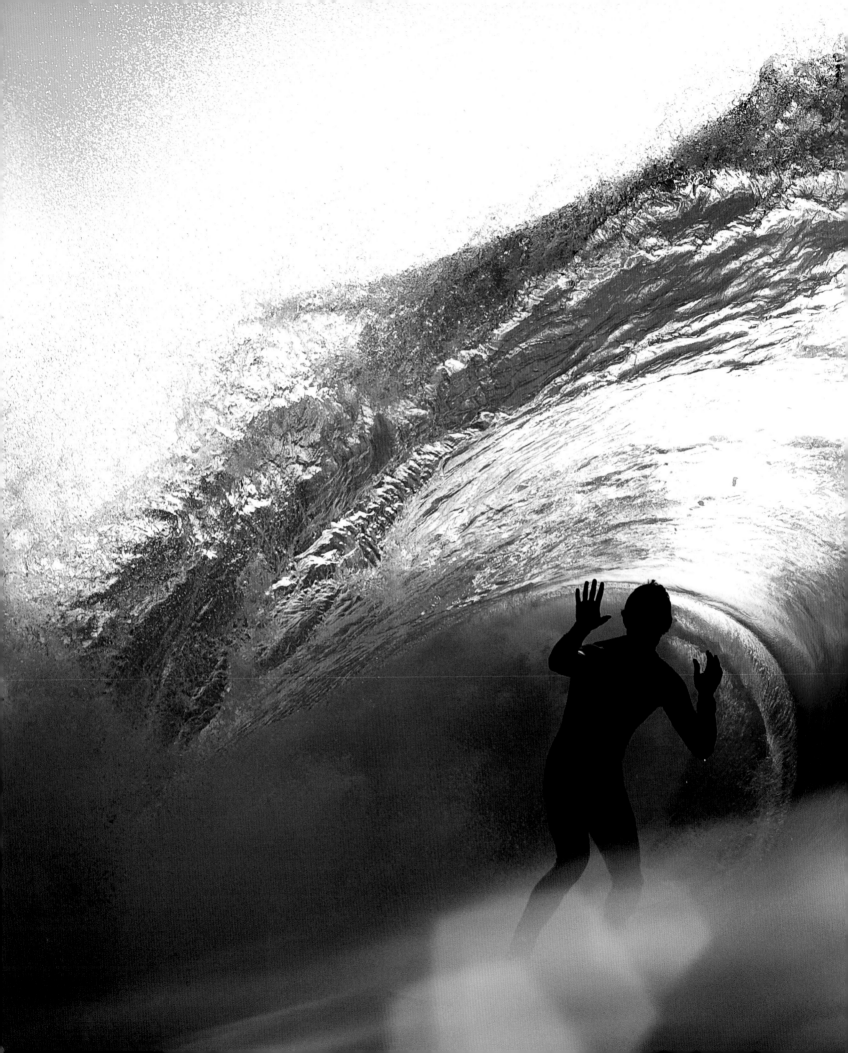

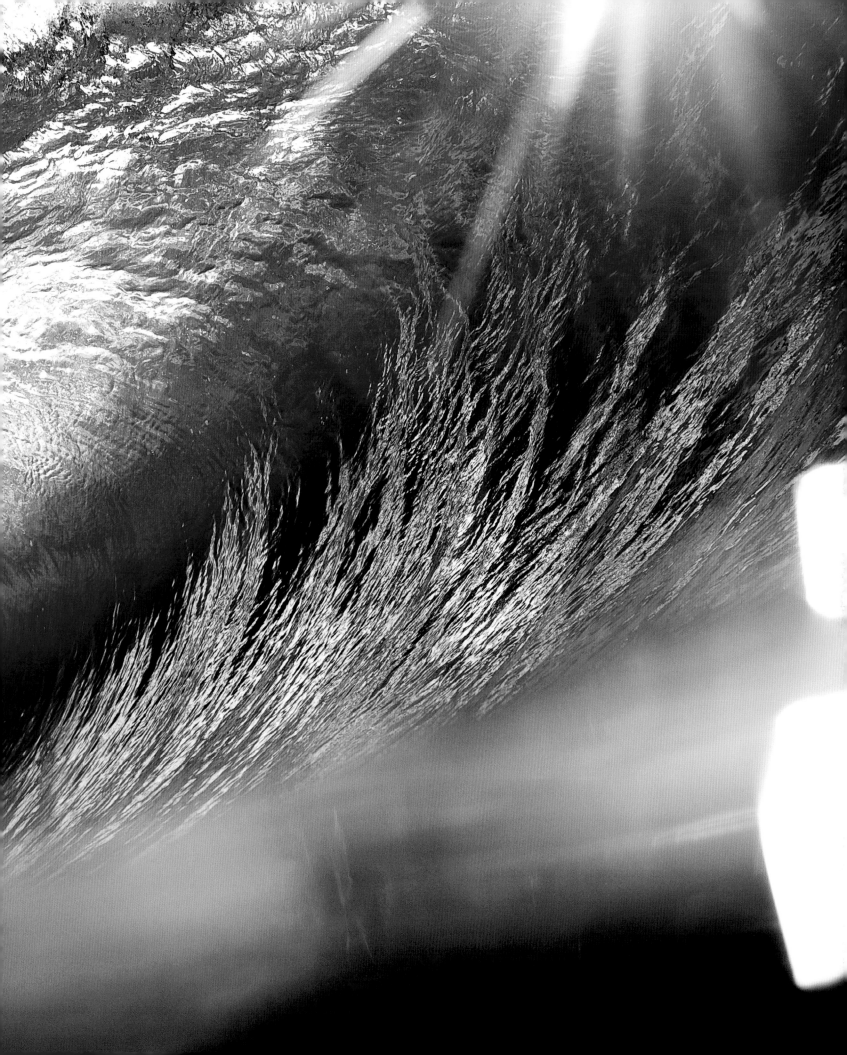

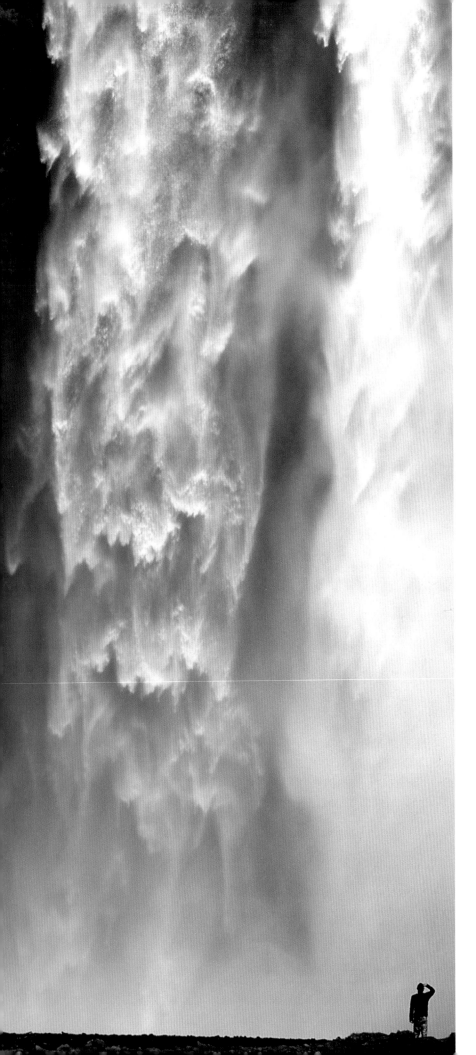

It's gotta be all about quality. That's the only way photographers will survive, and that's the only way mags will survive.

So with those kind of things happening, how do you see your work changing in the future?
I think I'll have to be more multi-faceted and able to document sessions in as many ways as possible. I need to be good from the land, good from the water, and good with video...just have as good an understanding of cameras as I possibly can.

Okay. Now, as a photographer based in Ireland, do you find that the only time you get to go surfing yourself is when it's cloudy and raining?
Yeah, for sure! It's like, "Hey, it's six foot and pissing down...brilliant!" (Laughs) Obviously, whenever it's sunny and perfect I have to shoot, so usually I don't get to surf on those days. But actually I don't mind surfing when it's pissing down and miserable 'cos no one else can be arsed, so I don't have to deal with the crowds. I'm out there on me own, lovin' it!

How significant have jetskis been to the whole big-wave, slab-hunting movement of recent years?
Oh, they've been hugely significant. Jetskis have put humans into situations they physically couldn't have got into 10 years ago. And I think the whole performance level has changed as a result. You can't surf a three- to four-foot slab and go, "Man, this is a crazy slab!"...'cos it's not! (Laughs) It's got to be 10 foot at least, and you have to fade way back behind the thing to be taken seriously these days.　　　　　❏

"WHAT I'M INTO NOW IS TRYING TO GET TIGHT SHOTS WITH BIGGER LENSES...STILL PUTTING MYSELF IN HEAVY POSITIONS IN HEAVY WAVES, BUT TRYING TO GET A DIFFERENT PERSPECTIVE."

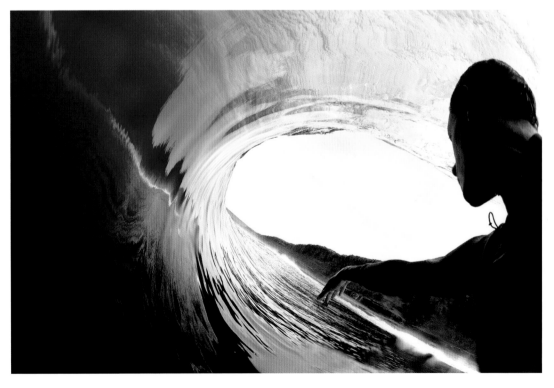

PREVIOUS SPREAD **Fergal Smith, Riley's**
ABOVE RIGHT **Tom Doidge-Harrison, Lahinch**
RIGHT **Fergal Smith POV, Riley's**
LEFT **Jake Boex, Iceland**

//YASSINE OUHILAL

NOVA SCOTIA-BASED ARCTIC WANDERER

COLD BUT OFTEN BREATHTAKINGLY BEAUTIFUL, THE COASTAL FRINGES OF THE ARCTIC ARE SOME OF THE WORLD'S LAST REMAINING FRONTIERS FOR SURF EXPLORATION. PHOTOGRAPHER AND FILMMAKER YAZZY OUHILAL HAS MADE IT HIS LIFE'S WORK TO INVESTIGATE AND DOCUMENT THESE PRISTINE WILDERNESSES.

Norway, Iceland, Russia, the Faroe Islands, Canada...they're not countries Joe Average would put at the top of his list of 'must visit' surf destinations. But lately, with half the world's best-known surf spots resembling the M25 at rush hour, adventurous surfers have been eyeing up the Arctic alternatives and wondering, 'What's up there?' A glance at the atlas reveals thousands of miles of swell-lashed coastline, inevitably with scores of perfect reefs and points still waiting to be discovered. So in recent years, aided by the magic of Google Earth and technological marvels such as heated wetsuits, the surf explorers of the 21st century have been grabbing their gear and heading north.

Yassine 'Yazzy' Ouhilal is a photographer and filmmaker who's been at the forefront of the quest to explore this new surf frontier. Based in Nova Scotia on Canada's east coast, he's been searching for cold water nirvanas since the mid '00s. From day one his photos captured the attention of photo editors around the world; instead of the usual tropical locations, here were empty pointbreaks amid wilderness landscapes, often half-buried in snow. Having found a niche, Yazzy's Arctic adventures have since taken him to Norway, the Faroe Islands, Iceland and northwest Russia. Like many of his contemporaries, he's had the sense to work in more

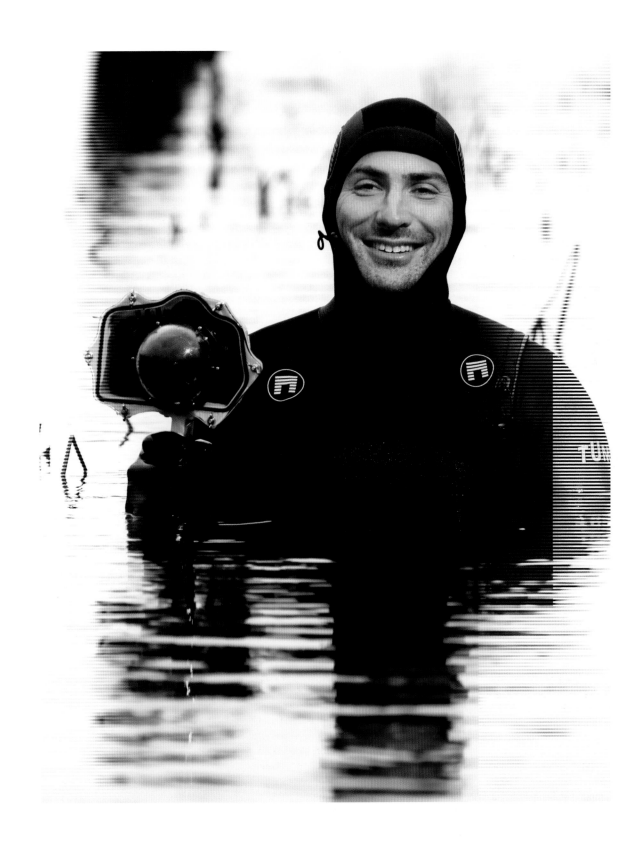

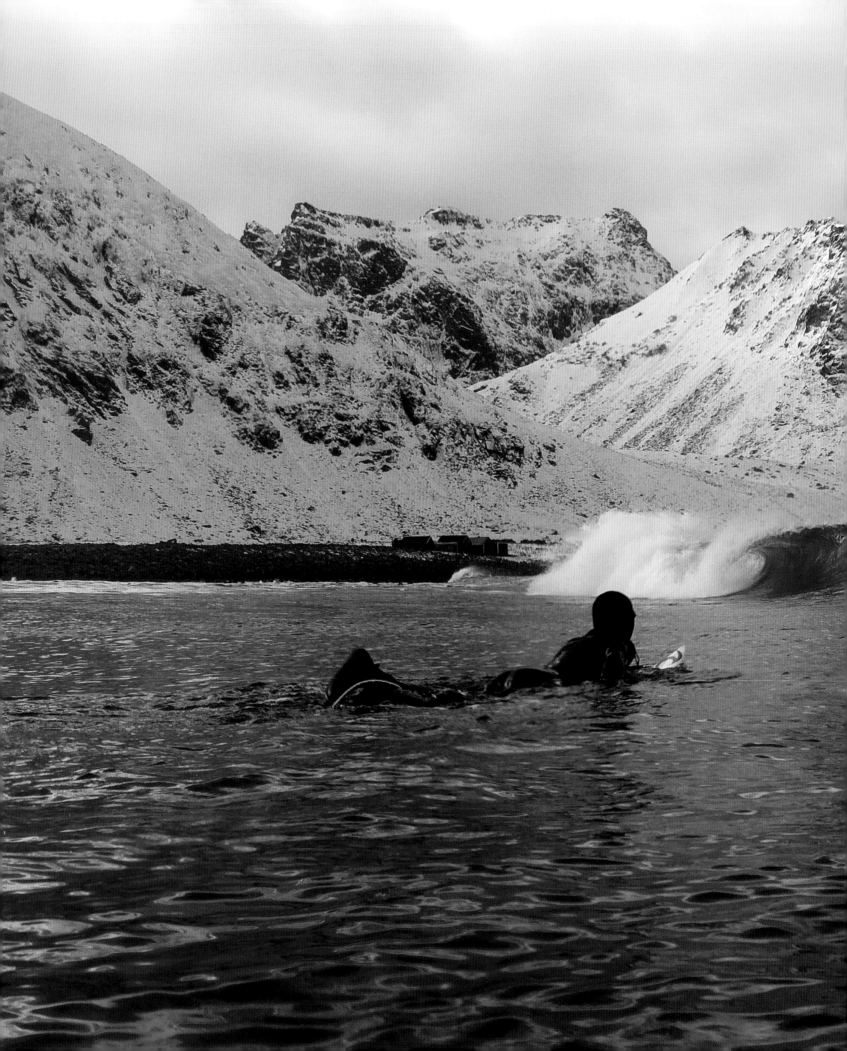

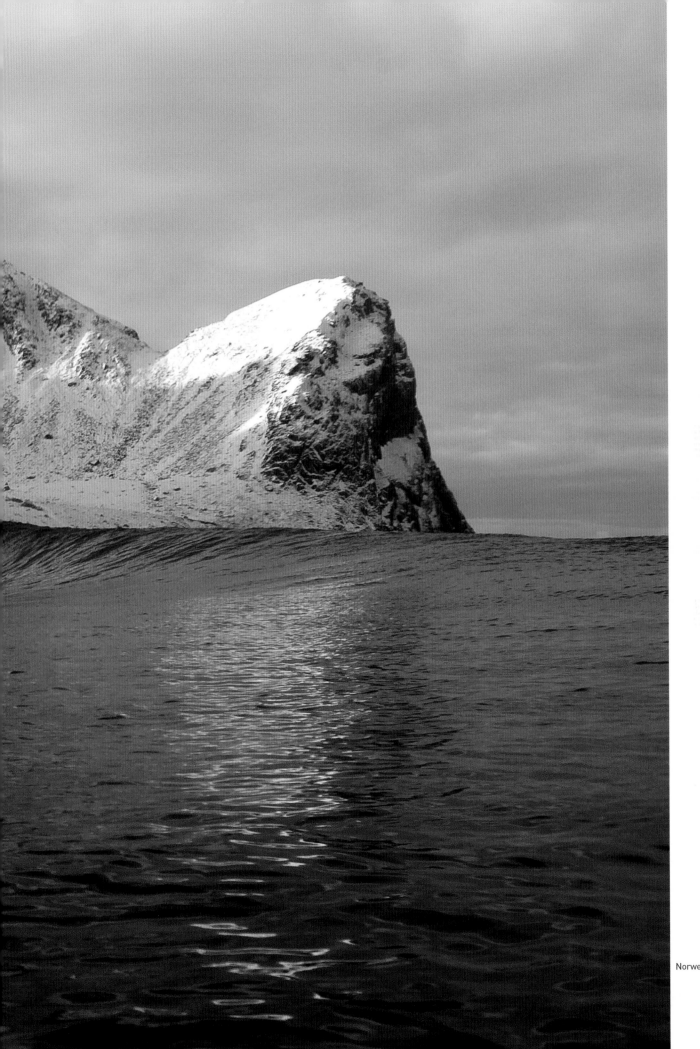

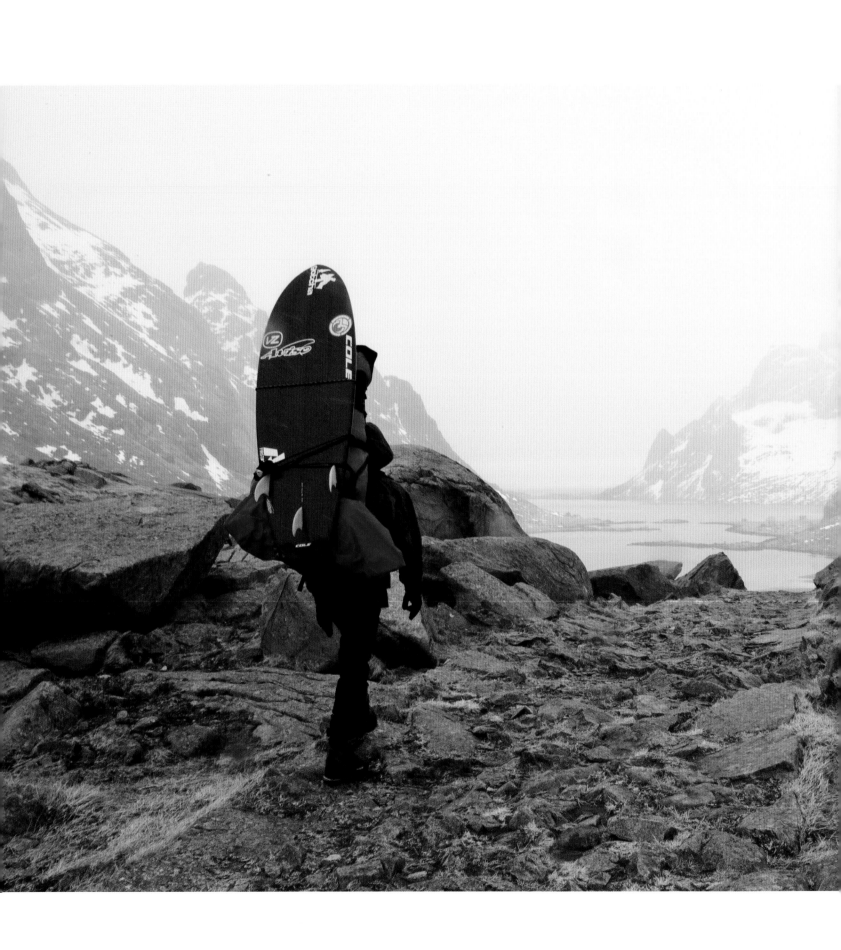

Hiking, northern Norway

"SOME OF THE GLACIERS I VISITED ARE DISAPPEARING AT INCREDIBLE RATES. WHEN I SHOT THOSE PHOTOS I EXPERIENCED REALLY MIXED FEELINGS – AWE AT THE BEAUTY OF THOSE ANCIENT GLACIERS, BUT SADNESS IN THE FACT THAT ALL THAT ICE WILL BE GONE IN 20 YEARS."

than one medium, branching out into fine art photography and documentary filmmaking on recent trips.

Yassine was born in Morocco, and moved to Canada when he was three. His father is Moroccan, his mother is Bulgarian. He grew up in Montreal, and his first experience of the ocean was during a summer holiday to Cape Cod in Massachusetts where he learnt to bodyboard in the shorebreak. In his teens, his passion was tennis and he was good; at 16 he won a sports scholarship to a college in Hawaii. Not long after arriving in the islands, Yazzy and a couple of mates thought it would be fun to rent boards at Waikiki and cruise a few waves. He was instantly hooked, and after a few months tennis got the elbow in favour of surfing. Returning to Montreal, he enrolled at Concordia University where he studied filmmaking, his head still buzzing from his surfing adventures in the Pacific. After graduating he started documenting the surf scene around his home in Nova Scotia. He submitted his first efforts to a number of surf mags, and several of them – including *Surfer* and *CARVE* – ran articles. Encouraged by the response, Yazzy decided to venture further, this time across the Atlantic to the Faroe Islands and Norway.

Yazzy wasn't the first photographer to visit Norway's remote Lofoten Islands, home to a dreamy horseshoe-shaped bay with a perfect left on one side and a perfect right on the other. But he timed his first trip there (in the winter of 2007) to maximise the chances of encountering some proper Arctic weather...and the Norse weather gods duly obliged. He took some stunning shots of Californian shredders Pat Millen and Ricky Whitlock busting airs against backdrops of snow-covered mountains, and the surf mags loved them. While surfers in Hawaii and Australia were bleating on about crowded lineups, here were a couple of Californians scoring world-class waves a thousand miles from anyone else. The water may have been nad shrivellingly cold, but Yazzy's reasons for going there made perfect sense. "For me, the surfing dream is still alive. It just got colder. Since I'm used to surfing in Eastern Canada throughout the winter, the cold doesn't really bother me. I think improved wetsuit technology and colder conditions

are a good trade-off for crowds. I'd rather surf and freeze in the Arctic somewhere than surf at crowded Pipe."

In 2008 Yazzy visited Norway again, this time to cover a two-week Rip Curl team trip. Lofoten turned on and showed just how perfect Norwegian waves can get...but tantalisingly just for one day, with early arrival Romain Laulhe from France being the sole surfer to experience the flawless four- to six-foot barrels.

Yazzy vowed to return, and after much planning he rounded up a crew and jetted into Oslo yet again the following winter. This trip was his most ambitious yet, a full-on expedition to explore the coast of northern Norway then continue over the border into Russia. The crew comprised an eclectic mix of surfers – old buddy Pat Millen, plus longboarders Christian Wach and Cyrus Sutton, all from California. The mammoth road trip lasted 44 days and the crew encountered every high and low imaginable. "The high point was actually the very last day of the expedition. We got back to our base in Norway just in time to score the best swell of the trip. That last day was absolutely perfect. The left turned on with barrelling waves and nobody else out – it definitely made it all worthwhile. The low point was when we found ourselves stuck in a Russian mining town without access to the coastline, due to military restrictions and lack of permits. Everyone was just exhausted from all the driving and we kind of looked at each other and thought, 'What are we doing here?' We'd gone so far to try to find new places, but at that point we were thinking maybe we'd gone a bit too far."

As well as shooting stills, Yazzy (and other members of the crew) also shot hours of video on the trip using Canon 5D mk II cameras. Yazzy is a big fan of Canon's new generation of cameras and loved using the 5D. "It was pretty easy to go from shooting stills to video. The way technology is going now, the line between photography and filmmaking is getting thinner

"FOR ME, THE SURFING DREAM IS STILL ALIVE. IT JUST GOT COLDER. I'D RATHER SURF AND FREEZE IN THE ARCTIC SOMEWHERE THAN SURF AT CROWDED PIPE."

Christian Wach, near the Russian border

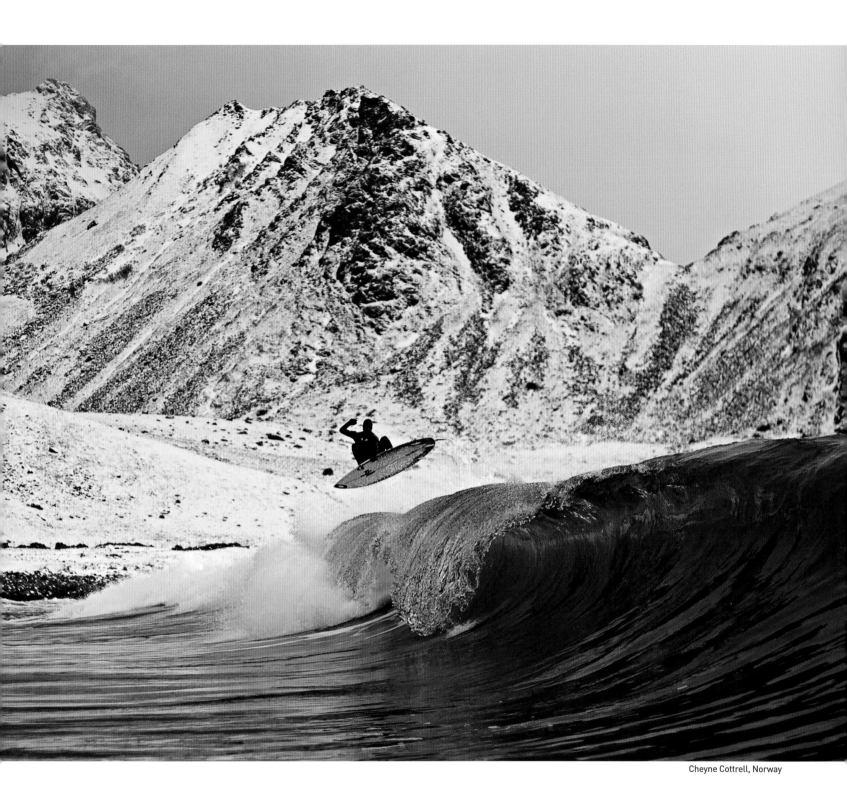

Cheyne Cottrell, Norway

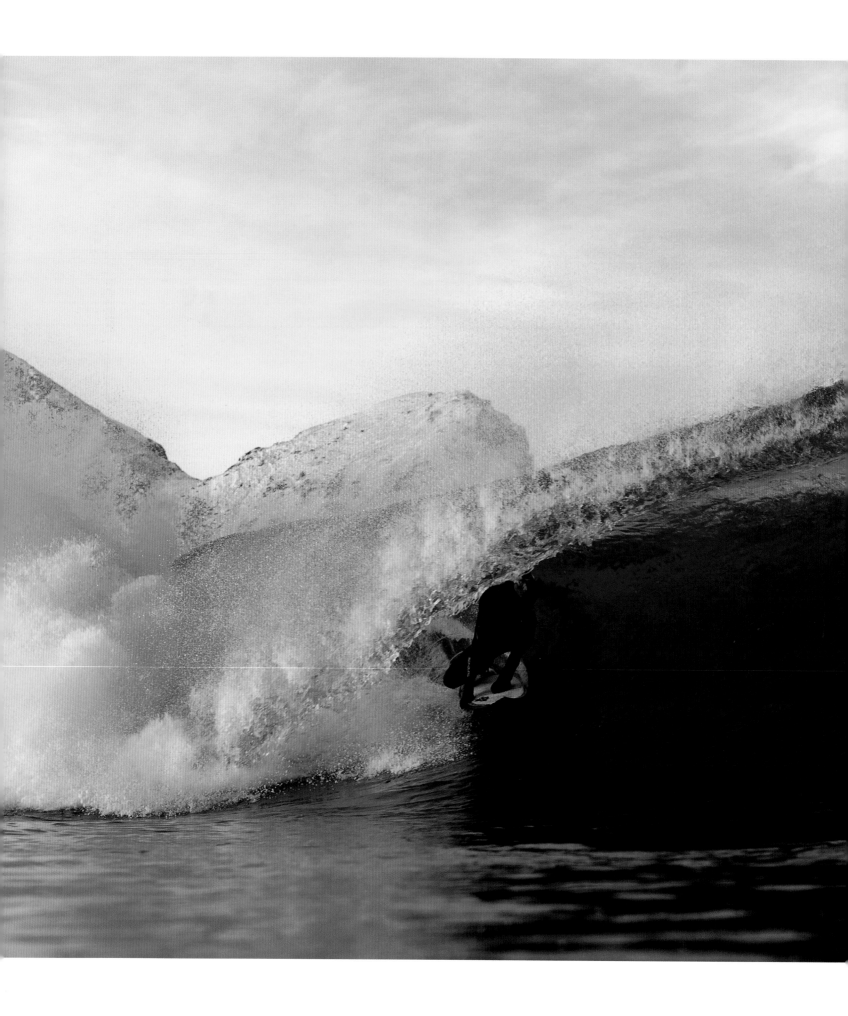

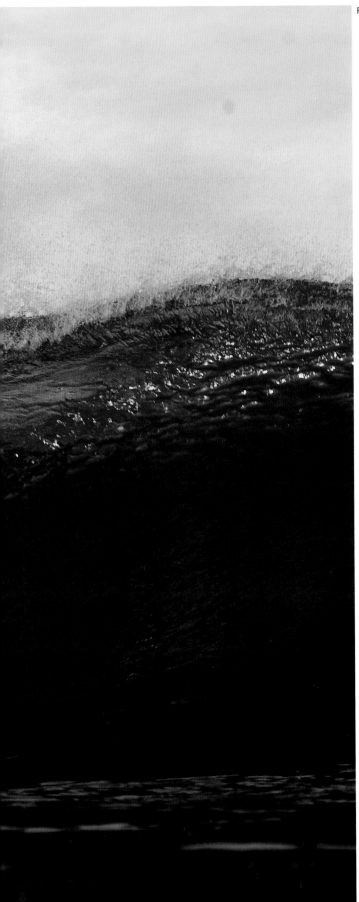

Romain Laulhe, Norway

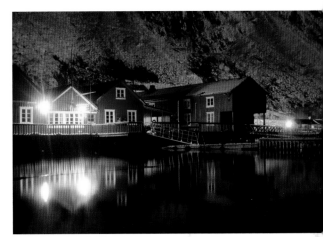

Norway's version of Malibu.

and thinner every day. I found it really exciting to shoot video with the 5D. As a photographer, I know how to compose my shots and how my glass works. And to be able to translate that into a cinematic medium was really incredible."

Yazzy edited the footage into a short documentary entitled *Arctic Surf*, setting it to a soundtrack of Phillip Glass and MGMT tunes. An elegant montage of time-lapse sequences, interviews and high-octane action, the film was showered with praise at Canada's prestigious Atlantic Film Festival. It has since been viewed more than 300,000 times on YouTube. One web viewer succinctly commented: "You gotta have woolly mammoth balls to try this. Proper respect."

During the many months he's spent in the far north, Yazzy has become acutely aware of the devastating effects climate change is having on the Arctic environment. Moved to do something to increase awareness about the situation, he spent several weeks in Iceland last year working on a landscape photography project. The resulting photos formed an exhibition entitled 'Thawscapes' which subsequently toured a series of galleries in North America. The bleak yet beautiful panoramics show landscapes being revealed for the first time by receding glaciers. "Some of the glaciers I visited are disappearing at incredible rates. They'll be gone in our lifetimes. When I shot those photos I experienced really mixed feelings – awe at the beauty of those ancient glaciers, but sadness in the fact that all that ice will be gone in 20 years. So I wanted to capture those images, and share them with people, and get them thinking about about what's going on."

Yazzy's current project is another film, this time a feature-length documentary, provisionally titled *Arctica*. Building on the theme of *Arctic Surf*, it's an in-depth look at surfing in a wide range of Arctic and sub-Arctic regions including Iceland, the Faroe Islands, Norway and northern Japan. "These are all areas with great potential for surf discovery, and there are some really interesting stories about their still young surf cultures. It's going to be a really exciting project." □

//ANTHONY WALSH
PRO SURFER WITH A SIDELINE

WALSH

Australian tube slayer Anthony Walsh is first and foremost a pro surfer – he trains, he does contests, he gets exposure for his sponsors. But recently he's developed a sideline business – taking watershots, including some amazing point-of-view (POV) photos from deep in the barrel. A couple of years ago Walshy heard that the guys at Del Mar Housings in San Diego were experimenting with some innovative POV camera rigs, and were looking for surfers to collaborate on a photography project. Erik Hjermstad and Tyler Reid already made some of the highest quality camera housings on the market, and their latest idea was to get surfers themselves involved in the image making process. They hooked up with Walshy and Californian surfers Brian Conley, Travis Potter and Derek Dunfee, and together formed a loose collective of surfer / photographers. Erik and Tyler helped the surfers design and build POV rigs, then the surfers headed off to the four corners of the world on a quest to capture fresh images from inside the green room. The project is on-going so we're likely to see a lot more crazy angles from the collective in the months and years to come. So far Walshy has used his backpack-mounted POV rig at Nias and Teahupoo, and the results have been impressive.

So Walshy, you're doing this partly for fun, partly 'cos you're interested in photography, and partly 'cos it's your job as a pro surfer to get exposure. Right?
Yeah, that's right. My brother Stephen and I shoot each other all the time...both still photos and video. At home where we live [Lennox Head in New South Wales] there isn't always a photographer around to shoot. So I grab my camera, get some shots of Stephen, and then we swap around. It just makes us worth a lot more to our sponsors as surfers.

Tell us a bit about the backpack rig you used for the POV shots you did last year. Did the Del Mar guys come up with that design or was it a collaboration?
Yeah, the guys at Del Mar in California had already made a couple of these backpack rigs. Each rig is specifically designed for the individual surfer...for their stance, size and style of surfing. The angle of the arm needs to be specific to the surfer every time. I actually made 98 percent of the rig myself, with Tyler and Erik just advising me and showing how to use the tools. They were busy with their own projects, making housings and other stuff. It took me ages to build

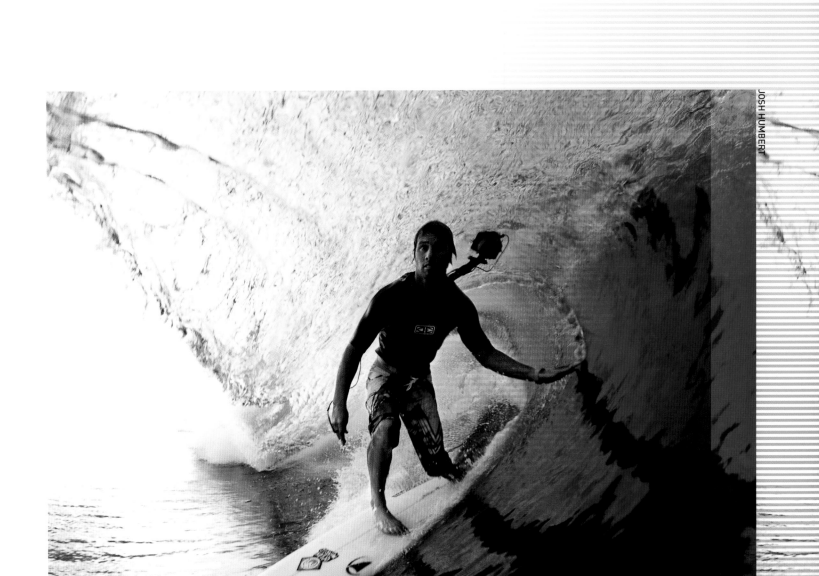

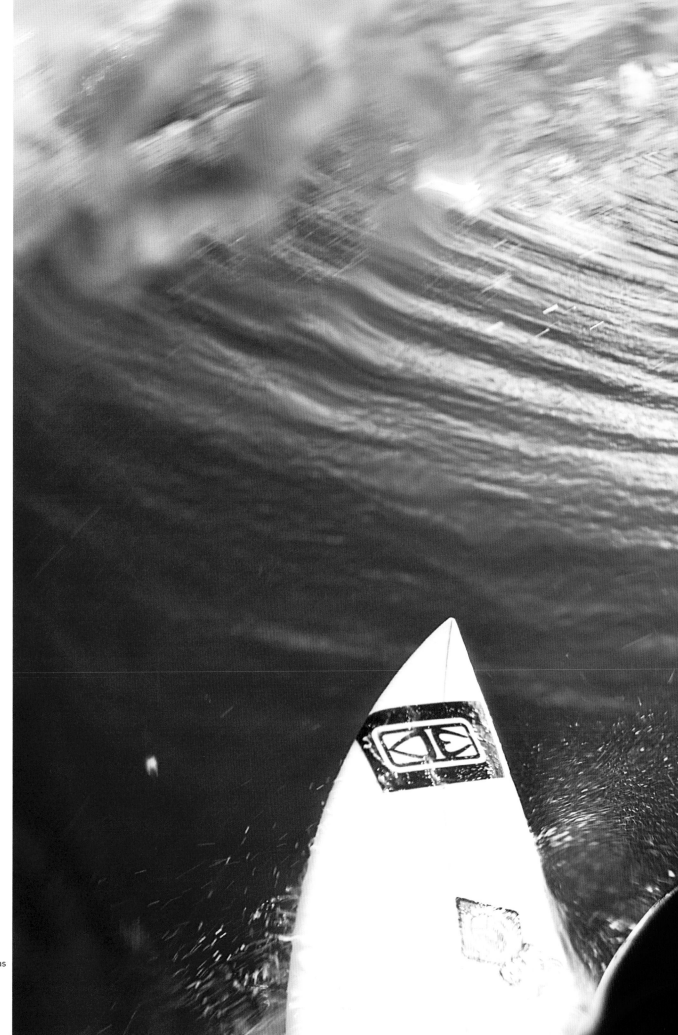

Walshy POV shot, Nias

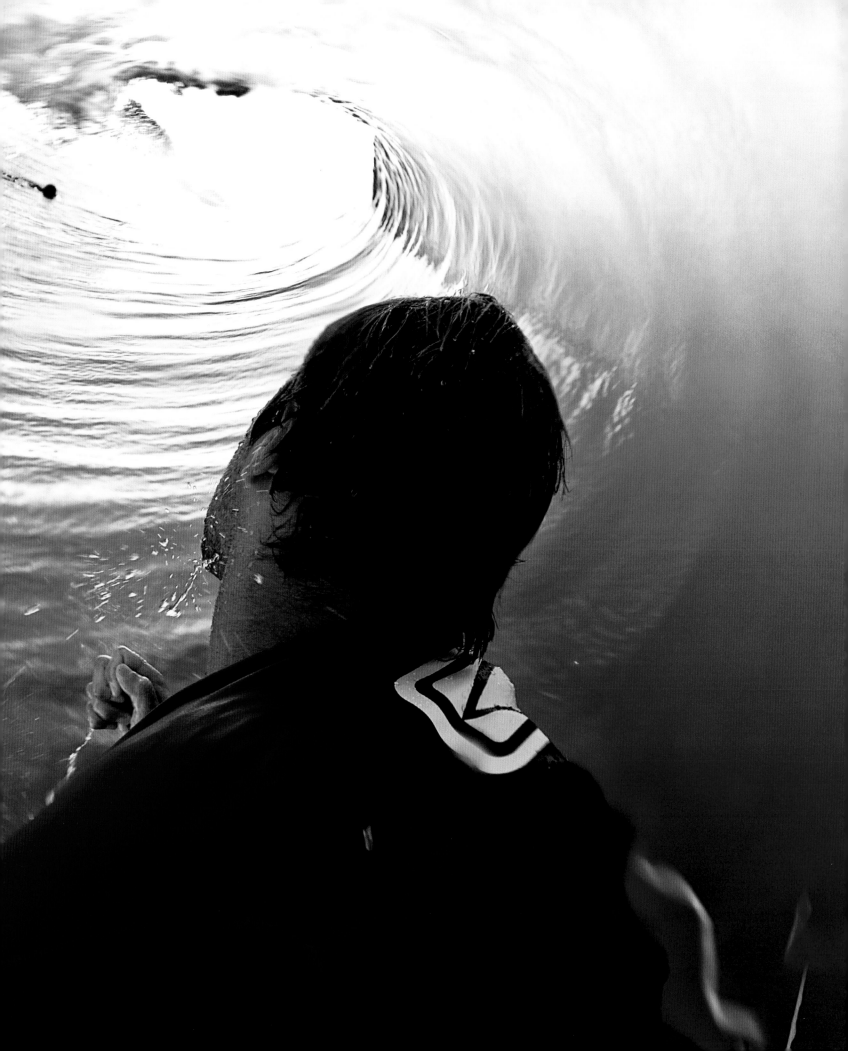

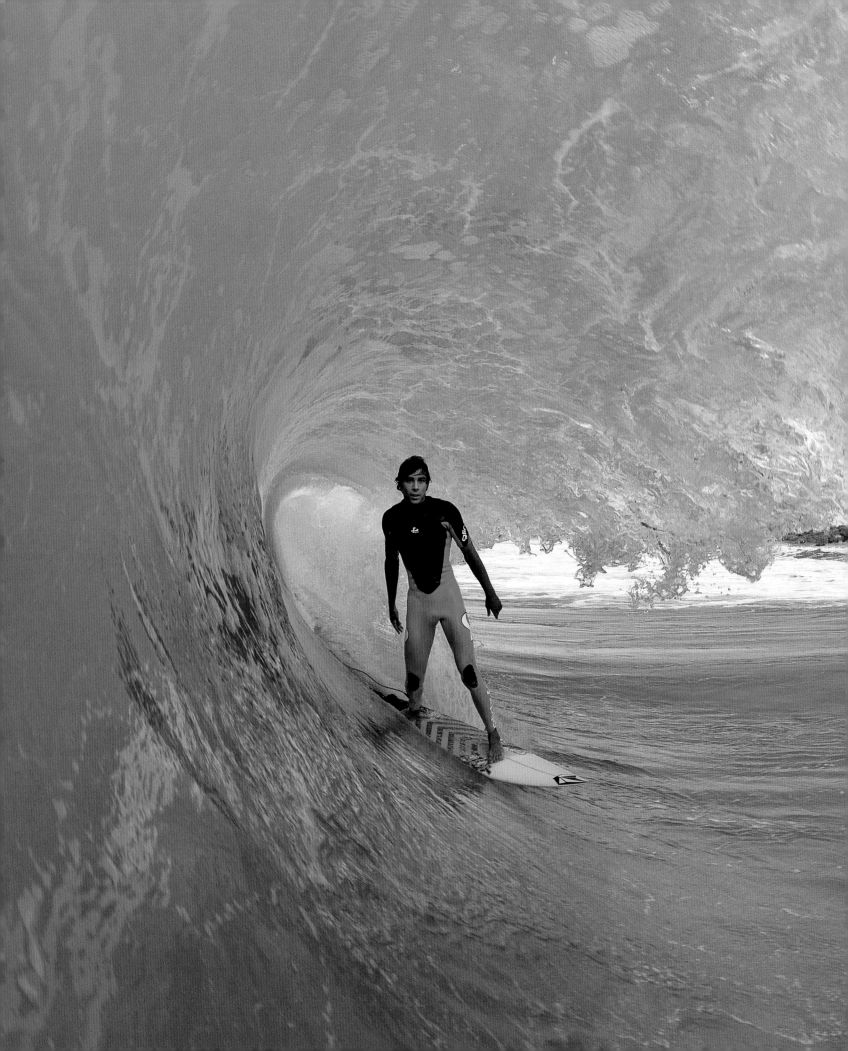

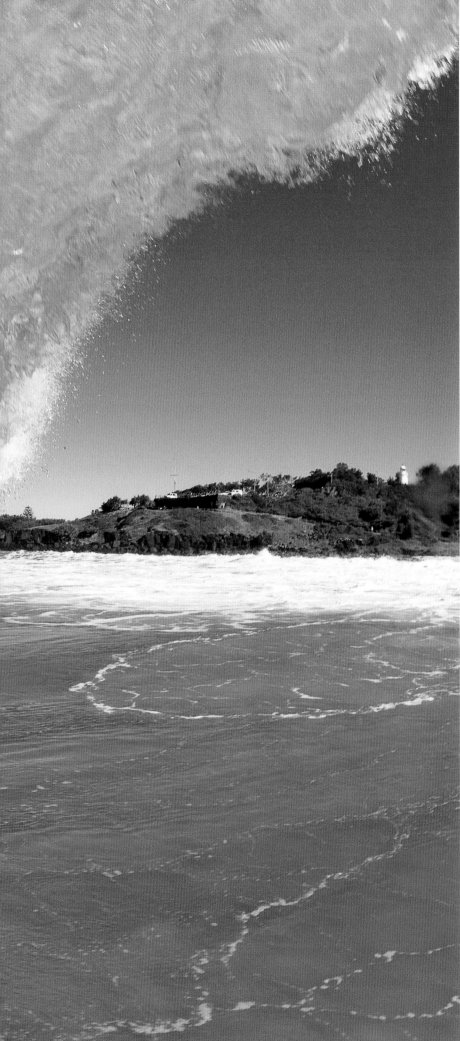

Stephen Walsh, Ballina, NSW

it – about four weeks off and on. It's made out of a whole combination of materials: carbon fibre, fibreglass, foam, plastic... The actual backpack is a modified CamelBak and the arm is bolted onto that.

How comfortable is it to wear?
It's actually pretty comfortable 'cos we put a load of extra padding on the backpack. But it's really difficult to surf with!

Okay, so tell us about the first time you used the rig. That was at Nias, right?
Yeah, the first session was at Nias. I thought the best time to try it would be early morning, when it wasn't crowded. I put my gear on in the dark and paddled out. It was six foot solid. I was waiting for that early light coming straight into the barrel. I didn't get off to a great start though...I went over the falls a bunch of times 'cos my board, a 6'0", was too small. I didn't have the paddle power I needed 'cos of the weight of the rig. So I swapped the 6'0" for a 6'6" and that made it easier to get into the waves. But even on a bigger board there was a lot to think about. The hardest thing was adjusting my balance, which was getting thrown off by the weight distribution of the rig. Then I still had to get in the barrel and fire the trigger at the right time. It wasn't as easy as it looks!

"AFTER I'D CAUGHT A COUPLE OF GOOD WAVES I WAS SO EXCITED THAT I JUST HAD TO COME IN AND LOOK AT THE PHOTOS... AND I WASN'T DISAPPOINTED. I NEARLY JUMPED OUT OF MY SKIN WHEN I SAW THE BEST SHOT."

Did you have a feeling you'd nailed some good shots before you actually saw the results?

Well, I knew I'd got good waves so I was pretty hopeful, but I didn't know for sure. You just never know what you've got until you take a look. The shots could be out of focus, or too dark, or there might be water droplets on the port, or you might've pressed the trigger at the wrong time...heaps of things can go wrong. Anyway, after I'd caught a couple of good waves I was so excited that I just had to come in and look at the photos...and I wasn't disappointed. I nearly jumped out of my skin when I saw the best shot – that one where you can see my hand firing the trigger. It was the best shot I'd ever taken. All the hard work had paid off.

And after that trip, you went to Tahiti and got some more POV shots at Teahupoo...

Yeah, I got a few more at Chopes. It was easier in some respects 'cos I was surfing frontside, but the wave is obviously heavier. The photo Josh Humbert got of me wearing the rig [page 81] was actually taken a couple of seconds before I had my worst experience with the gear. Just after I passed him, the lip hit the camera and pulled me straight off the board and onto my back in the trough of the wave. Then the board got sucked over in the lip and hit me right in the face!

Ouch. But all in all you must be stoked with the results you've got. The shots have been used in loads of mags...

Aw yeah, they've been used all over the world – *ASL, TransWorld Surf, CARVE, ZigZag, Surf1st in Japan...*

And do you think the photographic work you're doing could be a pointer for what other pro surfers might do in the future?

Well, there are a lot of guys already trying to get different kinds of POV shots...the simplest way is just to hold the camera out behind you. As long as you get the angle right you can get some good shots. So, yeah, I think we'll see a lot more POV shots taken by surfers in the future, for sure.

So what's your career plan for the next two or three years, and how much will photography be a part of that?

My plan is to continue doing what I'm doing, to travel as much as I can, and also to do the contests I love in places like Hawaii, Tahiti and the Canary Islands. Photography is also a big part of the plan...not just POV but regular hand-held watershots and also video. As a surfer it's my job to get shots and footage for the companies who support me, and I reckon doing a bit of photography myself is a good way to achieve that. ◻

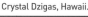
Crystal Dzigas, Hawaii.

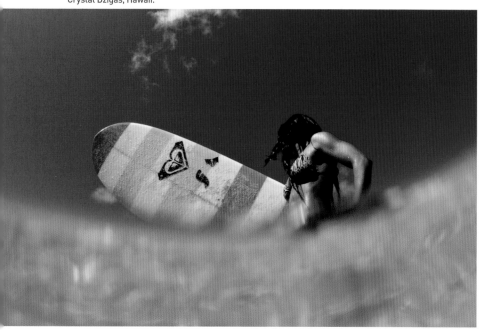

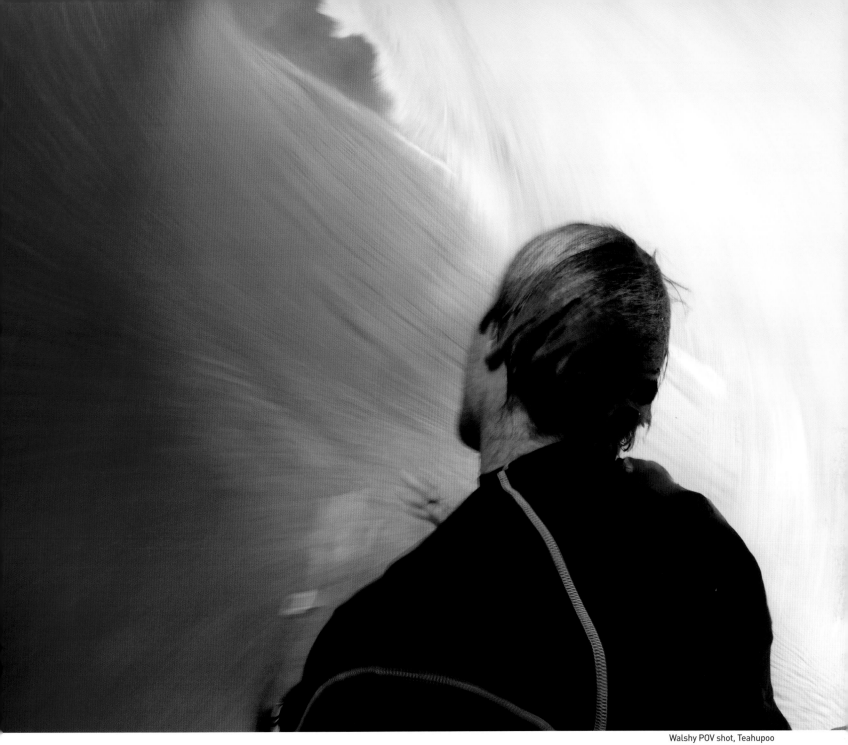

Walshy POV shot, Teahupoo

FUJI ► 2 RVP100 465 3 ► RVP100

//ROGER SHARP
MULTITALENTED BRIT WHO'S BEEN THERE, DONE THAT

Brit journalist and photographer Roger Sharp has worked in the surf media for 15 years, his career and fortunes during that time somewhat resembling a game of Snakes 'n Ladders. Brought up in Somerset, he got into bodyboarding and surfing while at school. He studied geology at university, and around that time started shooting photos of his mates on surf trips. After graduating he faced a bit of a dilemma: spend the rest of his life in the oil industry, perhaps on some dodgy rig in the Gulf of Texas, or try something else. He chose the latter option, and while he figured out what that 'something' was, he flitted back and forth to Europe on surf trips, funding his travels by doing a series of "shithouse minimum wage jobs" – working in a Samsung fridge depot, a Tesco warehouse, a brewery and a sawmill, among other glamourous locations. Sharpy spent the money he earned on camera gear and plane tickets, and he set about shooting photos and writing articles, inspired by the gonzo antics of *Australia's Surfing Life* contributors Derek Rielly, DC Green and Ted Grambeau. He had his first shots published in Brit mags *ThreeSixty* and *CARVE* in 1996, and by the end of the decade he was a regular contributor to *Surfing Life*, *Wavelength* and *Surfer*, among others. In 2000 he got the chance to work alongside Aussie mentor Rielly when pan-European magazine *Surf Europe* was launched. Sharpy later took over the editorship of the mag, but jacked it in after three years because he hated being chained to a desk. In 2006 he set up his own magazine *Slide*; dishearteningly the print side of the business fell foul of the global financial meltdown two years later and the title folded. After another spell freelancing he took up the offer of a job at *CARVE*, where he currently works as editor and senior staff photographer.

You've done a lot of trips up to Scotland over the years. When was your first trip and how many times have you been up there?
The first time I went up to Thurso was when I'd just finished school. I convinced a few of my friends to go up and check it out. We stayed in a mobile home. Since then I've been up there to cover the Coldwater Classic five times I think, and I've done at least another five or six trips. I've probably spent six months of my life up there.

Thurso East is the iconic Scottish wave, but once you get up there you realise that it doesn't

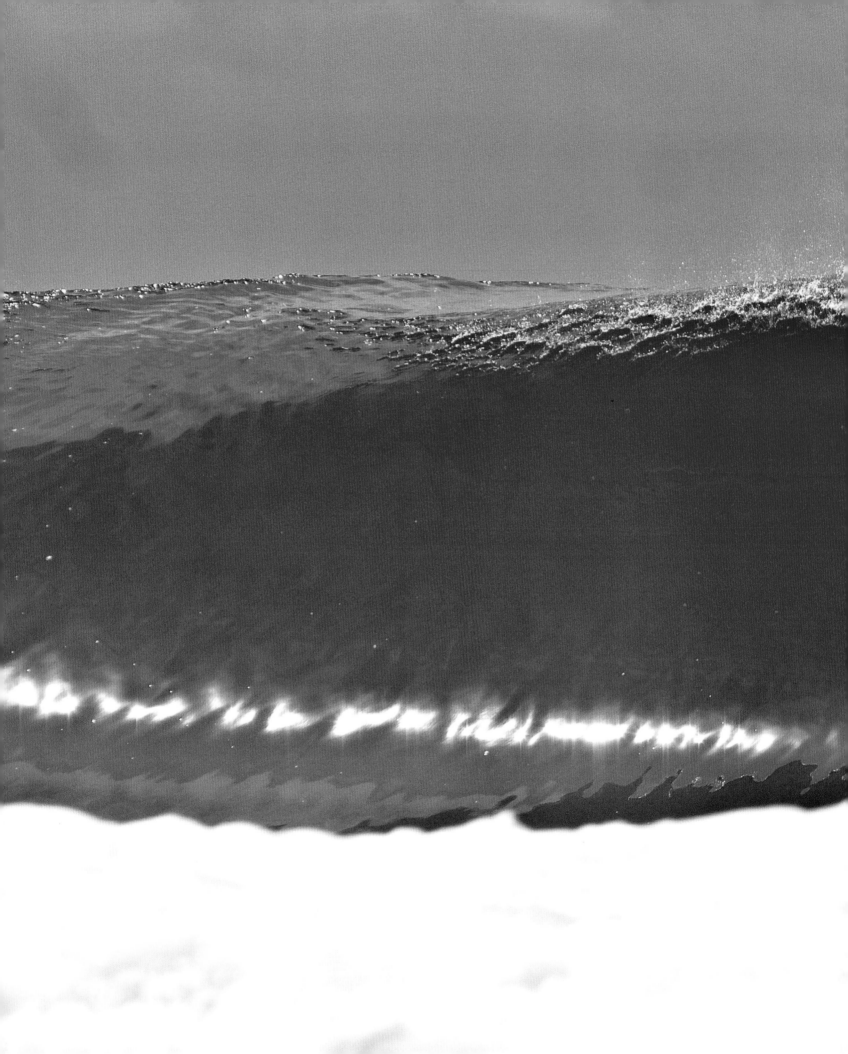

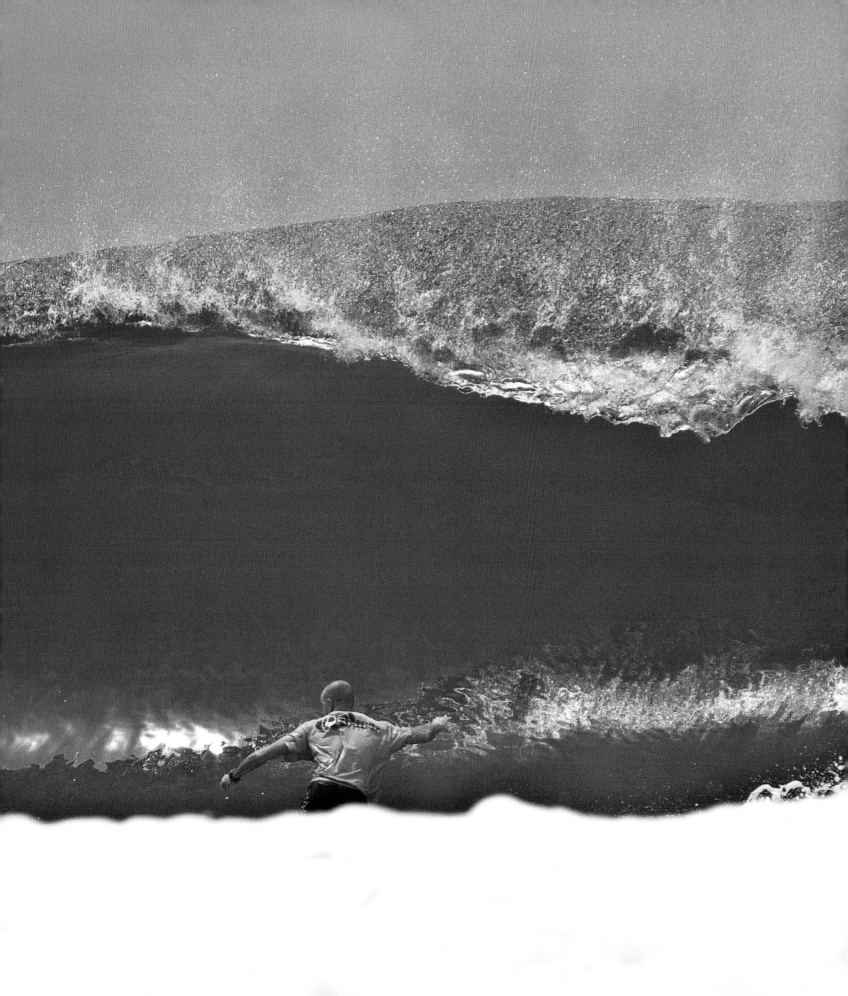

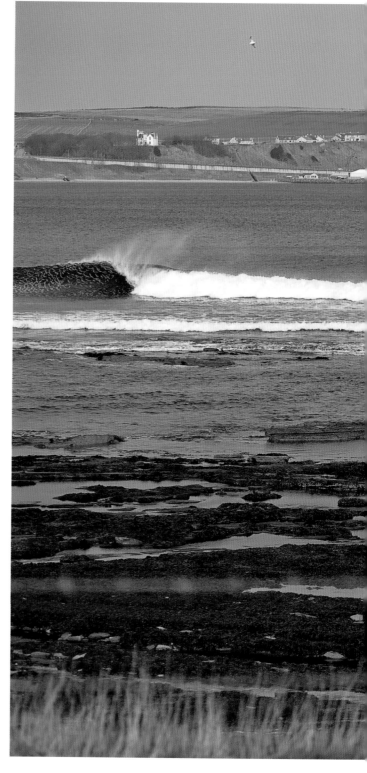

> "THURSO EAST IS FICKLE AS HELL. IT'S ONE OF THE BEST WAVES IN THE WORLD WHEN IT ALL COMES TOGETHER... BUT THAT DOESN'T HAPPEN OFTEN."

actually get good all that often...
Nah, it's fickle as hell. It's one of the best waves in the world when it all comes together, but that doesn't happen often. The wind's got to be proper southeast and the swell angle's got to be dead right...if it's too north or too west it won't quite do it. I got it perfect one day a couple of years ago – like, eight-foot on the outside, four-foot on the inside, super clean and sunny. It just looked like Indo or somewhere...perfectly blue and nice, not all brown and peaty like it often is.

In the last few years spots like Bagpipes and Number 10 have been added to the list of amazing Scottish waves. Do you think there are yet more waves to be discovered up there?
I think it's not so much a question of discovery, it's more about re-discovery. I shot some nice pics at The Dump a few years ago and that's a really good spot, but it hasn't been in the mags much since then. And there's loads of waves further along which get going on a bigger swell. But the thing is, if Thurso's good everyone goes there, or to Baggies. So on the days Thurso's good, there must be about 20 other waves all absolutely firing.

The geology's ideal along that section, isn't it?
Yeah, it's perfect, From John O'Groats all the way to Brims [Ness] it's just slab after slab. I went up in a helicopter one year to do some aerial shots for O'Neill and it was amazing to see that whole stretch from the air. Apart from the cliffs around Dunnet Head there's waves everywhere.

The drive up to Scotland is a killer though...
Doing it without a stop isn't much fun. Especially if you go the wrong way. I was up there one year with Robyn Davies and Mel Redman – we did a little summer trip 'cos the chart looked quite good – and they had to get back to Newquay the next day. So I drove the first bit through the Highlands, then jumped in the back of the van for a kip while Robyn took over. When I woke up a while later I looked out the window and saw all these signs for Stranraer...which is where you get the ferry to Northern Ireland! The girls had got lost in Glasgow, and rather

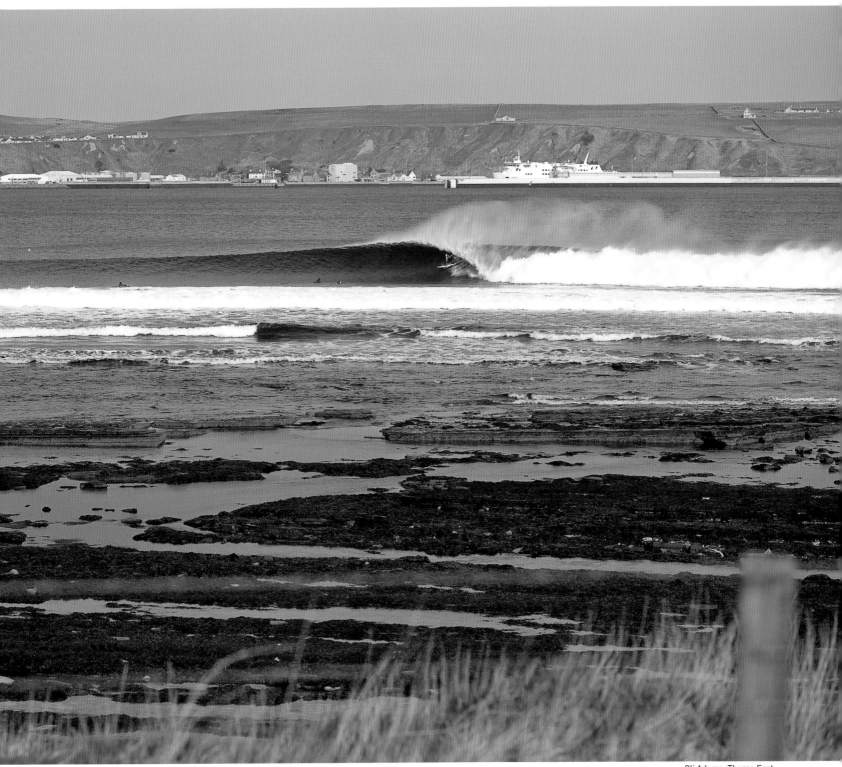

Oli Adams, Thurso East

than waking me they just kept on driving. So we'd gone about 80 miles the wrong way. But it was Robyn, I couldn't get too angry.

Okay, tell us about that session you shot from the water at Porthleven last February. Coldest shoot you've ever done?

Coldest I can remember. I was getting changed before the sun came up and the thermometer in my car was saying -1°C. I've shot from the water in Norway, up inside the Arctic Circle, and that was warmer! It's warmer in Norway in November than it is in Cornwall in February. It was classic 'Leven though. So good I couldn't get out. I swam for about three hours. By the time I got out I could hardly hold myself together I was just shivering so much. I was shivering for about five hours afterwards!

Okay, we've talked about British waves. If you had to pick a favourite region abroad, where would you go?

Well, if we're talking 'affordable', I'd say the Bundoran area [in northwest Ireland]. When it's four- to six-foot and clean, places like Black Spot and PMPA are just amazing. And G-Spot too...that's yet to be shot as well as it could be. When it's on, it's one of the best waves I've seen anywhere in the world.

And if we're talking about big-budget trips, where's the most productive place to shoot?

I'd have to say the Playgrounds region of the Mentawai's. E–Bay is one of my favourite waves to shoot from the water...such a good barrel. And you've got Pitstops and Rifles there too. Or you could head for the other end of the Mentawai's and shoot there. Macaronis is just amazing. It's good when it's clean, it's good when it's onshore. It's good for moves, it's good for barrels. It's the perfect wave really. Yeah, if you've got the budget the Mentawai's are unbeatable. It's just a really beautiful part of the world. There's nothing there except jungle, it's amazing.

Joss Ash, Lakey Peak

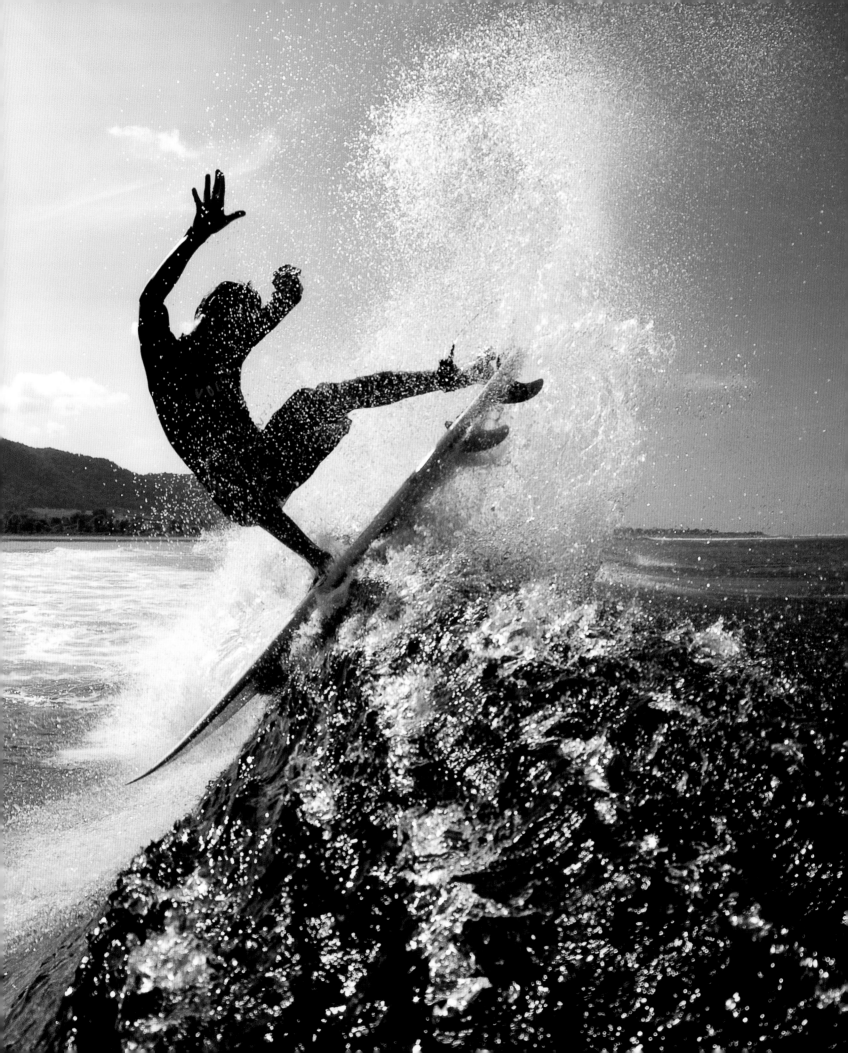

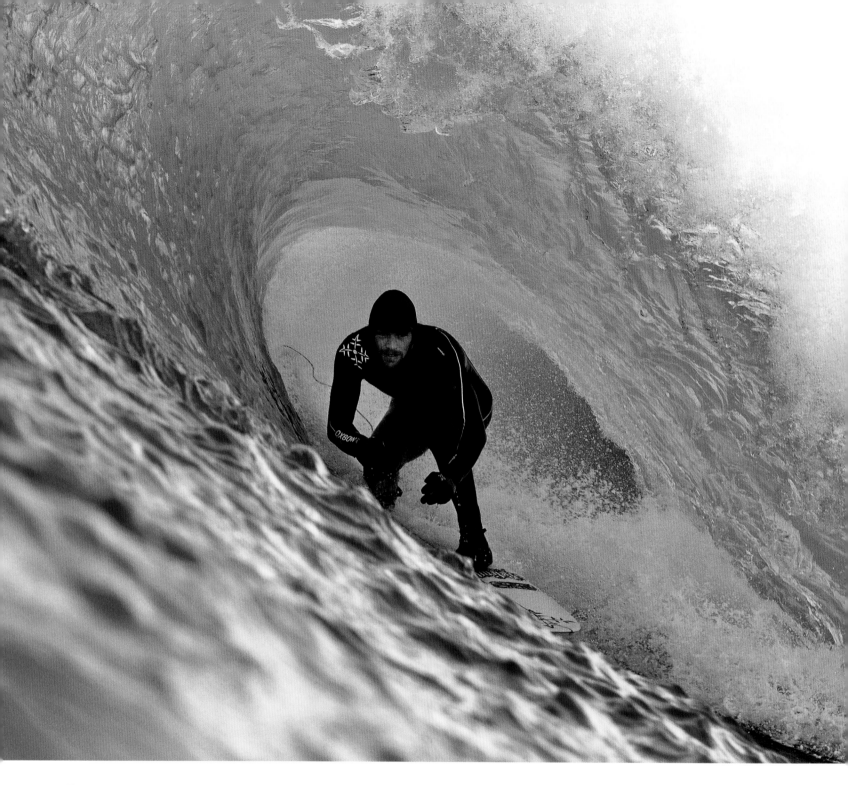

There are more and more boats operating out there every year, does that spoil the experience?

It just depends on your luck. The first time I went out there – with Sam [Lamiroy], Robyn and [John] Buchorski – we virtually had Macaroni's to ourselves for a couple of days. Eventually we saw another boat on the horizon, coming towards us. As it got closer we realised it wasn't so much a boat...more like a cruise ship with a helicopter on the roof! Turned out to be Kelly and the *Young Guns 2* crew. So 10 minutes later we had Dane [Reynolds], Jezza [Flores], Slater and all those guys in the lineup. But our guys didn't mind sharing the water with that lot. And I didn't really mind shooting Kelly at close range taking Macaroni's apart.

One not-so-fun aspect of photography is having to lug half a ton of camera gear with you on flights. Do you often get clobbered with excess baggage charges ?

I don't actually...but then I'm famous for being the most economical packer in the whole universe. When I did that three-week Mentawai's trip I had my camera bag (which I took on as hand baggage) and one case for my water housing, my fins, three pairs of boardies and a wash bag. That was it. I took one t–shirt which I wore on the plane, and I just wore boardies for the three weeks. When you're on a boat in the tropics you don't need anything else.

Okay, as a magazine editor you're constantly on the lookout for new images. Which photographer would you say is leading the field in Europe right now?

I'd say Mickey Smith. He's just a one-man industry, it's ridiculous. He's pretty much got his own waves and his own crew...a setup that any photographer would kill for. A lot of people would be happy just with Riley's, but he's got Riley's and Aileen's and Lauren's and all the other spots around there to play with. He's a

"THE THERMOMETER IN MY CAR WAS SAYING -1°C. I'VE SHOT FROM THE WATER IN NORWAY, UP INSIDE THE ARCTIC CIRCLE, AND THAT WAS WARMER! IT WAS CLASSIC 'LEVEN THOUGH. SO GOOD I COULDN'T GET OUT. I WAS SHIVERING FOR ABOUT FIVE HOURS AFTERWARDS!"

lucky boy, but he's made his own luck...

He's put a heck of a lot into it, getting those spots wired...
Oh yeah, sussing out those waves took ages, and it's bloody cold over there in the winter. So you've got to give it to him. He's a star, he's a pioneer...he's a magician really. I'd love for Mickey to go to Hawaii one winter, just the once, 'cos I'd love to see what he'd do out there. He's a loony enough swimmer to swim the massive days... he'd be out there cackling, loving it!

Final question. In terms of technology, where do you see surf photography going in the next five years? Are moving images going to replace stills?
Yeah, I think they will eventually, once the processor power gets up to speed. It's only a matter of time. My Canon 7D shoots video at 60 frames a second and you can run a half-page-size JPEG off one of those frames...so give it five years and cameras will be shooting 120 frames a second in HD. You'll just shoot everything and pick out the frame you want. But I think there'll always be a place for still photography, not least because of the logistics of storing all the data. If you're filming every wave in HD you're going to need a truckful of hard drives to store all the footage! ◻

ABOVE Ben Skinner, Porthleven
RIGHT Army checkpoint, Israel

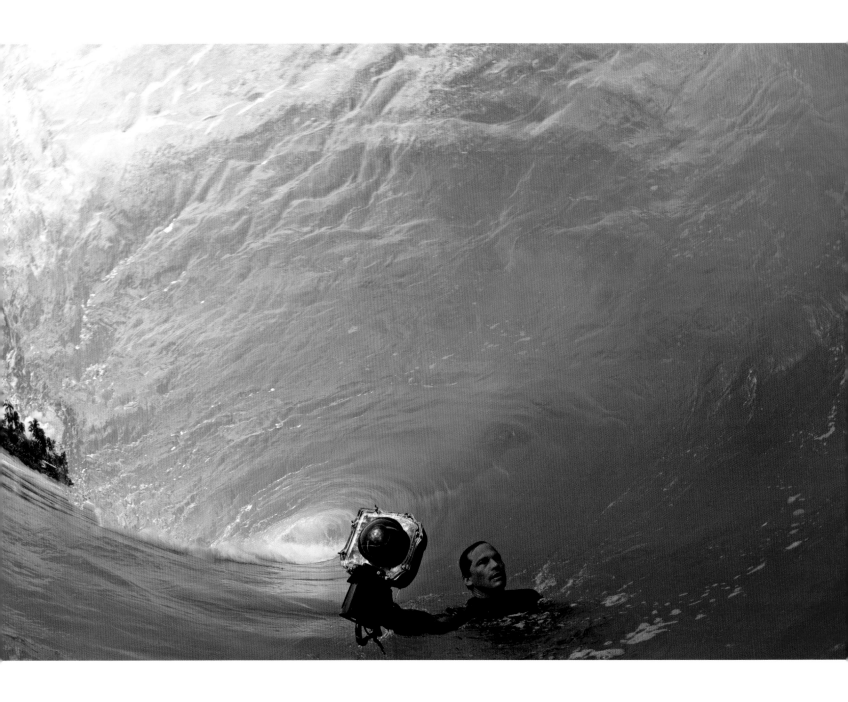

//CLARK LITTLE

SHOREBREAK MANIAC TURNED PHOTOGRAPHER

A CUBIC METRE OF WATER WEIGHS A METRIC TONNE. THAT'S A FACT WORTH
PONDERING WHEN YOU LOOK AT SOME OF CLARK LITTLE'S SHOREBREAK PHOTOS.

Up until four years ago Clark Little had a nine-to-five job working as a supervisor
at Wahiawa Botanical Gardens on the Hawaiian island of Oahu. The gardens are a
30-acre tropical paradise situated in the centre of the island, and Clark loved the
variety and 'hands on' nature of his job. One minute he'd be halfway up a Mindanao
gum tree, lopping a bough off with a chainsaw; the next he'd be hacking back an overgrown
thicket of bamboo; the next he'd be supervising a new landscaping project. After work he'd
head home to the North Shore, sometimes stopping at Waimea Bay where he'd surf the sand-
dredging shorebreak closeouts alongside a handful of psychotic bodyboarders. Over the years
Clark had built a rep as the craziest standup charger at this ultimate slamfest of a wave.

Back then, the only photos Clark took were the ubiquitous birthday and Christmas
snaps of friends and family. But all that changed one morning in 2007 when his wife, Sandy,
suggested they buy a photo of an empty wave for their bedroom wall. Clark liked the idea, but
seeing as he'd bodysurfed and surfed the shorebreak at Waimea for years, he reckoned he
could get a pretty decent shot himself. He'd never tried taking photos in beefy waves before
but, hey, it sounded like fun. So he swam out and fired off some shots using a Canon SD500

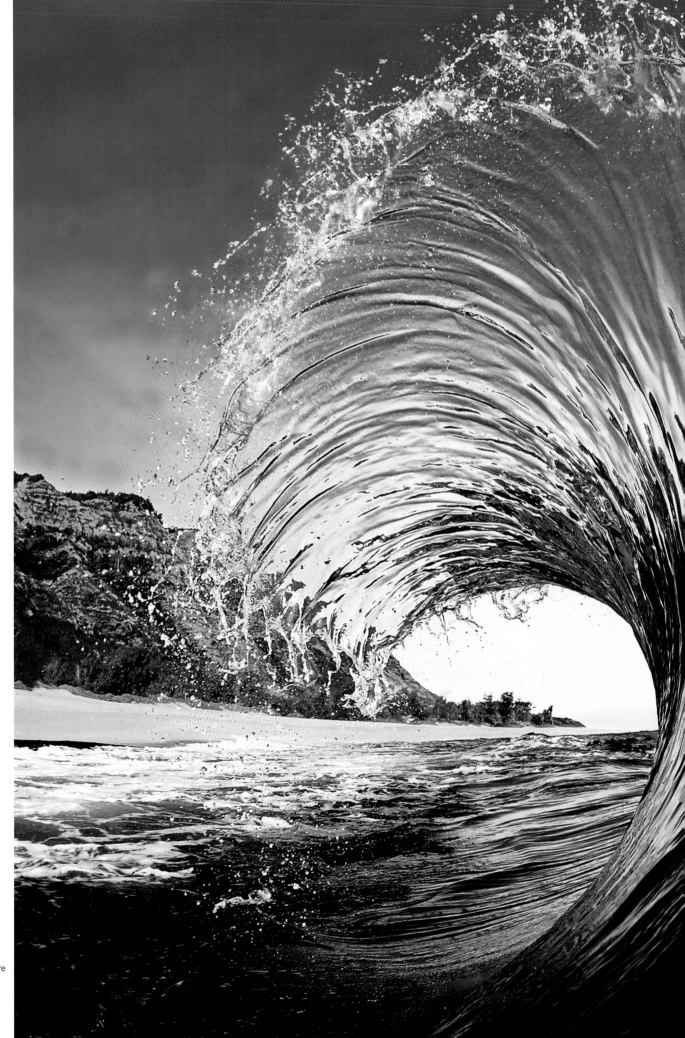

Backwash curl, North Shore

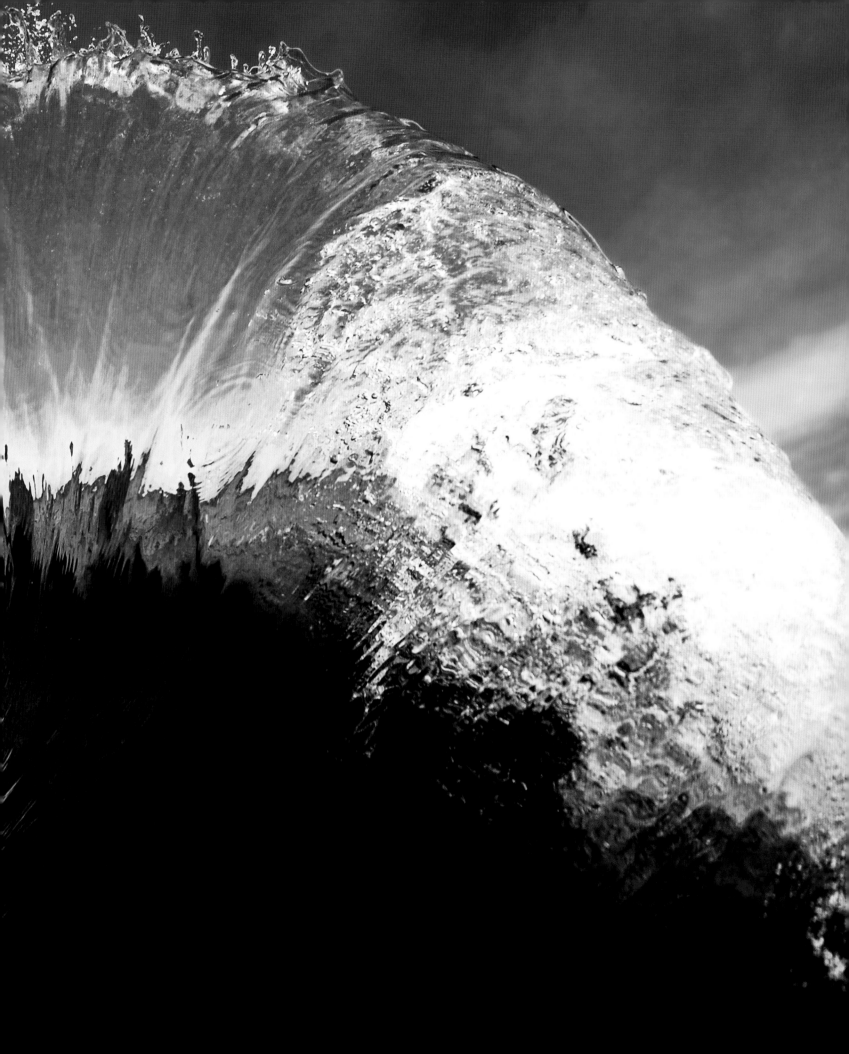

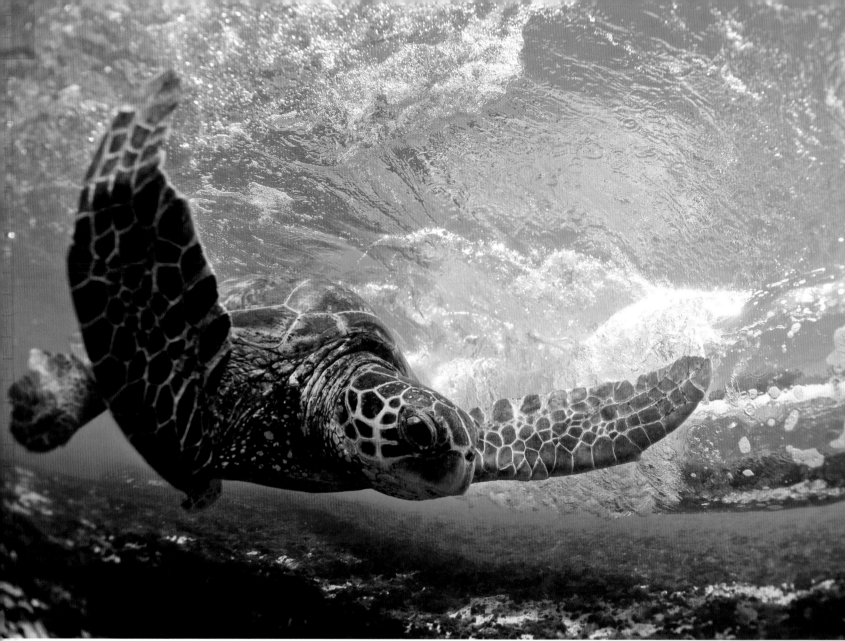

Green turtle, Laniakea

compact camera in a plastic housing. Despite the shortcomings of this basic 'point-and-shoot' camera, the results were startling. The best shot from the session captured the full majesty of a pitching shorebreak lip – with the sunlight turning the roof of the wave into an incandescent cavern. When Clark showed the shots to his dad (coincidentally a lecturer in photography), big brother Brock, and neighbourhood surf photographer Brian Bielmann, they all said the same thing. Go and get some more!

So Clark did that, and after nailing some more cracking images he began to realise he was onto something. The only thing holding him back was his equipment, or lack of it. So, with advice from Bielmann, he invested £2,500 in a state-of-the-art Nikon D200, a fisheye lens and a custom water-housing.

Over the next 12 months shorebreak photography became a part-time hobby and eventually a consuming passion. He started

"SOMETIMES I TRY TO TURBO OUT
THROUGH THE WAVE. AND SOMETIMES
I GO THE OTHER WAY...I JUST KINDA
CURL UP IN THE FOETAL POSITION AND
TUCK MY CAMERA INTO MY CHEST LIKE
A FOOTBALL. THEN I JUST TAKE A DEEP
BREATH, HOLD ON, AND HOPE I MAKE IT!"

submitting shots to surf mags like *Surfer* and *Australia's Surfing Life*, and set up a website selling prints and cards. It seemed like photography would be a nice little sideline, earning him a few extra bucks and giving him a reason to get up early for those magical North Shore sunrises.

One day a PR acquaintance suggested pitching a few shots to the mainstream media. Clark was pretty relaxed about the idea – he gave the thumbs up and headed off to work at the botanical gardens as usual. He didn't expect the response that awaited him the following day. "I woke up the next morning and I had 700 e-mails! It was crazy. *Good Morning America, Inside Edition, The Today Show*...all these people were e-mailing me and wanting to get hooked up."

The next thing he knew, Clark was in New York appearing as a studio guest on ABC's *Good Morning America*, a chat show viewed by tens of millions of Cheerio-munching Americans every day. The guy from Hawaii who loved getting pounded in the shorey at Waimea was suddenly big news.

As the media interest in his photos snowballed, Clark realised he'd have to devote more time to his new calling, so he resigned from his job at Wahiawa and made photography his full-time occupation. Since then his photos have appeared in dozens of top international magazines including *National Geographic, Geo, Paris Match, The Australian, Men's Journal, Sierra Magazine, Nikon World*, as well as countless surf mags. Apparently, President Obama even has one of Clark's shots on his wall in the Oval Office.

Clark's stomping ground is the world epicentre of big-wave surfing and there's no shortage of slamming shorebreak waves to photograph. So which spot on the North Shore does he rate as the heaviest? "Ke Iki, definitely. Ke Iki is the gnarliest shorebreak on Oahu...in fact it's probably one of the gnarliest in the world. The thing about Ke Iki is there's no second reef, or third reef. Every ounce of wave energy comes straight in and breaks on the shore. Pipeline has a second reef, Waimea Bay breaks outside...but at Ke Iki all the water just slams in, so you get waves that are sometimes thicker than they are tall."

It's the rawness of Clark's photos, the perspective that places you right there, which makes them so special. So how does he handle being out there in the impact zone at Ke Iki, standing on the sand with an eight-foot shorebreak about to land on his head? What does he do at the moment of impact? "Well, first of all I try to get the picture! Then there's a choice – do I go in or go out? Sometimes I try to turbo out through the wave. And sometimes I go the other way...I just kinda curl up in the foetal position and tuck my camera into my chest like a football. Then I just take a deep breath, hold on, and hope I make it!"

Last year Clark published a deluxe coffee table book which showcased the best of his photos, *The Shorebreak Art of Clark Little*. Endorsed by surfing A-listers Kelly Slater and Jack Johnson, the book received widespread acclaim. To promote it he did book signings and talks about his photography around the world.

Clark acknowledges the fact that he's fortunate to have family members and friends with the expertise to offer feedback and advice. His dad, his brother, and good friend Brian Bielmann have helped on the visual side of things, while his sister-in-law has chipped in with marketing advice. "Yeah, I've gotta say that it's a group effort. I share my work with my family and I love to get feedback from them. My dad has been a photography professor for 30 years, and he's a pretty harsh critic. He always just tells me the truth, you know. He'll say, 'No, I don't think these shots have anything,' or he'll say, 'Wow!' And my bro, he's been surfing all his life, so he knows which images are really strong straightaway. So for me to get that help and feedback is a huge advantage. But when all's said and done, I've still gotta go out there and pull the trigger."

Right now things are going really well for Clark. His book has been out for eight months and has sold thousands of copies. He admits he's bowled over by its success. "I'm so stoked. I put a huge investment into the book and I didn't really know what was

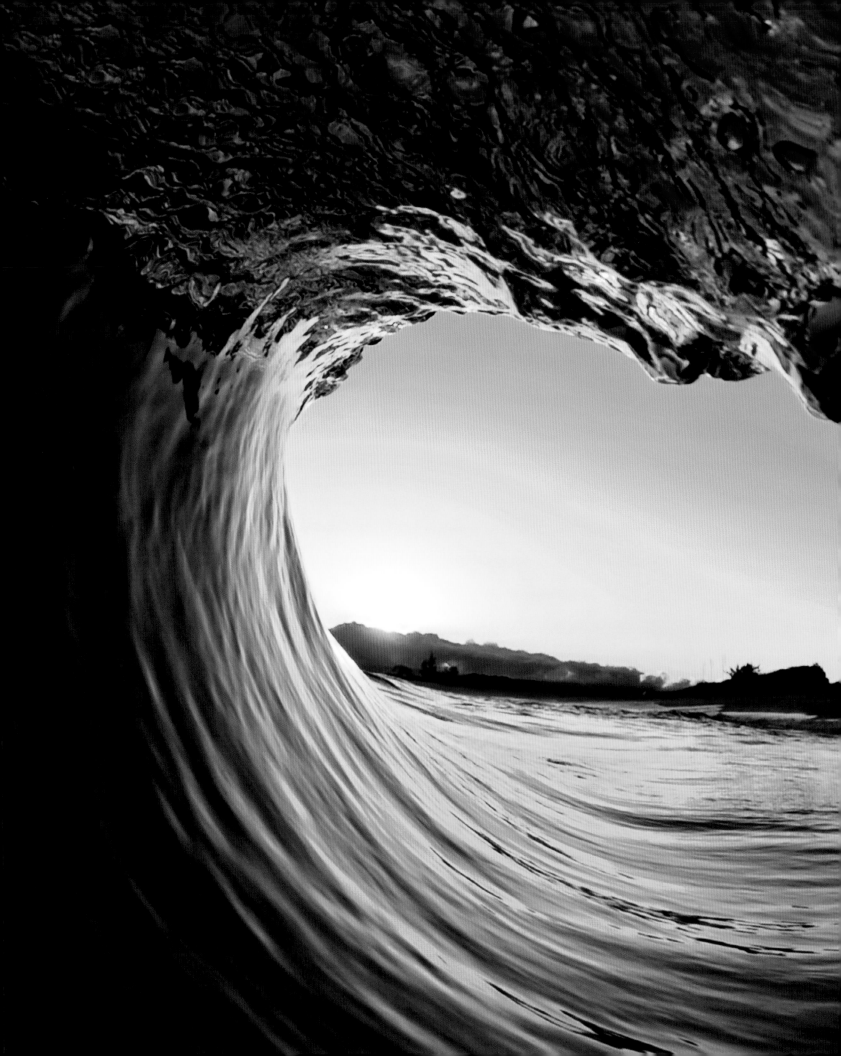

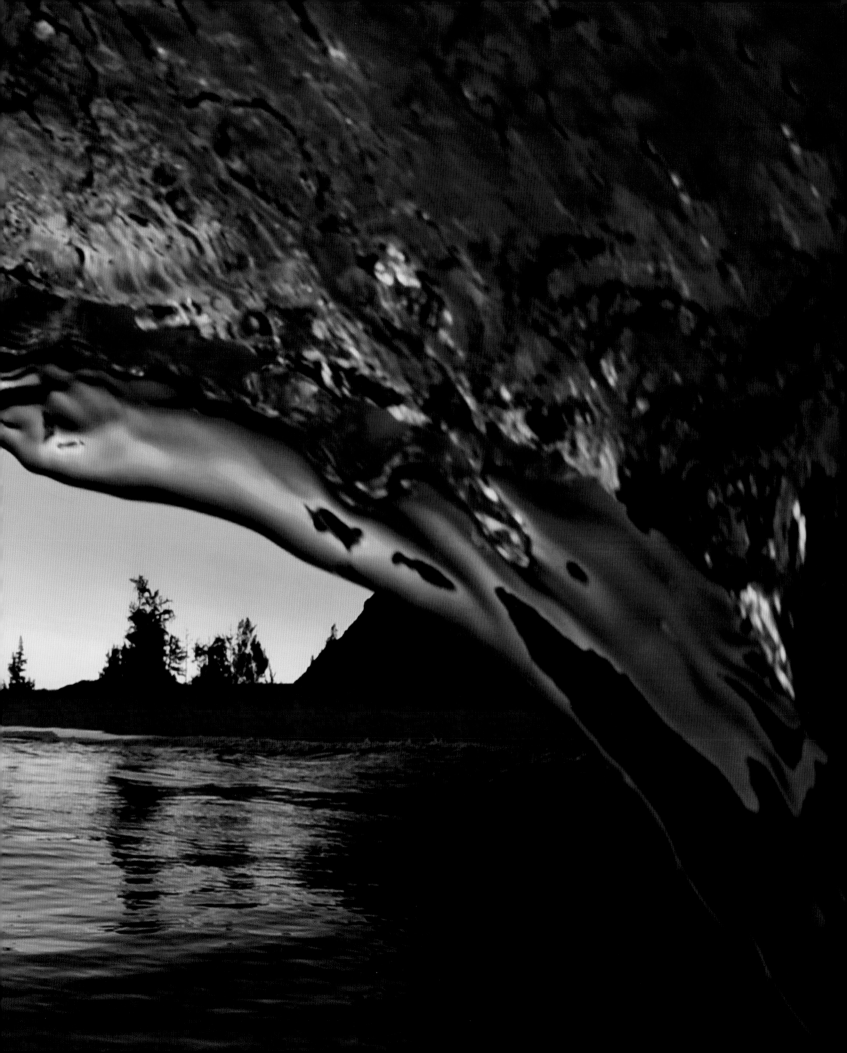

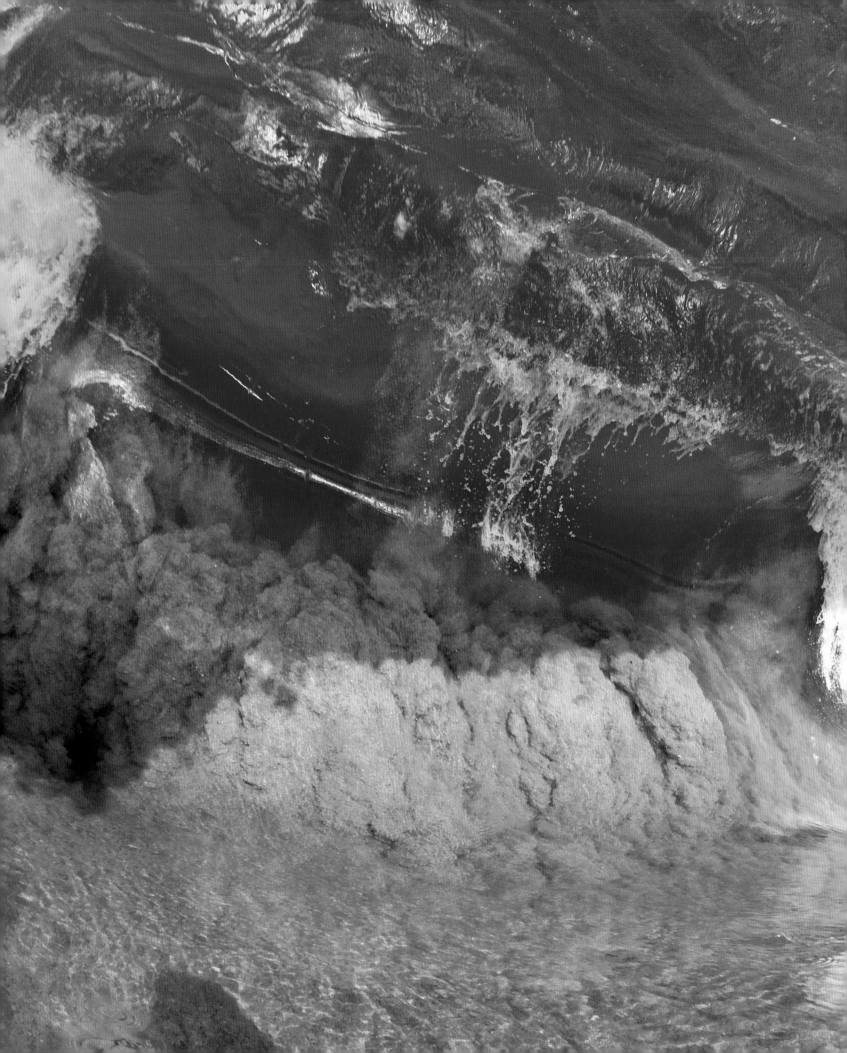

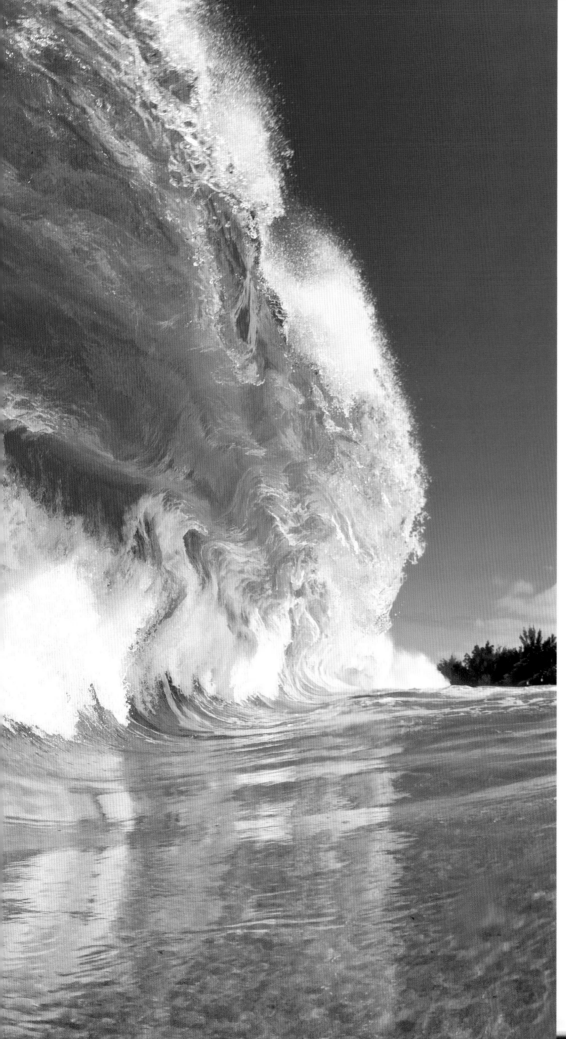

going to happen. But it's sold really well and I'm super stoked on all the positive feedback. To be able to share my photos with people all around the world is a treat."

So does he have any plans for a follow-up book of photos from other psycho shoreys around the world? Will we be seeing crazy new angles from inside the guts of waves like Puerto Escondido, La Graviere and Newport Wedge any time soon? "Well, I've thought about it, yeah. Maybe going from one coast of the US to the other...like, jumping in an RV and doing it for two months. I'd love to go to Australia as well, and Japan, and Brazil. So the answer is, yes, I'd love to, but I don't have any set plans yet."

Clark can barely believe that his mid-life career change has worked out so well, both creatively and commercially. "It's a dream come true. I mean, I never in a million years set out to do this. I didn't wake up one day and say, 'I'm going to be a surf photographer'. I just did it 'cos my wife wanted a picture for the house. Then when people said I should do more shots, I got a few tips, used my experience and just went for it. And now it's turned into a full-time career. It's crazy!" ◘

//DJ STRUNTZ
US EAST COAST LENSMAN WITH WEBBED FEET

To outsiders, the East Coast of the US is a somewhat baffling place. It doesn't cop a lot of swell (except during the hurricane season, when it gets battered) and it doesn't have a whole lot of reefs or points. And yet it has produced some of the most staggeringly talented surfers of our times: Kelly Slater, CJ and Damien Hobgood, Shea and Cory Lopez to name just a handful. Another East Coast achiever is North Carolina-based lensman DJ Struntz, whose talent has bagged him one of the most sought-after jobs in the surf media: staff photographer at *Surfing* magazine.

You're known for being one of the top photographers on the East Coast – have you always lived there?
No, I'm originally from Napa Valley in Northern California. Back in the day I had another life as a super-nerd marine biologist and I came over here to do a research scholarship in '97. After college, the Department of Commerce offered me a job as a research biologist in Wilmington [North Carolina], so I moved over here.

Were you into photography back then?
Yeah, I was into photography but kind of just as a hobby. I had some photos published in a wakeboarding magazine when I was 17, but then I just left it. Then in 2002 I went on a surf trip to Pascuales in Mexico with a few friends and I shot some photos down there. When I got back I sent a few of them to Dick Meseroll at E*SM [Eastern Surfing Magazine]*. He gave me a bunch of critique...basically told me that my film stock sucked and I needed to improve my equipment! But he also said that my eye was pretty good. So that was a challenge for me, I was like, 'Okay, I'll show you!'

So you got more into photography, covering the scene in your area...
Yeah. When I started shooting on the East Coast there was a good crew of young talent coming through so there was plenty of opportunity to get good shots. There weren't many other photographers around here either, so when I jumped in the water and started shooting it opened up some doors.

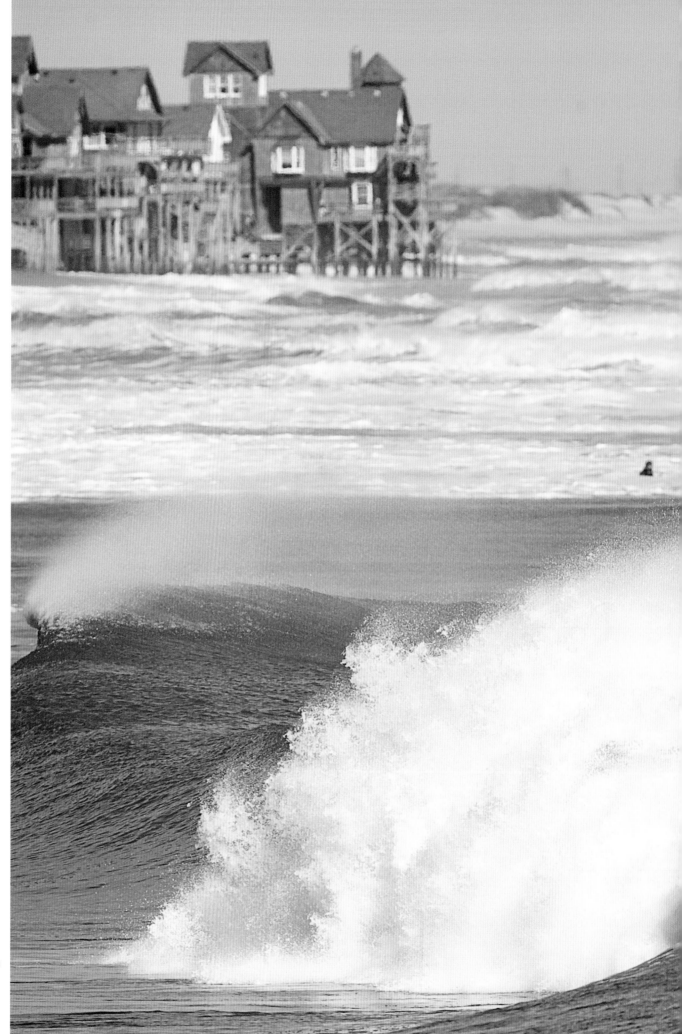

Peter Mendia, North Carolina

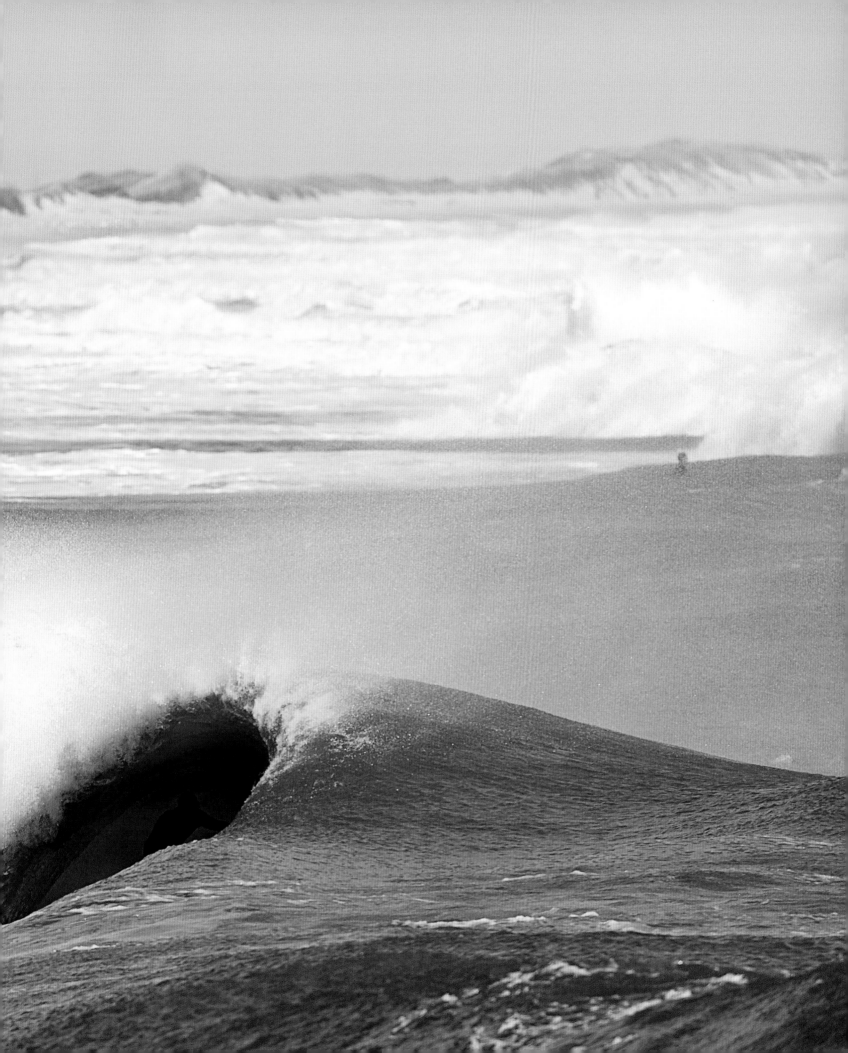

What was your first big break?

I did a trip to Nicaragua for *TransWorld Surf* at the beginning of 2003 and we got some nice waves. I was down there for three weeks with a crew from the East Coast – Ben Bourgeois, Asher Nolan, Brian Toth, Noah Snyder and a few other guys. *TransWorld* ran it as an eight-page article. Then, shortly after that trip, Flame [Larry Moore] invited me to come on board at *Surfing*.

What are your favourite spots to shoot on the East Coast?

Well, there are quite a few. There's a left on one of the outer islands, about two hours away…that's one of the best waves on the East Coast as far as beach breaks go. So Ben [Bourgeois] and I, and a few of the local kids, sneak up there quite a bit. It's not really a secret spot but it never gets too busy. It's on an uninhabited island – you have to either camp or stay on the mainland. There are wild horses running around and stuff. So we have that, and we have Hatteras. On hurricane swells Wrightsville can get pretty fun too – it's not as good as Hatteras but it's really rippable.

The East Coast doesn't have a ton of great points or reefs, and it doesn't get as much swell as California or Australia, yet it's produced some world-beating surfers like Slater and the Hobgoods. How come?

Um…I think it just makes you really hungry and appreciative. East Coast guys are used to surfing sloppy windswell most of the time, so when they get good waves they just go nuts. It's true that we don't get as much swell as other places, but when it's good here the waves are really punchy…kinda like a Hossegor-style beach break. And then, you know, Kelly and the Hobgood's just have crazy genetics. Those guys had amazing natural ability from a young age, and coupled with that East Coast drive to achieve, they just went out there and became superstars.

East Coast swells are often short-lived so I guess you have to be pretty switched on to make the most of them…

Yeah, most guys over here are really good at tracking swells. Damo, Ben and Kelly just pore over the charts, they're really good at breaking down what a storm's gonna do. And Shea Lopez might as well work for *The Weather Channel*! The storm swells and hurricane swells we get here are so unpredictable, and the window is really small. You've got to figure out where the waves will be good, and then get in and get out before the storm hits. So, working here has taught me how to shoot in less than ideal conditions, and how to make the surf look better than it is. Evan Slater [former *Surfing* editor] used to joke that I was 'the brown water navy' – he'd never send me to the dream destinations. Like, I've never done an Indo boat trip for *Surfing*. All the other guys go on these dream boat trips, but with me it's like, 'Okay DJ, you're going to Uruguay,' or, 'Okay DJ, you're going to Yemen'! But I've been to some really interesting countries as a result and I've done some great trips.

You've taken watershots at some heavy spots – do you do any specific training to stay in shape for those kind of missions?

I'm pretty fit anyway but I still train really hard. I view it as cheap life insurance. When you travel with surfers like the Hobgoods you have to be ready for anything. They demand a lot from themselves, and they demand a lot from the photographers they travel with. They don't want a photographer who's just gonna laze around, bitch 'n moan, and take naps during the day. So, yeah, I train pretty hard. I do cross training, aerobics, anaerobic threshold training…

What the heck is anaerobic threshold training? Doesn't sound much fun…

Well, it's pretty intense. You do push-ups, pull-ups, body-weight squats… just as many cycles as you can do in 20 minutes. So in 20

"THE BEST WAY I CAN DESCRIBE IT WOULD BE LIKE JUMPING OFF YOUR ROOF ONTO CEMENT AND LANDING ON YOUR KNEES. IT WAS PRETTY BONE-JARRING."

Julian Wilson and friend, Panama

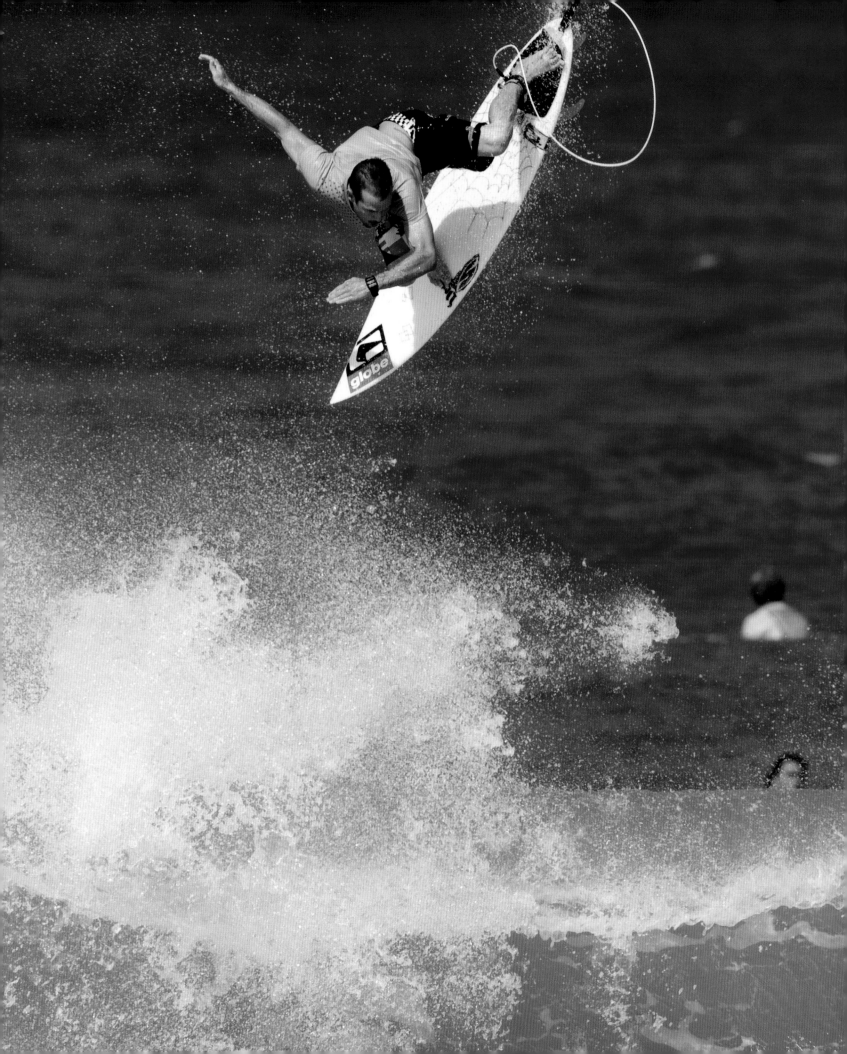

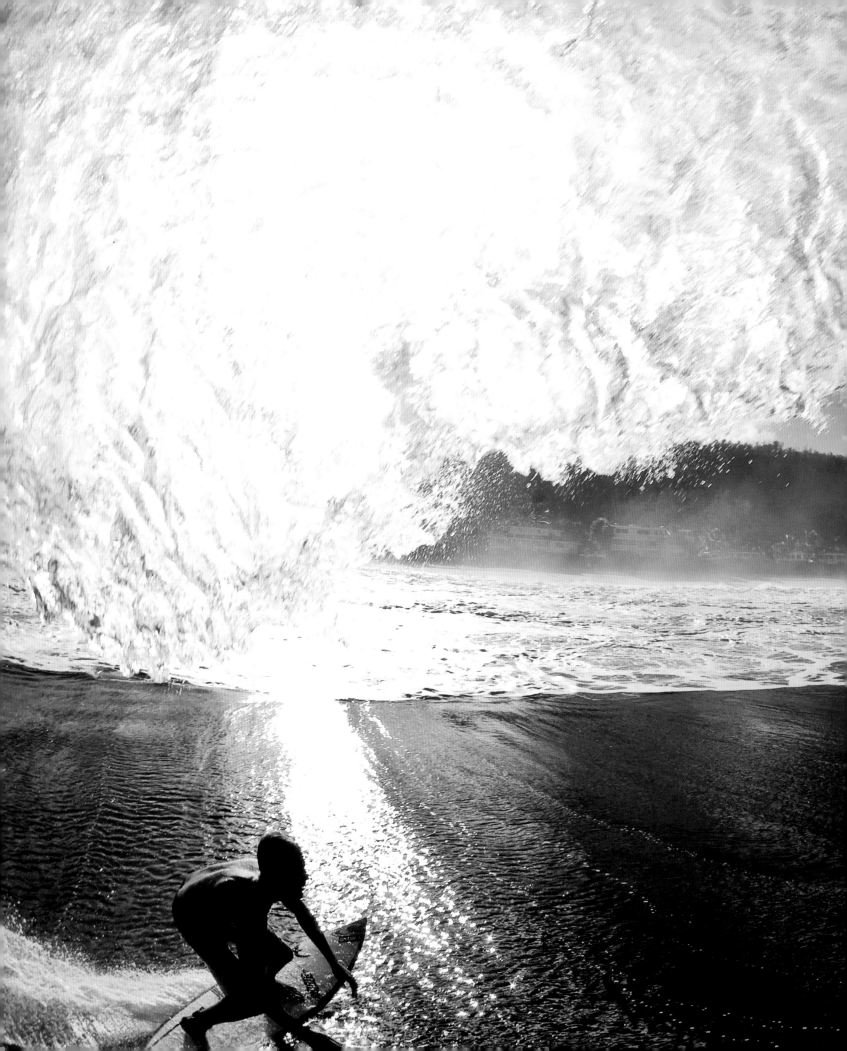

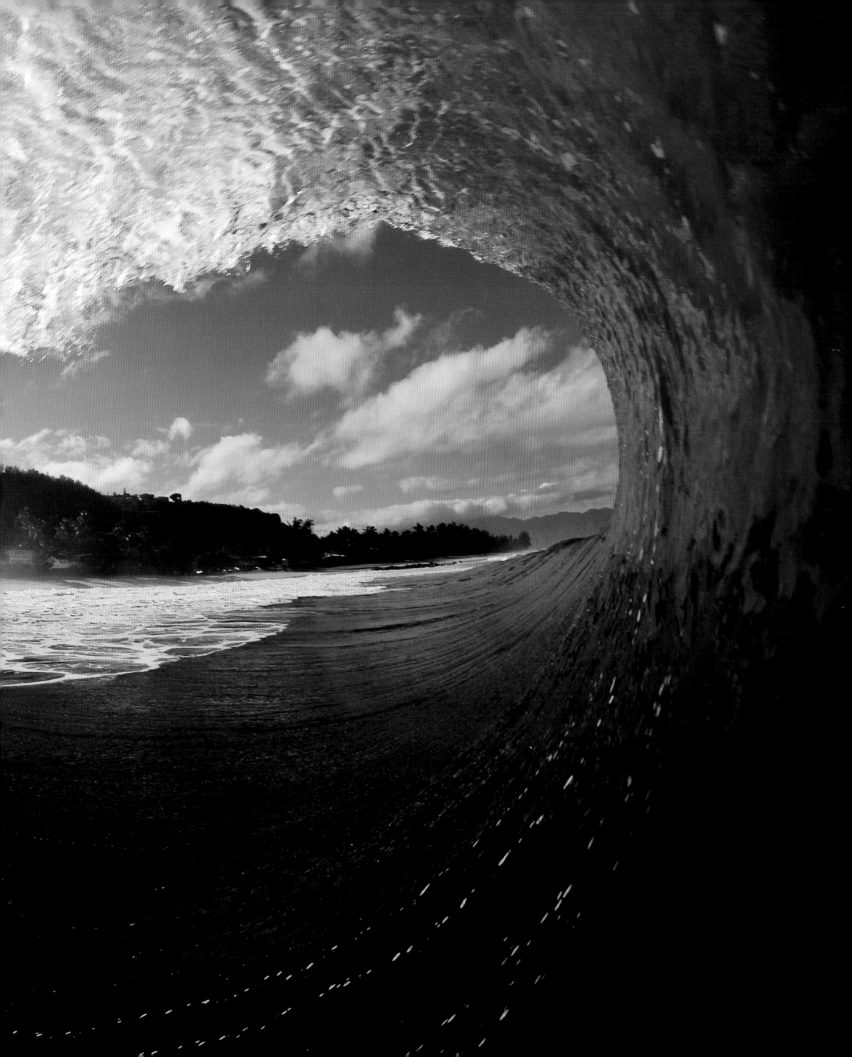

minutes you're done...but you wanna puke!

Okay, and when you're in the water, what happens when things get heavy? How do you deal with getting caught inside at a heavy reef?

It depends where I'm at. One thing I know is that you never want to be a couple of feet in front of where the lip is coming down. I've had that happen once, at The Box in Western Australia. I took a lip in the lap and that was very painful! And I've been chucked over the falls at Teahupoo... that wasn't much fun either. And I've been caught inside at big Pipe, like, after swimming for eight hours. I just got thrashed. But it depends where I'm at. If I think I can beat it, then I'll just swim as hard as I can with my eyes open, looking for where the lip is coming down, looking for pockets between the turbulence. You get these kind of fingers of turbulence that grab you... they're the things that really get you. So it just depends. If I see a whole set of waves coming at me, I might even push up into the whitewater, let it blast me in, then swim around again. It's a split second decision. The best guys in Hawaii, guys like [Daniel] Russo and [Scott] Aichner, they're amazing at it. I have all the respect in the world for guys who swim in those kind of conditions, day in, day out.

Let's rewind to that time you went over the falls at Teahupoo. That must have been pretty horrendous...

Well, it was definitely pretty exciting! The waves weren't massive or anything, I guess it was about six feet. I was lining up to get a shot of CJ [Hobgood] but I was a little out of position. As I went up the face I could feel myself getting stuck, and it was like, 'Oh my gosh, here we go!' The best way I can describe it would be like jumping off your roof onto cement and landing on your knees. 'Cos I landed on my knees, straight on the reef. It was pretty bone-jarring. When I came up I was seeing stars, you know, pretty shaken up. I had some water in my housing and my leg was killing me. So I swam around to the nearest boat and Pancho [Sullivan] hauled me in. The sets were pretty inconsistent so luckily I didn't have to deal with any more waves, I just swam around and got back to the channel.

So you're one of eight or nine staff photographers at *Surfing*. How many trips do they send you on each year?

It works out at about a trip a month. But I don't like to go and camp out for five weeks or whatever, because of my family...I have a wife and a little boy. So I prefer 'strike missions' where I just go for a few days or a week.

You've done a lot of trips down to the Caribbean, I guess that's just a short hop for you...

Yeah, I'm always there in the winter time. Europe, the Caribbean, Central America...they're all pretty easy hops from here. I've done a few trips to Africa too – I was the first photographer on that left down south in the desert [Skeleton Bay], on the Google Earth Challenge trip. And for Globe I've been to the South Pacific and I've done the Fiji contest a few times. Over the last few years my work has taken me to about 25 different countries, so I think I've been really

fortunate. It's a cool way to see the world. ❑

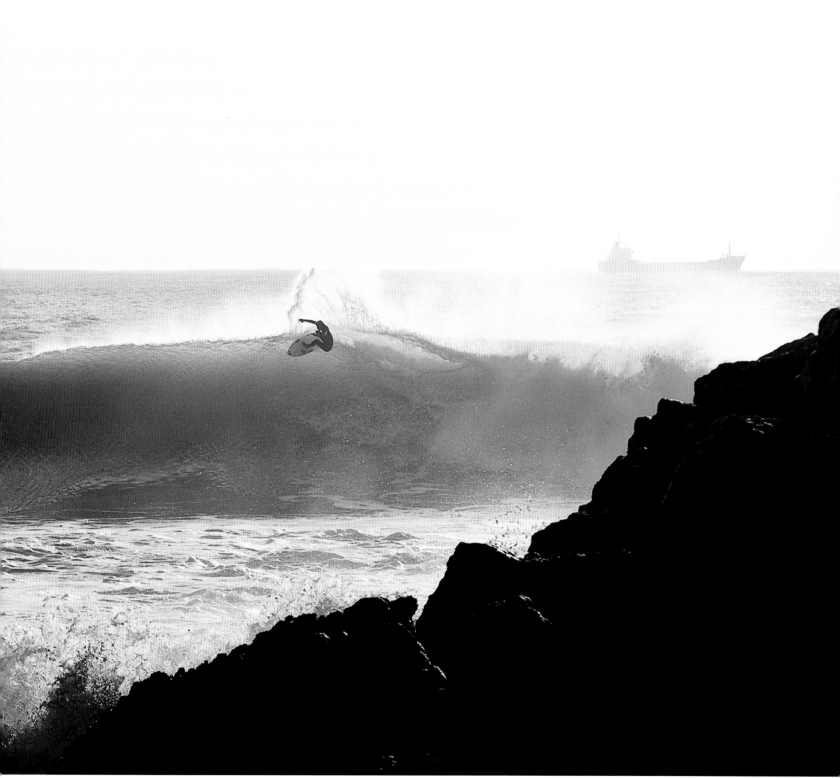

Dusty Payne, Morocco

PREVIOUS SPREAD **Mark Mathews, Off The Wall**

//TIM McKENNA
THE MAN WHO PUT TEAHUPOO ON THE MAP

EDITORS AND ART DIRECTORS ARE ALWAYS ON THE LOOKOUT FOR FRESH IMAGES, AND CREATIVELY-MINDED PHOTOGRAPHERS LIKE TIM MCKENNA ARE ALWAYS HAPPY TO OBLIGE. WATER SHOTS, LAND SHOTS, HELICOPTER SHOTS, UNDERWATER SHOTS, POINT-OF-VIEW SHOTS, LIFESTYLE, FASHION, PORTRAITS, SCENICS...HE CAN DO 'EM ALL.

"The wave, the shape of the barrel... it was just like nothing I'd ever seen before. I'd seen a lot of waves around the world – I'd been to Hawaii, I'd been on boat trips to Indo – but I knew straightaway that this was something else, something incredible." Tim McKenna remembers the first time he saw Teahupoo with searing clarity. The year was 1996 and Tim was on a photoshoot to Tahiti for French surf brand Oxbow with Gary Elkerton, Robbie Page and Duane DeSoto. It was Tim's first trip to French Polynesia and he was blown away by both the quality of the waves and the beauty of the islands. "Everywhere I looked I just wanted to take pictures. The lagoons, the mountains, the people, the culture, the villages...I fell in love with the place."

Although he sensed that Teahupoo had the potential to claim a place as one of the best waves in the world, Tim mentally filed the trip under 'good times', and got back to work on one of the many other assignments that keep a top surf photographer in business.

The following year a friend sent Tim a photo that took his mind straight back to that trip, and to the untapped potential of Tahiti. The picture wasn't of Teahupoo, but of its slightly less revered sister. "Sapinus is another break really similar to Teahupoo, and this was the first big tow-in day. One of the guys had got hold of a jetski and the others were in a dinghy. The waves were massive and I understood straightaway the potential for tow-ins in Tahiti. If Sapinus could get that big and that good, then I knew that Teahupoo could get even better."

Within 18 months of seeing that shot of Sapinus, Tim had succumbed to his initial instincts about Tahiti and relocated to the island with his family. Fifteen years on, the photos that Tim takes in his 'backyard' have become synonymous with Tahiti, capturing the beauty of the island's waves and culture.

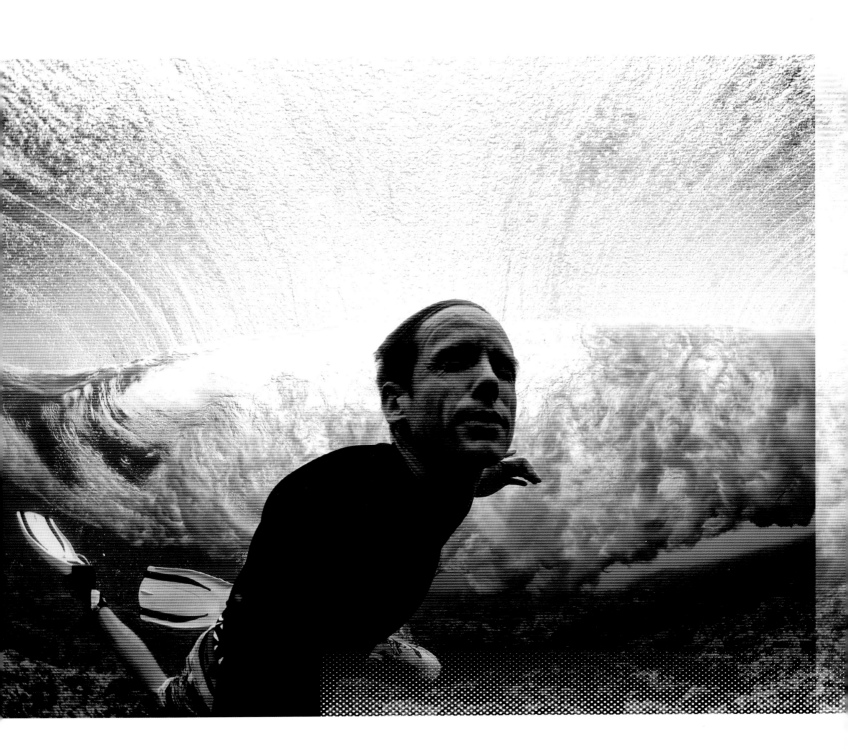

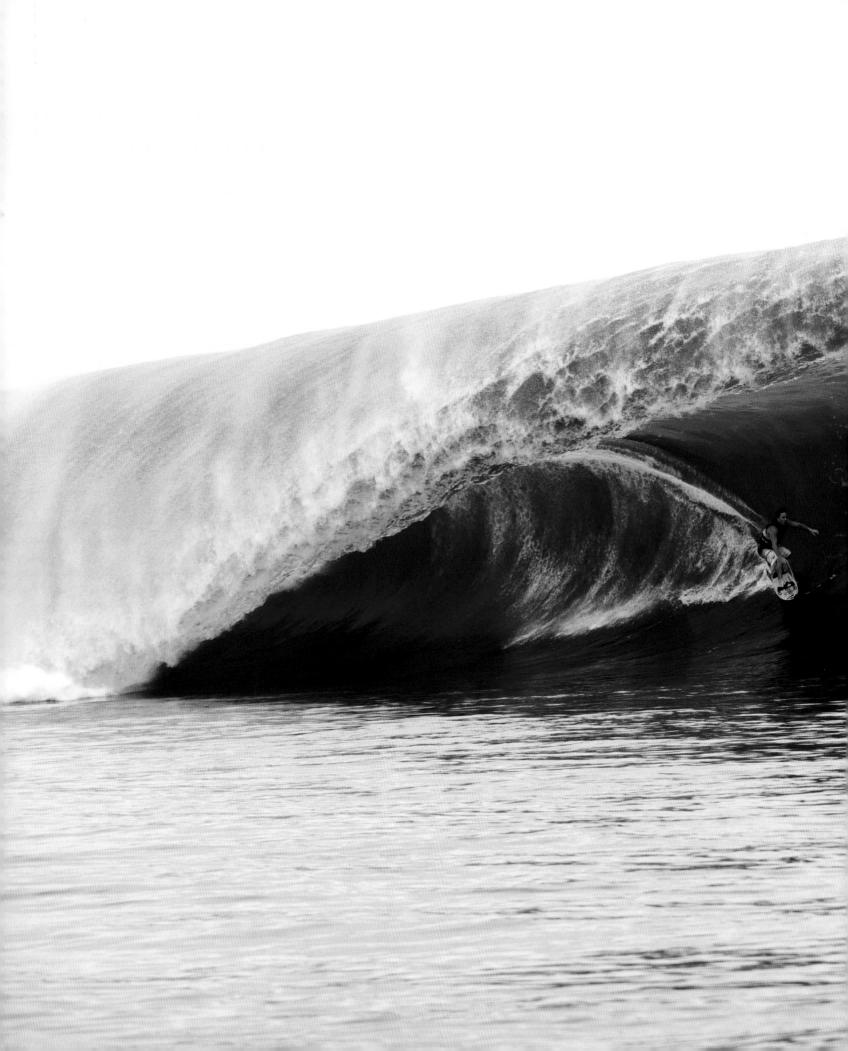

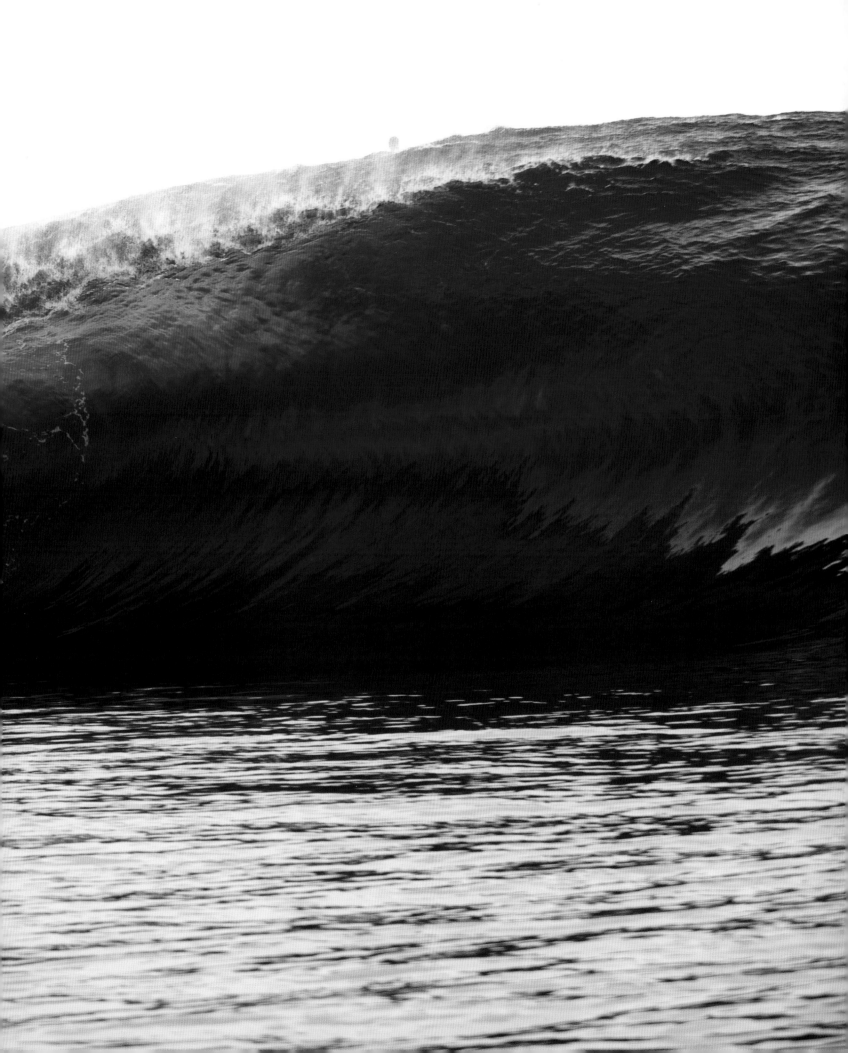

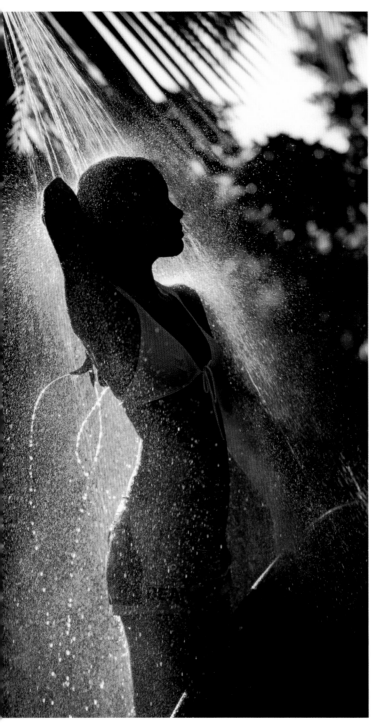

Swimwear shoot for Bear

Tim was born in Sydney but grew up in France, where his parents lectured at Bordeaux University. Recognising the merits of his citizenship, he returned to Australia and enrolled at university in Queensland with a view to eventually becoming a French teacher. While studying there he began to get interested in surf photography, inspired by the likes of Jeff Hornbaker and Ted Grambeau. Having completed his degree, Tim decided to put his teaching aspirations on the back burner and step into the slightly more exciting world of action sports photography.

Basing himself in southwest France, Tim set about shooting high-octane images of surfing, windsurfing, motocross and snowboarding. One of the first shots he had published in a surf mag was a striking image of Martin Potter lobbing his leashless board over a wave while wading in for a session at Les Cavaliers; Aussie mag *Surfing Life* ran it as a double-page spread when Pottz clinched the '89 world title. Soon after, Tim started working for Oxbow as their main man for team trips and fashion shoots, and he began to hone the skills that have seen him behind the lens for some of the most important shots of our generation.

Perhaps the most significant moment Tim has documented over the years was Laird Hamilton's 'Millennium Wave' at Teahupoo in August 2000. Of the many thousands of waves he's photographed in his career, Tim still remembers that wave the most clearly. "It was twice the size of the regular waves that day. Laird dropped down the face at full speed, straining on his footsteps, then realised he was in a cavern the size of an airport terminal. Although he was moving at full speed, he appeared to be in slow motion. The lip threw over and he disappeared into a cloud of spit. As we sped out of the impact zone he burst out of the whitewater right next to us. We all knew that he had just pulled into and survived the meanest tube ever surfed." And Tim had taken the defining shot.

As well as being one of the most jaw-droppingly spectacular waves on the planet, Teahupoo at size is also one of the most dangerous...and not just for surfers. Sometimes photographers find themselves wishing they'd packed an impact vest too. "The heaviest situation I've been in at Teahupoo was in 2003, just before Malik [Joyeux] rode one of the biggest waves ever out there. The swell that day was crazy...every half hour the sets were getting a couple of feet bigger. By the afternoon the waves were 15 to 20 feet. Halfway through the session, without any warning, our boat broke down...the engine just conked out and died. We started to drift into the impact zone. Everybody was yelling and freaking 'cos the current was so strong it would have taken us into the bowl in about 30 seconds. Luckily the boat drivers at Teahupoo are really quick, and the driver of another boat threw us a rope just in time to tow us out of danger. If it had taken 20 or 30 seconds longer I think I would have jumped."

Some of Tim's most striking images (and several of his covers) have been taken from under the waves, looking up. To help him stay in position for these kind of shots he wears a weighted diving belt. But how does he work out where to point the camera? "It's a bit like surfing and how you time your takeoff or your duckdive. When you see a wave that's coming your way, you assess the distance, dive under, then look where the whitewater's breaking to see where to shoot. You're kind of upside down when the surfer goes past above you. It's a weird feeling but a great vision!"

Although sessions at Teahupoo tend to steal the limelight in Tahiti, the island also has a number of other world-class breaks. When the pro's were in town for the 2009 Billabong Pro contest, Tim sneaked off to a secret spot 'out west' with Kelly Slater, Manoa Drollet and Benji Sanchis. He describes their destination as one of the most fickle waves on the planet, hyper-sensitive to the slightest shift in wind or swell direction. But the gamble paid off. "I got out there with Manoa and Benji and it was absolutely flawless. Kelly was still at the hotel eating with his girlfriend, so I called him and said, 'I think you've got to get out here now!' He said, 'Okay, I'll get ready – come and get me in half-an-hour.' So I took some shots of Manoa and Benji, then rushed back to get Kelly. By the time we got back out to

PREVIOUS SPREAD **Kalani Chapman, Teahupoo**

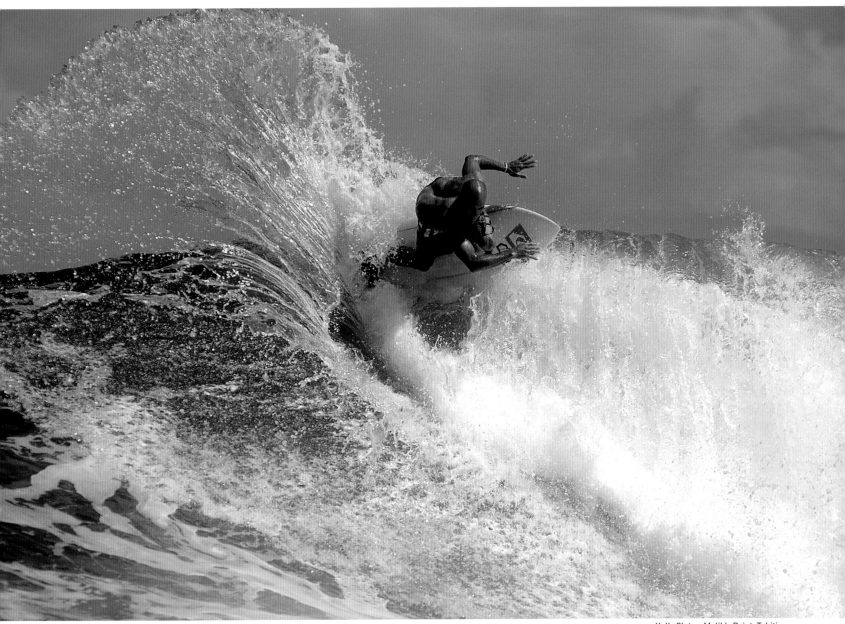

Kelly Slater, Malik's Point, Tahiti.

"I THINK KELLY LIKES THE CHALLENGE OF RIDING A
NEW SHAPE OF BOARD...IT'S LIKE HE'S TRYING TO MAKE
THINGS A LITTLE HARDER FOR HIMSELF SO HE CAN RISE
TO THE OCCASION!"

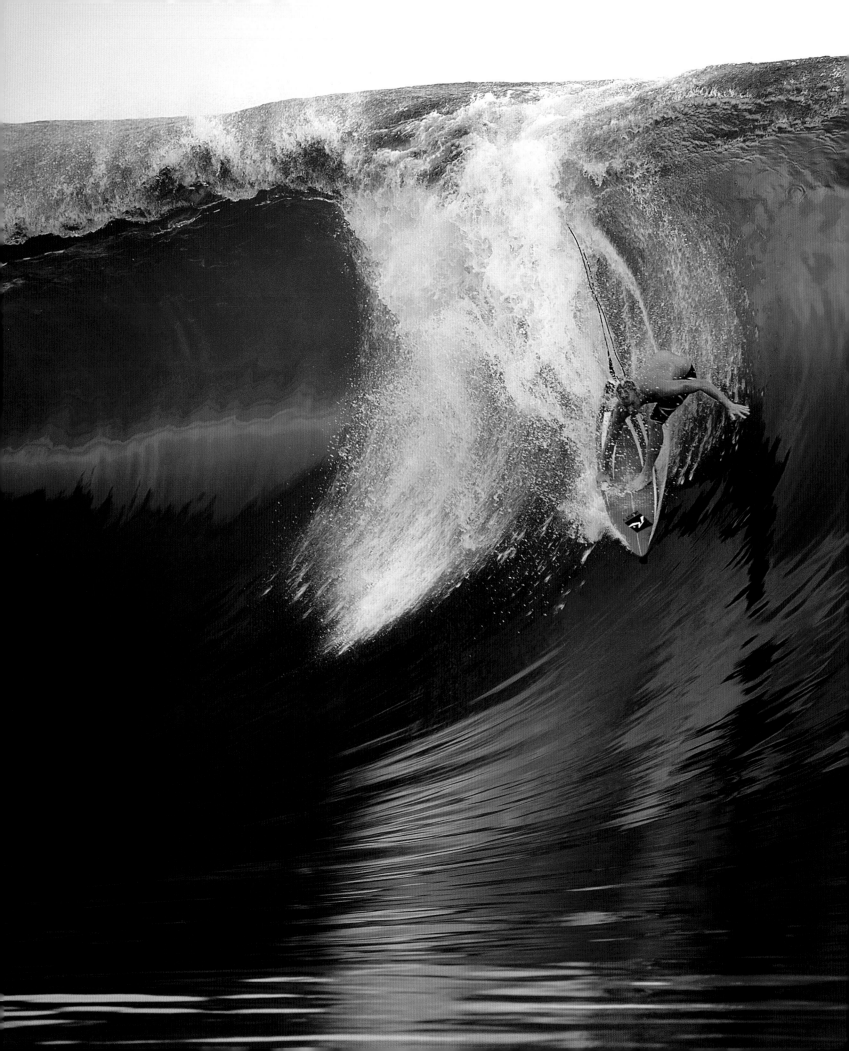

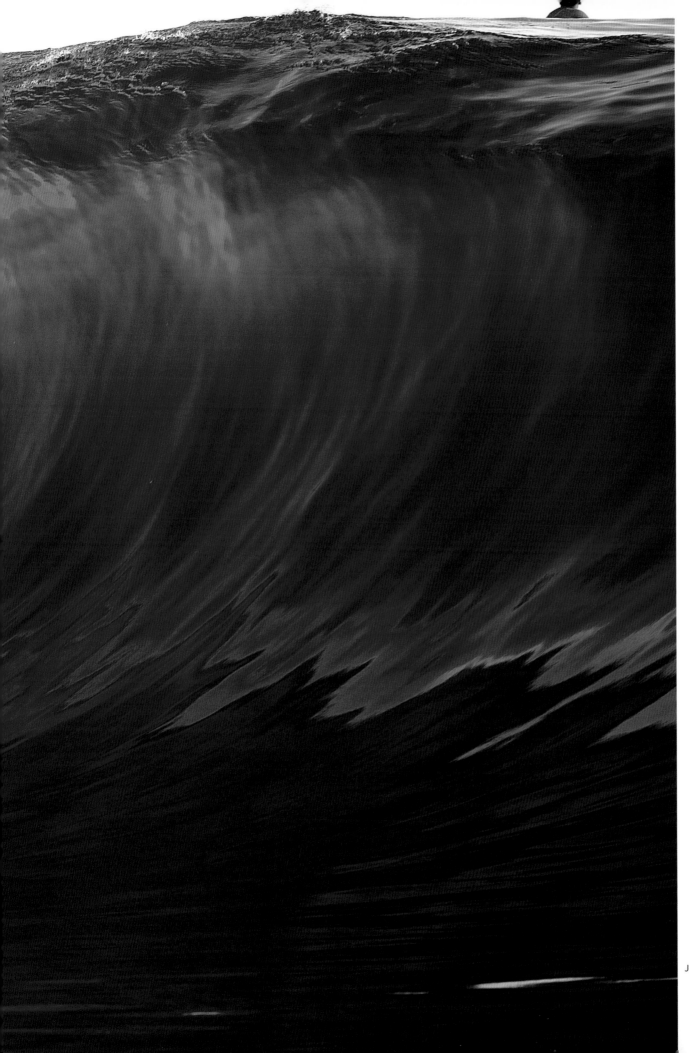

Jamie O'Brien, Teahupoo

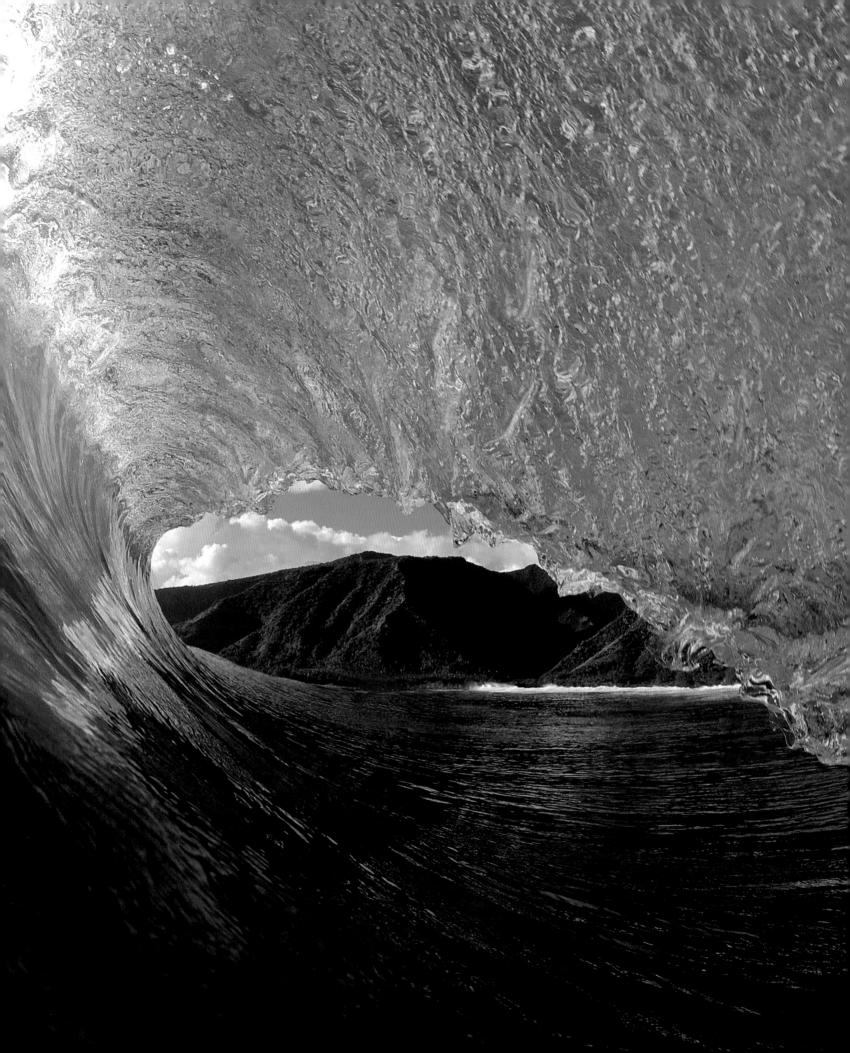

"NOWHERE ELSE IN THE WORLD HAVE I FELT SUCH A HARMONY BETWEEN PEOPLE AND NATURE. THERE'S A KIND OF MAGICAL CONNECTION, WHAT WE CALL THE 'MANA'. IT'S EVERYTHING THAT YOU CAN'T REALLY EXPLAIN..."

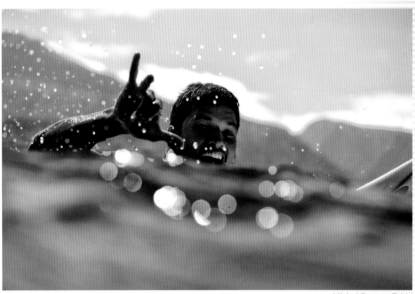

Michel Bourez, Tahiti

the lineup the wind had veered round a bit and the waves weren't so clean. So everyone got back in the boat and we waited for an hour or so. Then the wind dropped and the waves started to pulse again. Kelly was riding one of his Wizard Sleeve boards, and when he got the good ones he was flying through the sections, carving 360s and stalling perfectly for the barrels. I think he likes the challenge of riding a new shape of board...it's like he's trying to make things a little harder for himself so he can rise to the occasion!"

Tim has known Kelly for years, so what does he make of the nine-time world champ's seemingly endless capacity to push boundaries? What the hell is Kelly's secret to eternal youth and just generally being an amazing surfer? "Kelly is simply smart. Sure, he's got incredible talent, but he also has the intelligence to manage all the things you need to stay at the top – keeping fit and healthy, keeping relaxed and focussed. And no one is more connected when it comes to scoring great waves everywhere he goes. I think his secret is simply his love of surfing."

Tim is unquestionably one of the masters of his art in the modern surfing era, so he's well placed to reflect on what the future holds for surf photography in this brave new world of digital imagery. "In the next five years I think surf photography will become more mainstream and we'll see surf images being bombarded practically live on the internet. But I think there'll still be a market for books and magazines with in-depth articles and high quality photos. I find that an image looks so much better when you can touch it and feel it."

Whether displayed in magazines, in books, or on computer screens, there's no doubt that Tim's photographs are among those that define the 'early years' of this modern age of surfing — with jetskis, experimental boards, and surfers putting their lives on the line in ridiculously heavy waves. In the coming years, Tim's quiet determination to produce fresh images and seek out new waves will doubtless lead him right across French Polynesia. But wherever his travels take him, he'll always be drawn back to Tahiti. "Nowhere else in the world have I felt such a harmony between people and nature. There's a kind of magical connection, what we call the 'mana'. It's everything that you can't really explain...just a kind of atmosphere that makes Tahiti so special. Like, if you're out in the lineup and it's raining and onshore, within half an hour the clouds might part and the waves start to pulse, and you see this rainbow. And you look around at the other guys and say 'this is incredible'."

//WILL BAILEY
WELSHMAN WHO GOT THE KEYS TO NUMBER10

Will Bailey is a relative newcomer to the British scene but in the space of a few years he's earned himself a solid rep as a talented all-round lensman. Will hails from Bridgend in the Vale of Glamorgan and studied photography as part of a three-year New Media degree at university. A keen surfer, he started shooting snaps of his mates while on September trips to France. After graduating, he decided to give surf photography a go and spent a week covering the 2007 Quiksilver Pro contest in Hossegor. Quiksilver used some of Will's shots on their website and *CARVE* magazine ran a selection in their autumn contest round-up. Encouraged by this response, he invested in better camera gear and set out on the freelance trail. Three years on, Will is a regular contributor to *CARVE* and sister Irish mag *Tonnta*, and he fills any gaps in his calendar doing commercial work including team shoots for Quiksilver and Nike.

You've done quite a few shoots at 'Y Bocs' [a semi-secret spot in West Wales], do you rate it as one of the best spots in your neck of the woods?
Yeah, definitely. When it's good it's really really good. I reckon it's the best break in Wales when it's on.

Getting there always sounds such a mission...
Yeah, it's a really tough place to score. It's in the middle of a military firing range – you can't get near the place when they're firing and they basically fire all day, every day...well, except weekends. It sounds like a war zone when they're going at it. The chances of getting perfect conditions with the right tides when they're not firing are pretty slim. Then there's the fact that it's a two-mile walk and a half-mile paddle out to the lineup.

It seems so cruel to keep a wave like that permanently off-limits...
Yeah it sucks, 'cos if there's swell, Mondays to Fridays are pretty much out the question. You're wasting your time if you drive all the way up there and then they raise the flags. If you're in the water they come out with a boat and tell you to leave. If you refuse I think they do a military arrest or something. But you wouldn't want to be out there when they're firing anyway, it's

Mark Vaughan, Bagpipes

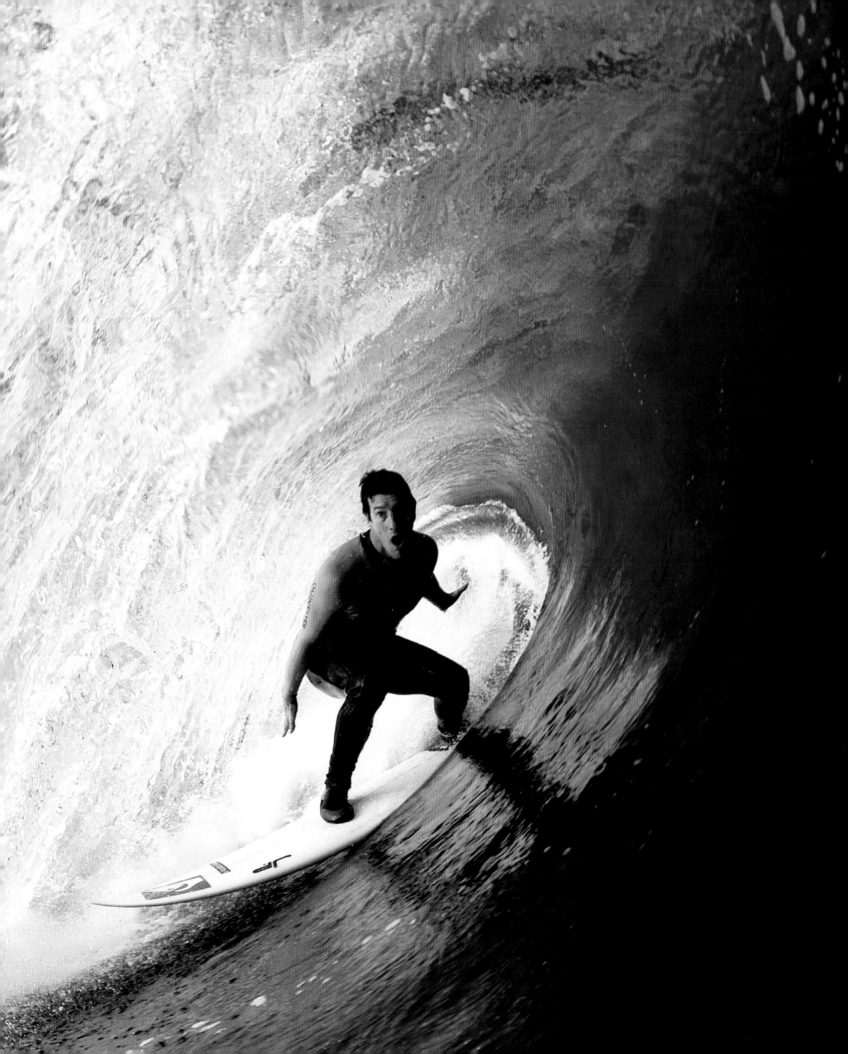

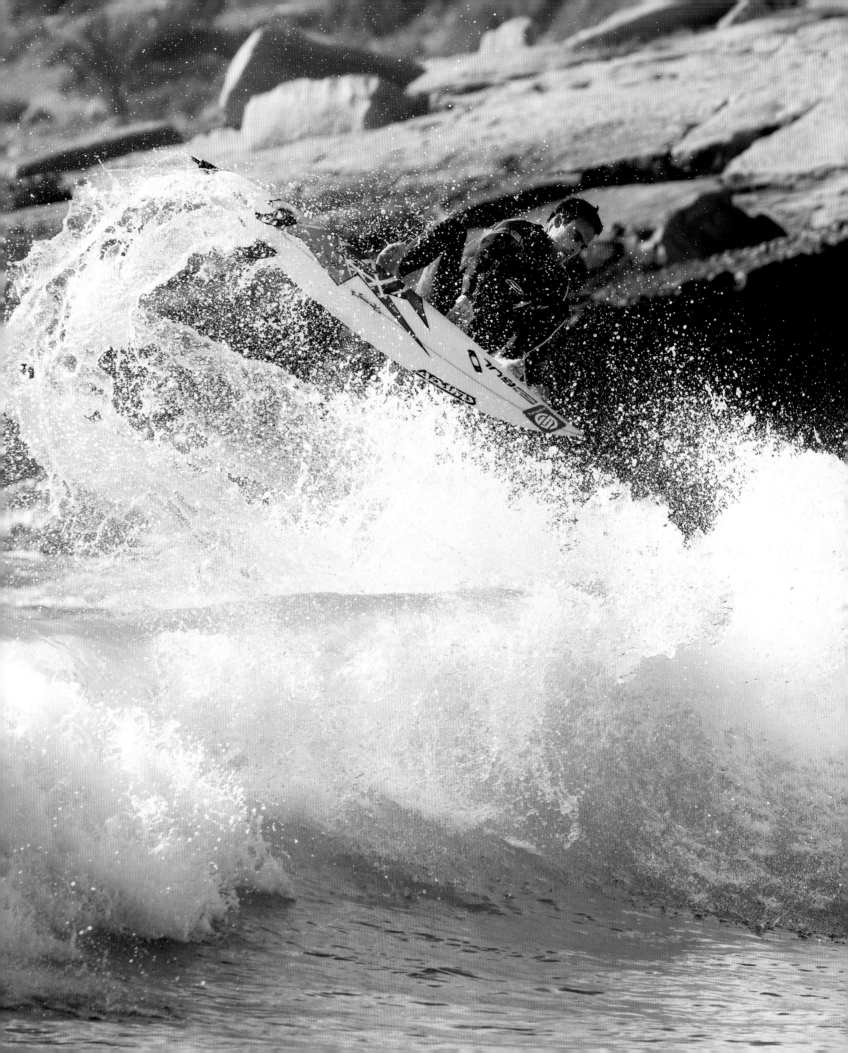

"WHILE I WAS UNDER THE WAVE SOME GUY GRABBED HOLD OF ME, PULLED ME DOWN, AND WOULDN'T LET GO. I WAS GASPING FOR AIR SO I TRIED TO KICK HIM OFF, BUT HE HAD MY LEGS IN A DEATH GRIP."

Lyndon Wake, Toby Donachie, Damien Conway and Luis Eyre, Hossegor

really intense – machine guns rattling off, tanks firing...it's pretty crazy. And I've seen bullets and shell casings on the reef when I've been walking out at low tide...the range spans that whole area. So, yeah, if you actually manage to get good waves out there, you're really lucky!

You're one of these guys who doesn't seem to mind the cold too much. How do you deal with the harsh conditions in Scotland and Wales in the wintertime?
Well, I've got three wetsuits and I always try and keep one of them dry. That helps. A nice 5mm suit with a built-in hood is ideal for the winter. I think it's actually colder in Wales than it is up in Scotland in the winter, because we have so much river water going into the sea here in Wales. So I've probably suffered more here than I have up there.

And mentally, how do you psyche yourself up?
Well, if the surf's really good I don't think about it, I just sort of suffer. As long as I'm getting the photos, I'm happy enough. I just get on with it.

I guess guys like Vaughanie [Mark Vaughan] are good to have on winter shoots because he's so enthusiastic.
Yeah. He's so keen he's like a 16-year-old grom! He's always so amped.

Is Nathan [Phillips] like that too?
Nah, he's the opposite. You have to bring people like Vaughanie along to get him to do anything! (Laughs)

You've racked up a lot of trips to France in the last few years. It's the naked girls, isn't it?
(Laughs) Yeah, that's one of the reasons! I've been going there every September for years... me and a few mates, and then me and my girlfriend. It's just an easy, really fun trip. You get an apartment by the beach in Seignosse, spend all day surfing, and there's loads of parties and stuff.

It's funny seeing the top pro's out on the lash, isn't it?
Yeah, a lot of them seem to get a bit carried away when they're in France. I think it's the

Russ Winter, Taghazoute

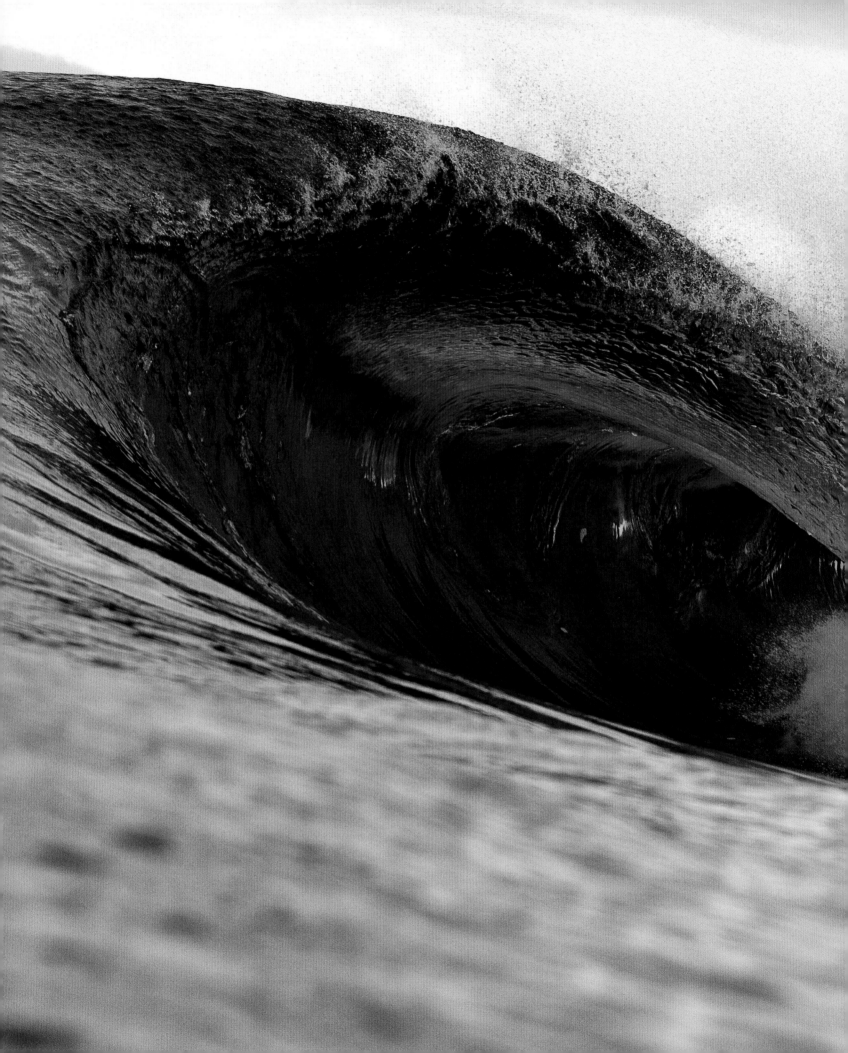

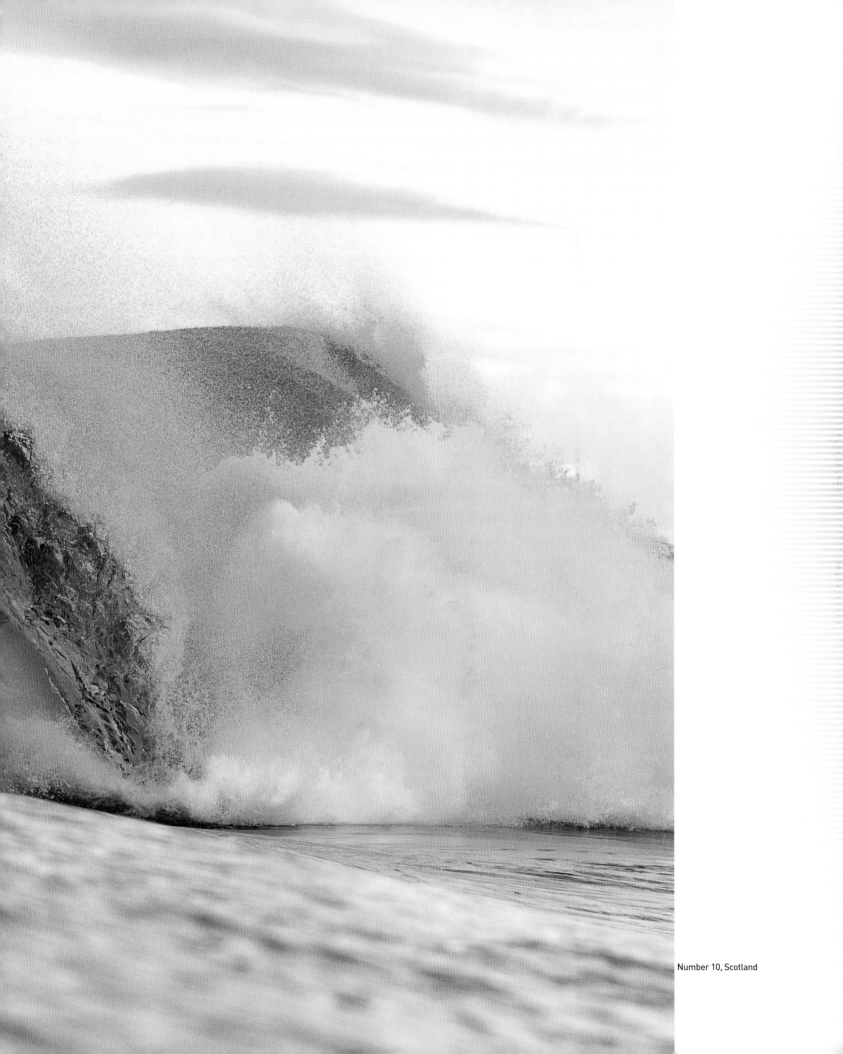

Number 10, Scotland

vino. When Mick [Fanning] won the contest a couple of years ago there was a massive party at the Café de Paris. Occy, Parko, Davo, Carwyn and everyone...it was pretty wild. People were falling over tables, they were all pretty trashed. Yeah, that was a good night.

Do you find the crowds around Hossegor make it hard to get photos?
Not really. If the surf's good it's usually fine for shooting. And if it's small and the waves are packed, you only have to drive 20 minutes up the coast to find a few quiet peaks.

If you're trying to do watershots, is La Graviere the first place you check each morning?
Yeah, it's usually the hollowest spot. It just depends on the banks. Capbreton can be good too.

Have you taken any hammerings out at La Grav'?
Nothing too bad. You take the odd hammering but it's normally over pretty quick.

What about at other spots?
Um...one time at Narrabeen I got caught inside by a clean-up set and got worked by two or three waves. While I was under the third wave some guy grabbed hold of me, pulled me down, and wouldn't let go. I was gasping for air so I tried to kick him off, but he had my legs in a death grip. When we popped up I was about to start yelling at him, but he was like, 'Help me, mate, I'm drowning!', so I didn't have a go at him. His leash had snapped and I think he'd swallowed some water, but he was alright once he got his breath back.

Okay...getting back to sessions in and around Britain, you shot one of the craziest barrelfests of the year at new Scottish slab Number 10 last autumn. Tell us how that came about.
Well, the boys [Mark 'Egor' Harris, Matt Capel and Mitch Corbett] had been up there for a few days. They'd towed this new slab and they said it was amazing, so I drove up. I didn't think it would be all that good for photos, but it turned out to be perfect. The light was amazing and I could just sit there on the inside and look straight into the barrels, it was ideal. Egor, Matt and Mitch totally went for it, they were fully charging a wave that seemed unrideable. Yeah, it was pretty special to be there and shoot those sessions.

By all accounts they were the first guys to ride Number 10. How come no one had tried before?
Well, when you watch it breaking it doesn't

"WHEN YOU WATCH IT BREAKING, NUMBER 10 DOESN'T REALLY LOOK RIDEABLE. IT FOLDS OVER REALLY QUICKLY FROM THE TAKEOFF AND IT BREAKS ONTO DRY ROCK, PRETTY MUCH."

really look rideable. It folds over really quickly from the takeoff and most of the waves virtually closeout or pinch shut at the end. Only a few of them stay open. And it breaks onto dry rock, pretty much. So I guess no one thought, 'Right, let's have a crack at that!' basically because it looked unrideable.

From what I've heard, the sessions seemed to be a mix of serious full-on moments and ridiculous comedy moments...
Yeah, pretty much! It's a serious spot, you know, really heavy 'cos it's so shallow on that ledge. It's not 'scared for your life' heavy, more sort of 'bang your head' heavy. But, yeah, you could tell the guys were concentrating by the looks on their faces. The funny moments were mostly down to Mitch's lack of experience driving a jetski. Egor knew what he was doing 'cos he uses one all the time, lifeguarding. But Mitch had only driven one a few times before. On his second or third wave driving the ski, Mitch towed Matt into a wave but got into it too late, so he gunned it straight up the face, forgetting that Matt was still on the end of the rope. Matt just went 'WHOAAAA!' and went flying about 20 feet up in the air! Funniest thing I've ever seen.

They nailed some beefy barrels though, once Mitch had figured out the jetski...
Ah yeah, they got some absolute screamers. Matt got a solid eight-foot bomb and he was totally speechless...which is unusual.

All in all, you must have been pretty glad to have made the effort to drive up there...
Yeah, no question. The two good days we scored were amazing. I was so stoked. After we got back I was buzzing for a week. ◻

OPPOSITE TOP Mitch Corbett, Number 10
OPPOSITE MIDDLE Carwyn Williams, Hossegor
OPPOSITE BOTTOM Bagpipes

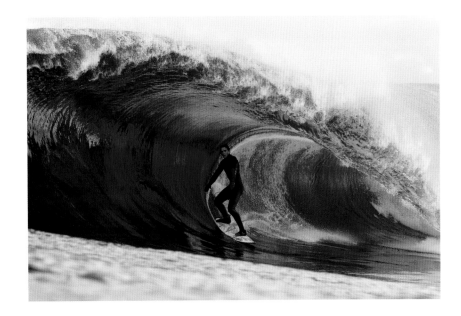

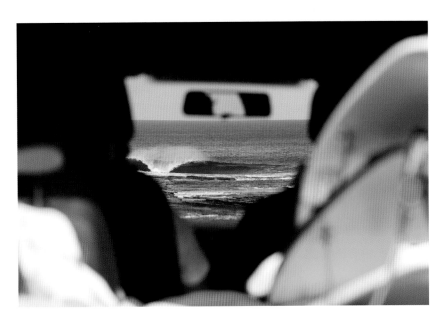

//LUCIA GRIGGI
DEDICATED FOLLOWER OF ACTION

GLOBETROTTER LUCIA GRIGGI IS A FAMILIAR FACE ON THE UK AND THE ASP TOURS; SHE SPECIALISES IN ACTION, PORTRAIT AND LIFESTYLE SHOTS.

British photographer Lucia Griggi has only been working professionally for five years but her battered passport gives an indication of the amount of travelling she's done in that time. Last year her itinerary included South Africa, France, Spain, Portugal, California, Hawaii, Scotland, Sri Lanka and Ireland, alternately following the ASP Men's and Women's World Tours and the UK Pro Surf Tour.

Lucia has become a familiar face on the international scene and she knows many of the top pro's well. When Joel Parkinson was leading last year's tour by a country mile at the halfway stage, Lucia captured him looking relaxed and supremely confident in the backyard of the house where he was staying at Jeffreys Bay in South Africa. "Joel's a really nice guy – very relaxed, very friendly, very approachable. He's incredibly focussed on his surfing. When he's getting ready for a heat he takes himself away, blocks out all the stuff going on around and just focusses. He'll sit there watching the waves for 30 or 40 minutes before his heat...it's like there's nothing in his field of vision except the waves. He gets right into that focussed state of mind. And you see that when he surfs a good heat – he's in tune with the waves, he surfs really smooth and he hardly ever makes a mistake. He gets pretty angry with himself if he

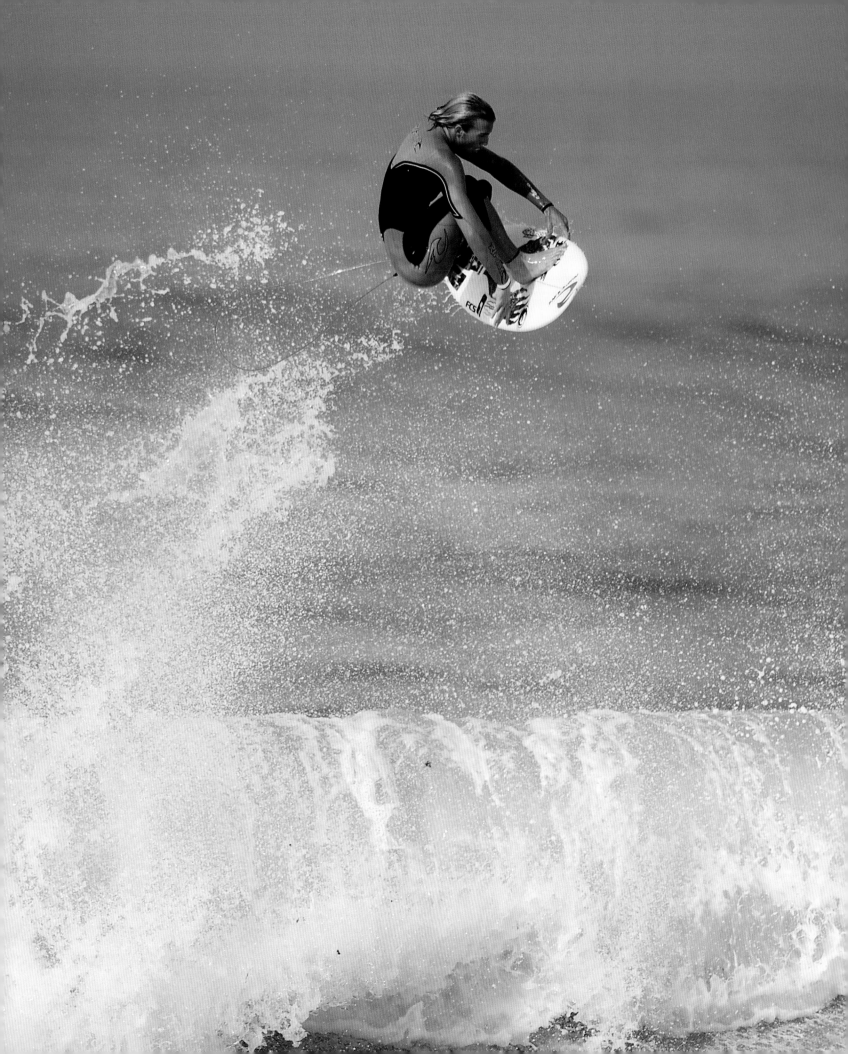

Owen Wright, Peniche

Jessi Miley-Dyer and Steph Gilmore, Hawaii

makes a mistake or something goes wrong. Like, when he lost his heat at Mundaka last year, I heard he got pretty angry...smashed up a board or two!"

There's more to Parko's character than just his intense competitive drive, however, as Lucia found out when she went along to visit a family that he and Mick Fanning sponsor in a township near J-Bay. "There's a cleaning lady who works at the house where Joel and the boys stay when they come to J-Bay. She's a lovely lady, everyone who stays there gets on really well with her. She's a single mother trying to bring up six kids in a township, but on top of that she's also been through some really tough times. When Joel and Mick heard her story they wanted to help, so now they sort of sponsor her family and go and visit every year. I went along with them to the township one day and we hung out and played with the kids, and I took some photos to give to them. So, yeah, that's a really good thing that Joel and Mick do."

Lucia's interest in photography began when she was at school in Surrey. She later studied Sports Nutrition at college in London, then moved down to Cornwall and worked as a surf instructor for a year or so. During the winter months she worked at foreign surf camps and she always took a camera on her travels. After getting various shots and

Bethany Hamilton, North Shore

"THE GIRLS LOVE WHAT THEY DO AND THAT'S WHAT IT'S ALL ABOUT AT THE END OF THE DAY. THEY LOVE TO TRAVEL THE WORLD, SURF ALL THESE COOL PLACES...THAT'S THE MAIN MOTIVATION. I THINK THE MONEY'S A SECONDARY THING. "

travel articles published in magazines, she started thinking about taking up photography full time. So she went for it and jumped in at the deep end, travelling to pro contests and shooting the action wherever it was happening. She learnt as she went along from books, magazines and good old trial-and-error. Encouragement and advice came from the likes of American photographer Tom Servais and SurfGirl magazine editor Louise Searle. As well as editorial work, she paid the bills by doing commercial jobs for companies such as Roxy, Calvin Klein, Rimmel, Davidoff, Rip Curl, Sri Lankan Airlines and Casio.

Lucia has followed the ASP Women's Tour, off and on, for the past four years and now knows many of the girls well. She reckons the tour doesn't get anything like the media coverage that it should, except in dedicated women's surf mags like *SurfGirl* and *Surfeuses*. A big gripe on the women's tour is the discrepancy in prize money – the men get four times as much – but Lucia says the girls only have themselves to blame for that. "There is an issue with the money, but you've got to remember that it was the girls' decision to separate their tour from the men's [in 2004], because back in the day both tours used to run alongside each other. So, in financial terms, they kind of shot themselves in the foot really. I'm pretty sure that having their own tour, with separate events, is not bringing in the revenue they need. But although the money isn't great, the girls still love what they do and that's what it's all about at the end of the day. They love to travel the world, surf all these cool places...that's the main motivation. I think the money's a secondary thing. They all seem to get by. A lot of the girls spend three months in Hawaii over the winter, then four months in Oz, so their lives seem pretty sweet to me!"

Lucia's modest travel coffers only allowed her three weeks in Hawaii last year, but she made the most of her time there. She covered the Billabong Pipe Masters and the Billabong Girl's Pro at Honolua, as well as every hot free-surfing session from Off The Wall to Rocky Point. Even when the wind was onshore Lucia kept herself busy shooting portraits: up 'n comer Rosie Hodge drawing love hearts in the sand; shark attack survivor Bethany Hamilton gazing out to sea with a

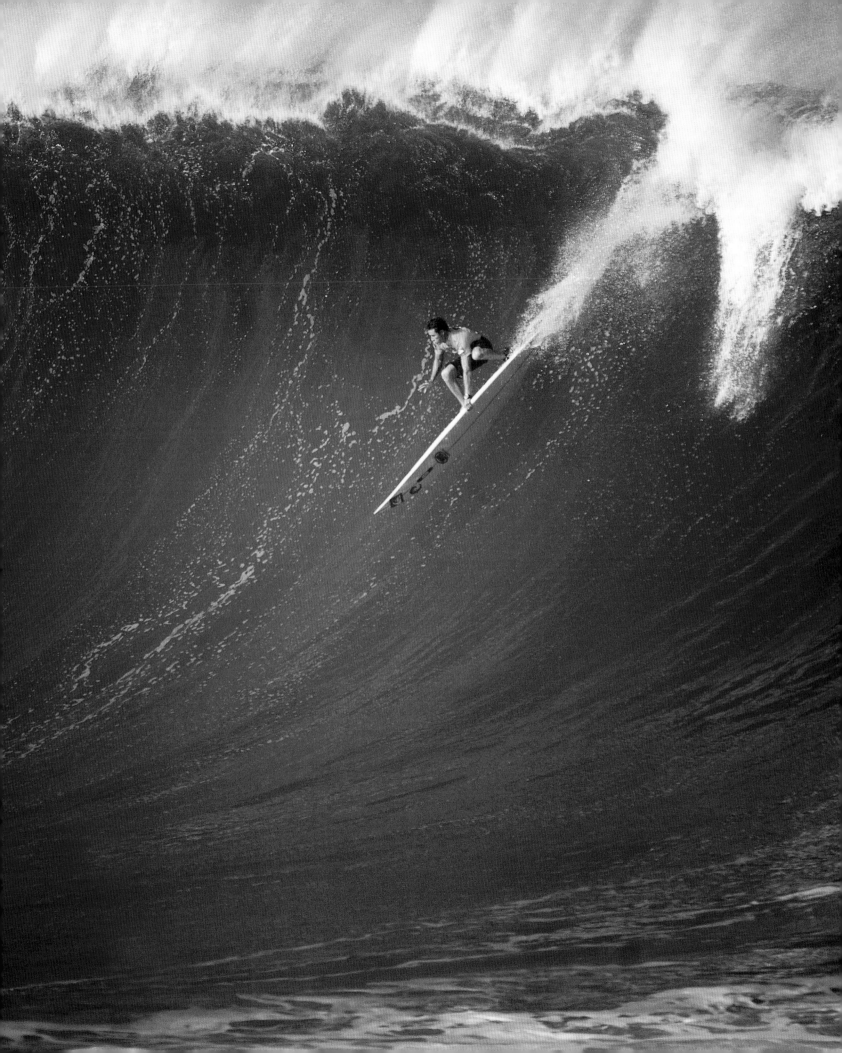

look of steely determination in her eyes; men's title contender Jordy Smith crouched down like a sprinter waiting to launch out of his blocks.

Most people agreed that last winter was the best Hawaiian season for years...and the icing on the cake was the monster swell that hit in early December. The morning of Wednesday 9 December dawned with clear skies, light offshores and 20- to 25-foot bombs unloading onto the point at Waimea Bay. For the first time in five years conditions were looking perfect for The Quiksilver In Memory Of Eddie Aikau big-wave invitational, and huge crowds made their way down to the natural amphitheatre to watch the action. With 28 of the world's best big-wave surfers awaiting his decision, veteran contest director George Downing gave the signal. The Eddie was on.

"I got down there really early and got a good position right on the point," says Lucia. "The sun hadn't come up yet, but even at that time there were thousands of people down there. The Kam Highway [the road along the North Shore] just gets totally gridlocked every time they run The Eddie, so if you're not there early you haven't a hope of getting a good spot.

"The waves got better and better as the day went on. The swell grew all morning and there was a period of about two hours in the afternoon when the sets were just rolling through continuously. Some of the waves had 40-foot faces, and when you're right there watching guys take drops like those...well, I had goosebumps!

"The atmosphere was amazing. The locals in the house next door were yelling and whistling and ringing a bell every time a set came into sight. But even then,

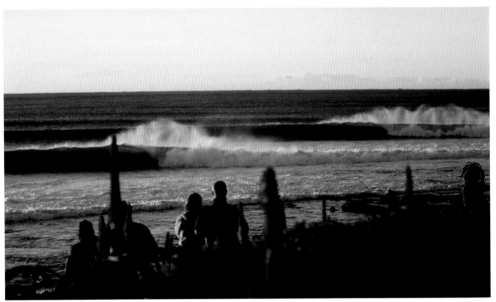

Jeffreys Bay

sometimes the guys in the lineup would get caught inside and they'd all be scrambling to get over the waves. Everywhere you looked it was mayhem – helicopters in the sky, jetskis in the channel. People were desperate to see what was happening. Some people climbed up onto the rocks next to Impossibles, which is a pretty crazy thing to do, and the lifeguards were yelling at them trying to get them down. There was just commotion everywhere!

"Yeah, I was stoked to be there for The Eddie, 'cos they hadn't had a huge swell like that during the waiting period for five years. It was such a spectacle, and the size of the waves was just ridiculous. That might be the only time I'll ever see it, so to be there and watch it was definitely something special." ◻

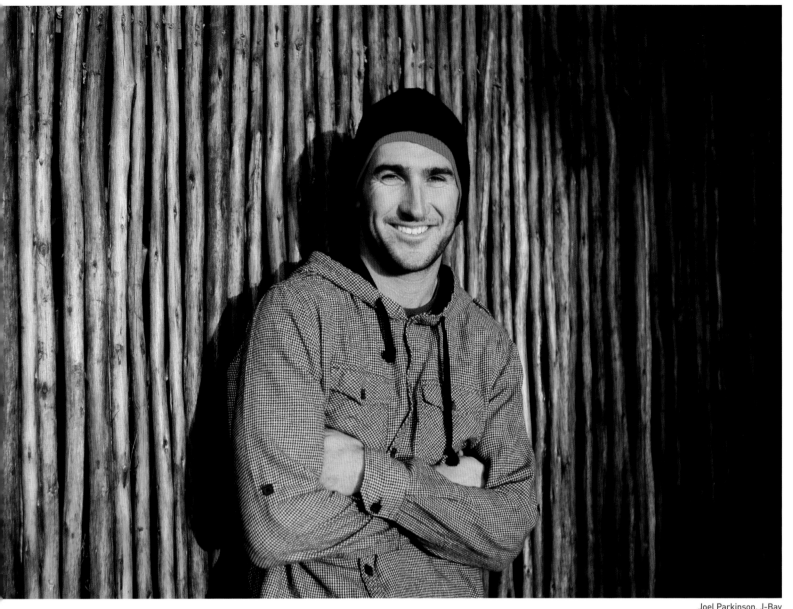

Joel Parkinson, J-Bay

"JOEL IS INCREDIBLY FOCUSSED ON HIS SURFING. HE GETS PRETTY ANGRY WITH HIMSELF IF HE MAKE A MISTAKE OR SOMETHING GOES WRONG. LIKE, WHEN HE LOST HIS HEAT AT MUNDAKA LAST YEAR, I HEARD HE GOT PRETTY ANGRY... SMASHED UP A BOARD OR TWO!"

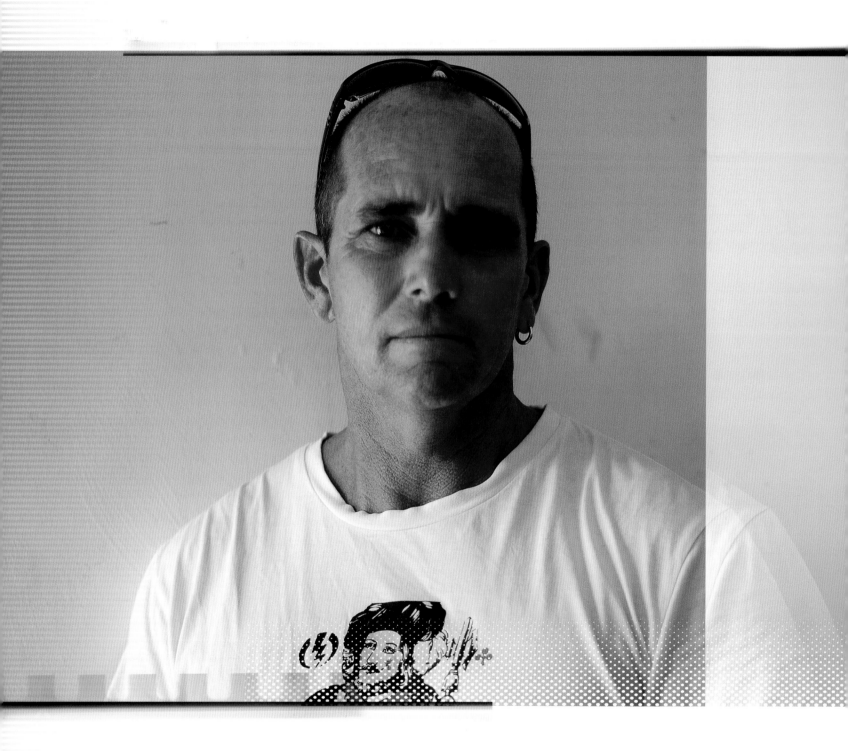

//SIMON WILLIAMS

SALTY SEADOG WITH PIRATE BLOOD IN HIS VEINS

Anyone familiar with Queensland-based photog Simon Williams' output over the last 15 years might quite reasonably assume he's lived there all his life. He's shot countless high-octane sessions on the Gold Coast; he's known Coolie kids Mick Fanning, Joel Parkinson and Dean Morrison since they were groms; and he's done more Mentawais boat trips than he has hair follicles on his head...or at least his chin. But in fact Swilly is an Englishman. He grew up in the Cornish village of St Agnes, where his dad owned a pub. A talented grom, he was a member of the English surf team in his teens and embarked on his first longhaul surf trip to Sri Lanka at 16. Around the same time he became interested in photography and his dad helped him out by buying him a decent telephoto. In his early twenties he emigrated to Australia after falling for a young lass from Mermaid Beach called Jenny. Together they set up S&J Photographics, with Swilly taking the shots and Jenny running the office. They got their first big break in 1990 when Aussie mag *Tracks* ran an eight-page article about a trip to the Solomon Islands. Since then Swilly's never looked back, taking on assignments for dozens of local and international surf brands, and contributing to a bevy of surf mags including *Waves, Tracks, Surfing, Pacific Longboarder, CARVE, Surf Girl* and *Japan's Surfin' Life*.

You scored an epic session at that New South Wales bommie last year with Jamie Mitchell and James Billy Watson. Your eyes must have popped out of their sockets when you saw those waves.
Yeah, I was really surprised, I never expected anything like that. It's such a fickle spot, it hardly ever breaks.

Who's idea was it to go out there?
Billy just rang me and said, "Look, we know this reef, we're gonna take you there and it's gonna be on..." I knew one or two photographers had been out there before, but they'd never been there on that swell direction and never really scored it. We were just very lucky to get an absolutely incredible session.

I heard it was a long session too. What time did you head out there?

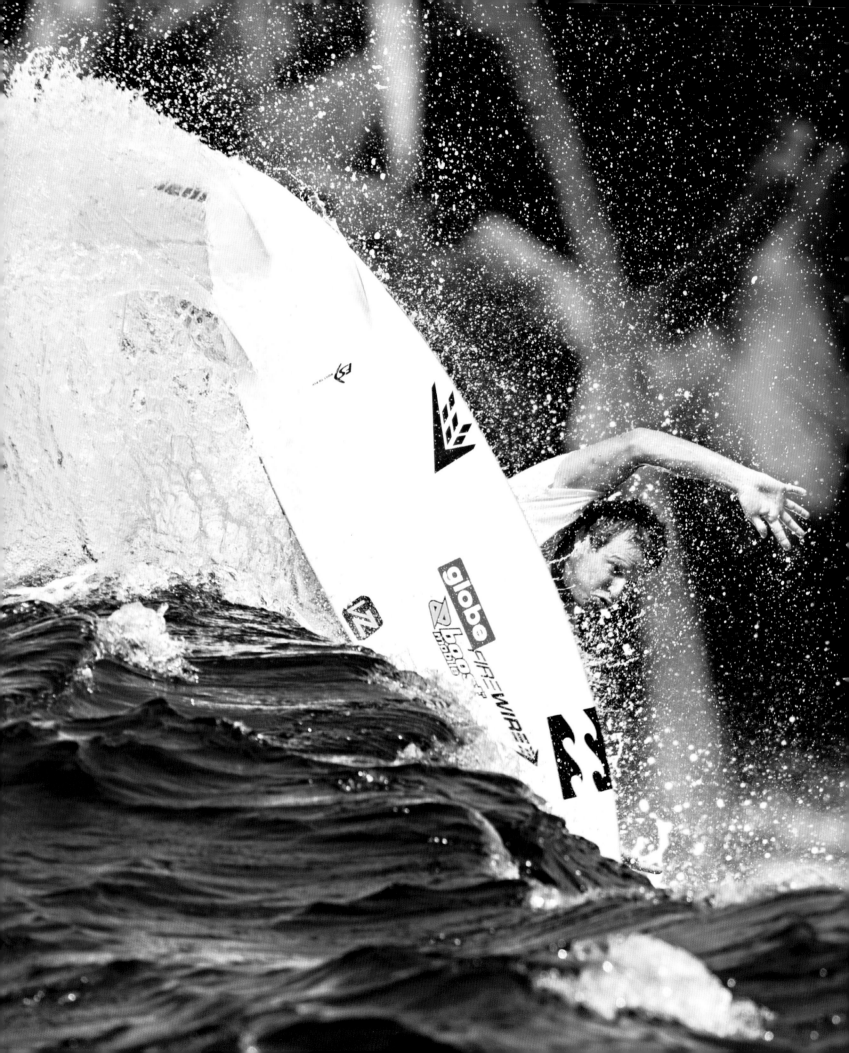

got. It was so round you could've driven a truck through it! But there were so many good waves that day...every wave the boys rode looked pretty amazing to me. The whole session was just incredible, so unexpected.

Jamie got pretty worked on one wave though, didn't he?
Yeah, at the end of the session. He got sucked up the face and went over the falls. It was horrible...he just got rag-dolled. He survived it, but my God, I wouldn't have survived that. It's lucky he's a triathlete! (Laughs) He virtually had a three-wave hold down. He popped up between waves but only up for a couple of seconds before the next one hit him, and then the one after that. That's when we decided to call it a day. Billy was also over it by then 'cos he got a rail in the guts and he was pissing a bit of blood. When we got back, Jamie drove him to the hospital and the pair of them had to wait in the Emergency Room until 10 o'clock that night. So it was a real long day for those boys!

Was Billy okay?
Yeah, it was nothing serious. He was fine the next day.

And was it Billy who came up with the name Krispy Kremes?
I think it was a joint effort. That's not its real name...the boys just invented that for the mags. Some of the waves have a foamball that kinda rolls back on itself, like a doughnut. And Krispy Kremes are a brand of doughnut over here. It's funny, even when we made up an alternative name for it, the local guys weren't happy. They were going, "F--k, mate, it's a really well-respected spot, you can't call it Krispy Kremes, it's taking the piss!" But if we'd said its real name in the mags, they would've gone nuts. So what can you do? (Laughs) You're damned if you do and you're damned if you don't!

Well, I reckon the locals have a point, you guys could have called it Thick Lip or something. It looks like a beast of a wave. There can't be many like that on your stretch of the East Coast...
Nah, there's nothing like it really. It's a powerful break, for sure. There's no real back to those waves. That's what happens when a big open-ocean swell hits a slab of rock five kilometres off the coast. It's a heavy spot. And sharky, very sharky. They reckon there's a place near there where the tiger sharks breed.

"INDO HAS PHENOMENAL BACKDROPS, AND THEY'RE REALLY IMPORTANT I RECKON. A PHOTO OF A WAVE ON IT'S OWN IS ACTUALLY QUITE BORING, BUT WHEN YOU ADD PALM TREES AND CLIFFS AND ISLANDS, ALL OF A SUDDEN THE PHOTO COMES ALIVE. IT'S GOT DEPTH."

When we parked up it was dark, and it was just getting light when we went through the bar so it would have been about 5.30. Then it took us about 40 minutes to get out there. Yeah, it was a long session...the boys would have been in the water from about seven in the morning 'til two in the afternoon. They only stopped to swap around driving the jetski.

Big swell?
Yeah, pretty big...I think it was 4.5 metres or something on the swell forecast. It was coming straight up from the south, kinda missing the Gold Coast...like, the Superbank was only about four- to five-foot. That sometimes happens with south swells, they just kinda sweep straight past.

But that spot picked up the swell because it's so far out...
Exactly. It's about five kilometres off the coast. Just a big bommie out in the middle of nowhere. I guess there's a big slab of rock down there somewhere...although you wouldn't know it, there aren't any rocks sticking out or anything. The whole reef is underwater.

What were the highlights of the session?
I remember an absolute bomb that Jamie

Taj Burrow, Mentawai Islands

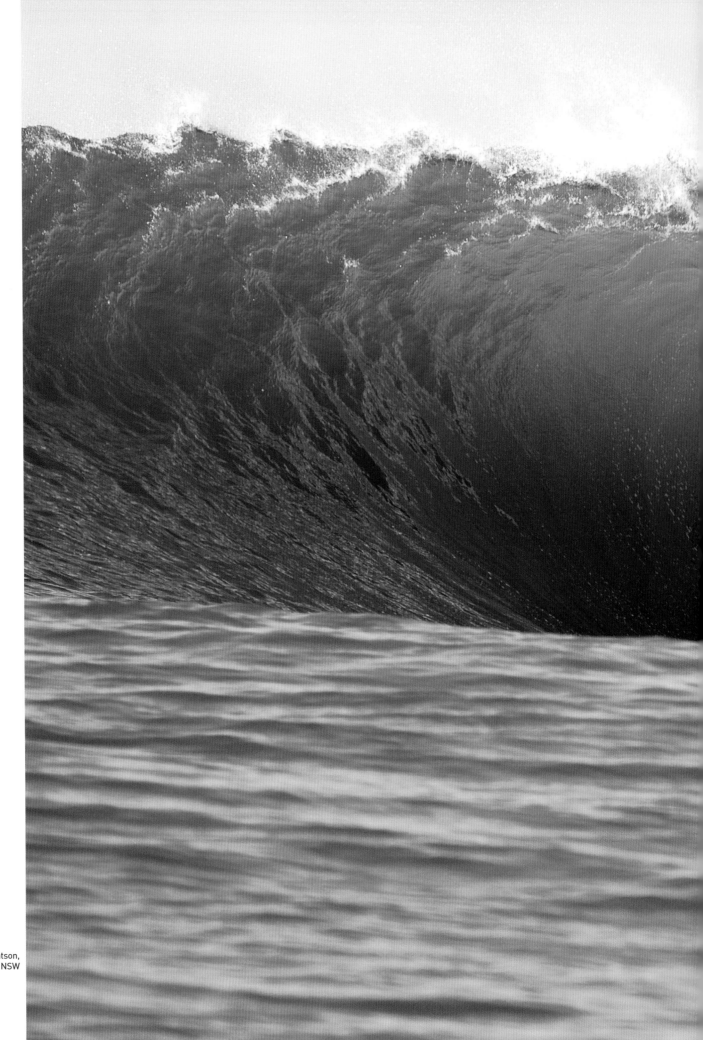

James Billy Watson,
'Krispy Kremes', NSW

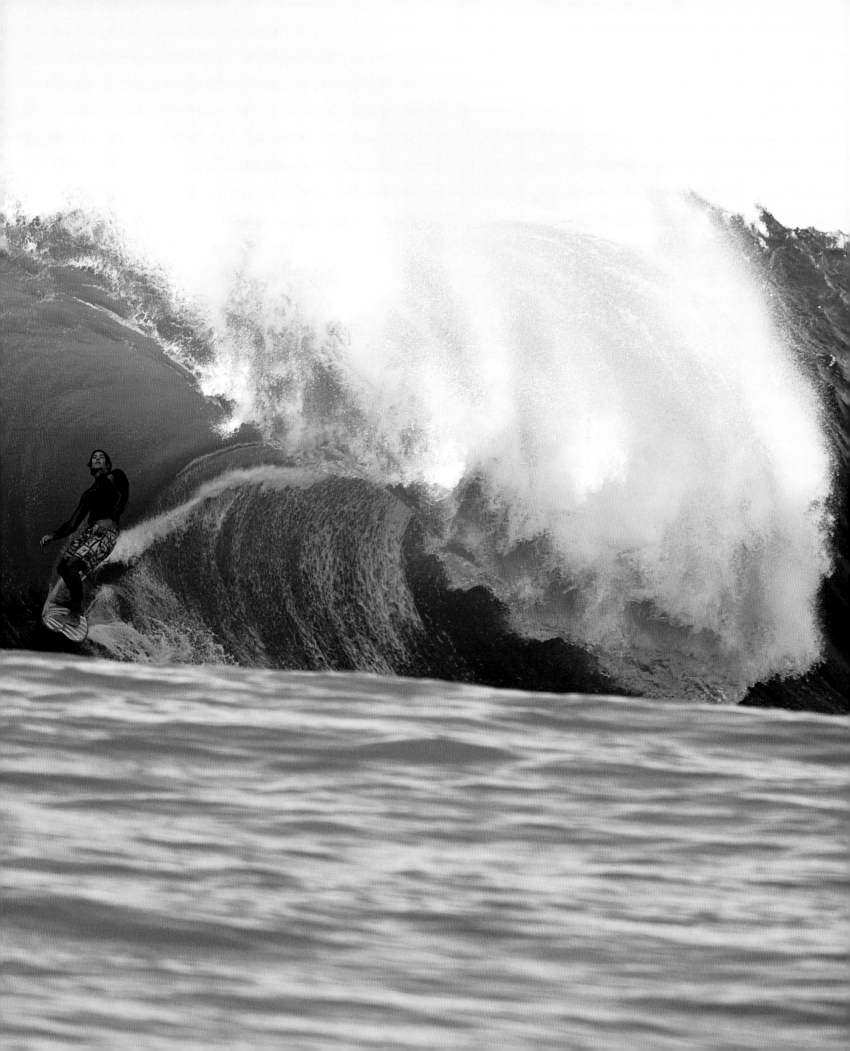

Nice.

Yeah, you wouldn't really want to swim out there.

Do you think about sharks...when you're in the water at other spots?

Well, I try not to...but if I'm shooting somewhere I know is sharky then, yeah, I think about 'em. The other day I was down at Ballina, shooting at North Wall with Asher Pacey and Ryan Hipwood. Eight months ago a kid was eaten there. I was out in the water – pretty murky coloured water – and this frickin' massive thing suddenly came flying past and made a grab at these bait fish. It made the biggest splash, right in front of me. It was so close I could smell the smell of fish in the air. And I screamed my head off like a little schoolgirl. Asher goes, "Don't worry, Swilly, it's just a blue fin!" Everybody was laughing at me. They knew it was just a tuna 'cos they'd seen it jumping out the back, while I'd been looking the other way shooting.

Okay, let's talk about Indo. You've done a ridiculous number of trips there over the years. What makes it your favourite place to work? The light, the waves, the consistency, the water colour...?

All those things. Yeah, you've gotta have all the elements. Indo also has phenomenal backdrops, and they're really important I reckon. 'Cos when you think about it, a photo of a wave on it's own is actually quite boring...it's just a wave. But when you add palm trees and cliffs and islands, all of a sudden the photo comes alive. It's got depth.

Out of all the waves you've photographed over there, which do you reckon is the most flawless on a perfect day?

I'd say Macaroni's. Macaroni's on a good day is just insane. If you're talking about absolutely flawless waves, it's hard to beat that place.

Do you keep count of the number of Indo boats trips you've done altogether?

Nah, I don't. I really couldn't tell ya. I normally go with five or six groups per year and I've been doing it for about 11 or 12 years. Jeez, that's a lot isn't it?

You should have your own private cabin on the *Mangalui*, with a nice brass plate on the door saying SWILLY'S CABIN.

Yeah, I should! (Laughs) Nah, I just have a little bunk bed in the living room which I crawl into every night. It's good actually, 'cos everyone else sleeps on the lower deck and I get my own little space. And when you're doing back-to-back trips, that's a real blessing.

Have you ever done, like, three trips in a row?

Mate, I've done five in a row! I'm not sure I'd do that again though. Yeah, that was quite a stint. By the end of it I had a parrot and a peg leg!

Nat Young and Owen Wright, Indo boat trip

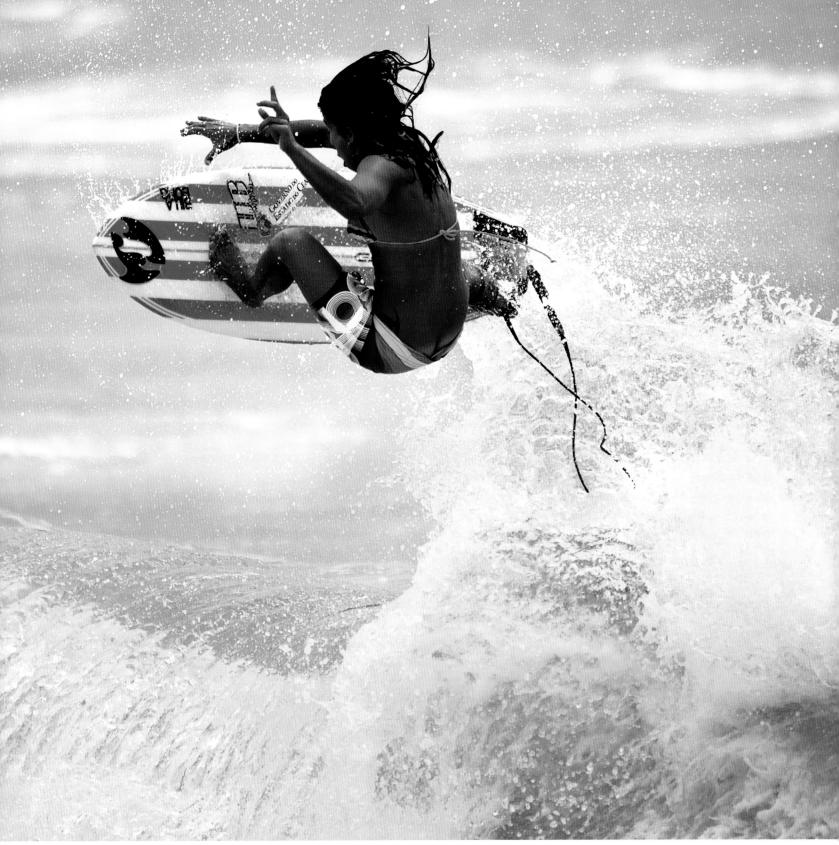

Silvana Lima, Snapper Rocks

153

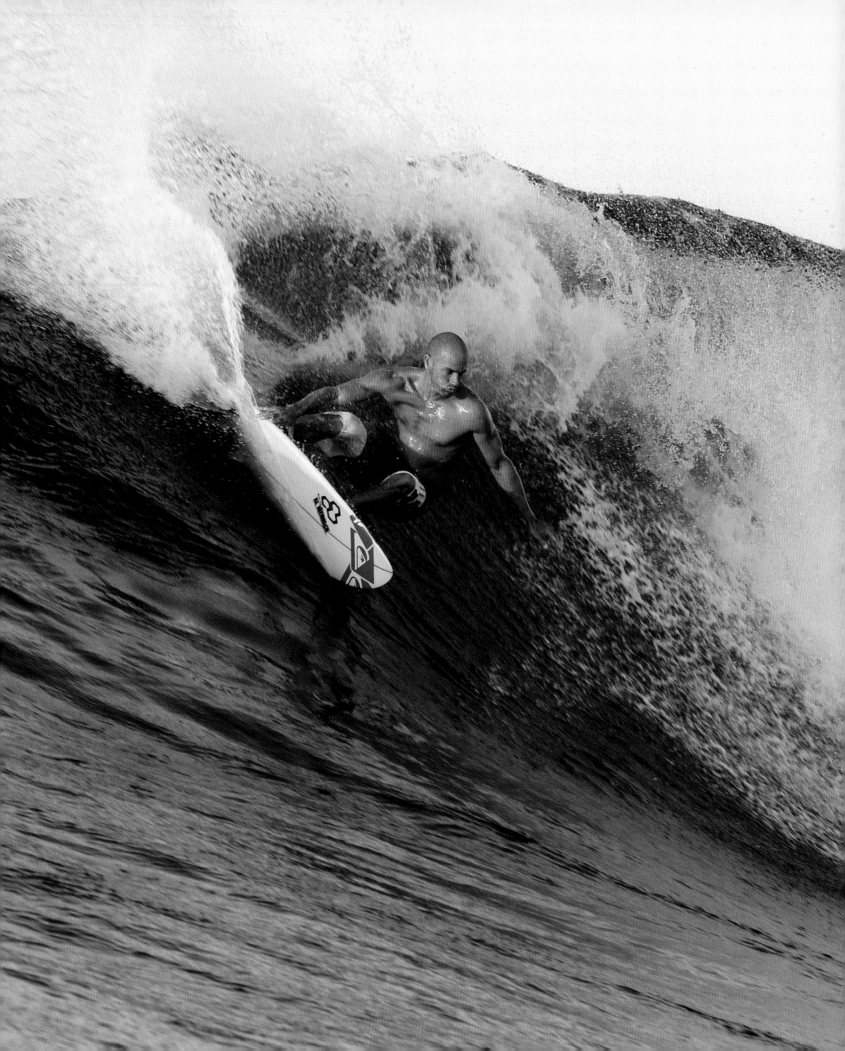

"THE BEST TRIPS ARE ACTUALLY THE ONES THAT SPEED BY. WHEN YOU'RE SURFING ALL DAY LONG AND HAVING A GREAT TIME, TIME PASSES REALLY QUICK."

Did you kiss the ground when you got back to Padang after the fifth trip?
Yeah, I think I did! (Laughs) But actually most trips over there are really good fun, 'cos most times you get good waves. The best trips are actually the ones that speed by. The guys get on the boat, you score a few sessions, and before you know it you're saying goodbye. When you're surfing all day long and having a great time, time passes really quick. By the evening you're so tired, you have a drink and a feed, and that's it, you're crashing.

You've done a lot of all-girl trips to Indo. Which of the girls do you rate the highest for sheer surfing skill and guts?
Off the top of my head I'd say Steph Gilmore, Sofia [Mulanovich], Bec [Rebecca Woods], Sally Fitzgibbons, Sarah Beardmore and Laura Enever. I love working with the girls.

Okay, so you've got a wealth of experience shooting photos on boat trips. What advice would you give to a newbie heading out to Indo for the first time?
Well, someone once told me, years and years ago, "Seize the moment!" And you've really gotta do that, whether it's the first day of a trip or the last. Because you just never know when you're gonna get that golden shot. When you're on a boat with a bunch of surfers, sometimes you can get very complacent. You might think, 'Hey, it's only the first day, I can't be bothered to shoot it, I'll shoot it tomorrow.' Never do that. Never. It might rain for the next six days!

Final question, to bring it back to the Gold Coast. You've known Mick, Parko and Dingo since they were snotty-nosed groms. Those guys must have got up to a few japes...
Just a few! (Laughs) Let's think...well, when they were grommets, about 15 or 16, I used to take 'em surfing down to places like Byron Bay, a couple of hours south. One time, we were driving through Byron and there was a bunch of ferals standing by the side of the road. You know, full-blown hippie ferals. I guess they were trying to hitch a ride. Anyway, next moment I heard Mick shouting at the top of his voice, "GET A WASH, YA BASTARDS!" and I looked around and the three of 'em were all leaning out of the windows pelting the ferals with bottles of water! The ferals just got nailed. I saw a water bottle ricocheting off this one bloke's head! I was like, "Aw, no! What have you done!" (Laughs) Cheeky little devils!

Kelly Slater, Caroline Islands

//GEAR

Surf photographers use a range of equipment to capture the action. Most is widely available through professional photographic retailers, but water housings can only be bought from a handful of specialist manufacturers.

01 DIGITAL SLR CAMERA

For the ultimate in image quality, control and versatility nothing comes close to a state-of-the-art digital SLR camera. The Canon 7D is currently the weapon of choice for many surf photogs. With a frame rate of 8fps and a big bright viewfinder, it's perfect for land shots and water shots. As a bonus it can also shoot fantastic quality HD video.

02 MEDIUM FOCAL LENGTH ZOOM LENS

A zoom lens is invaluable when shooting from a set position, such as a boat moored in the channel next to a reef. 70-200mm zooms are popular among surf photogs. One of the drawbacks of zoom lenses is that lens flare tends to be more pronounced because there are more lens elements.

03 TELEPHOTO LENS

Fixed focus lenses don't have the flexibility of zoom lenses, but purists claim they're optically superior. A 135mm like this is ideal for lineup shots.

04 SUPER TELEPHOTO LENS

If you're shooting from the beach, a 500mm or 600mm super telephoto is essential to capture the action. They may be heavy and cumbersome, but these high-powered autofocus beasts do an incredible job, filling the viewfinder even if you're hundreds of yards from the lineup. They're super expensive, so you'd better plan on taking a lot of very good photos if you're going to splash out on one of these.

05 TELE-CONVERTER

A tele-converter attaches onto the back of the lens and multiplies the focal length of the lens it's used with. Tele-converters typically have a magnification factor of 1.4x or 2x.

06 FISHEYE LENS

Top water photogs use fisheye lenses (with a focal length of 10-15mm) to shoot those incredible in-the-tube images we all love. The big challenge here is positioning – the photog needs to hold his position in the barrel section of the wave while the surfers scream past him, missing him only by inches. The dangers are considerable in heavy waves with shallow rocks or coral below.

07 WATER HOUSING

Water housings are built to survive the heaviest situations, while allowing access to the camera's controls. This AquaTech CO7 is designed for a Canon 7D. The body of the housing is made from polyurethane and epoxy, the controls are stainless steel, aluminium and high-strength plastic. The ports are interchangeable – the dome port on this housing is for a 10mm fisheye; the telephoto port alongside is for use with a 50mm or 85mm lens.

08 SWIM FINS

Most water photogs use standard bodyboard fins for swimming in the lineup.

09 TRIPOD

Essential for bearing the weight of a super telephoto. Carbon fibre tripods are lighter but more expensive than aluminium tripods.

10 FLASHGUN

An essential accessory for indoor shots or portraiture. Bright, contrasty lighting conditions can also be improved by using fill-in flash.

11 LAPTOP

At the end of every day, review your shots and copy the best onto your laptop. Software programmes such as Aperture will provide all the editing options you'll need.

12 COMPACT CAMERA

Top-of-the-range compacts like the Canon G10 can be handy in situations where an SLR is unwelcome or unwieldy. Full manual controls and the ability to shoot Raw files make it a winner.

13 MOBILE PHONE

Optically not great, but just about acceptable for candid shots if there isn't a proper camera within reach.

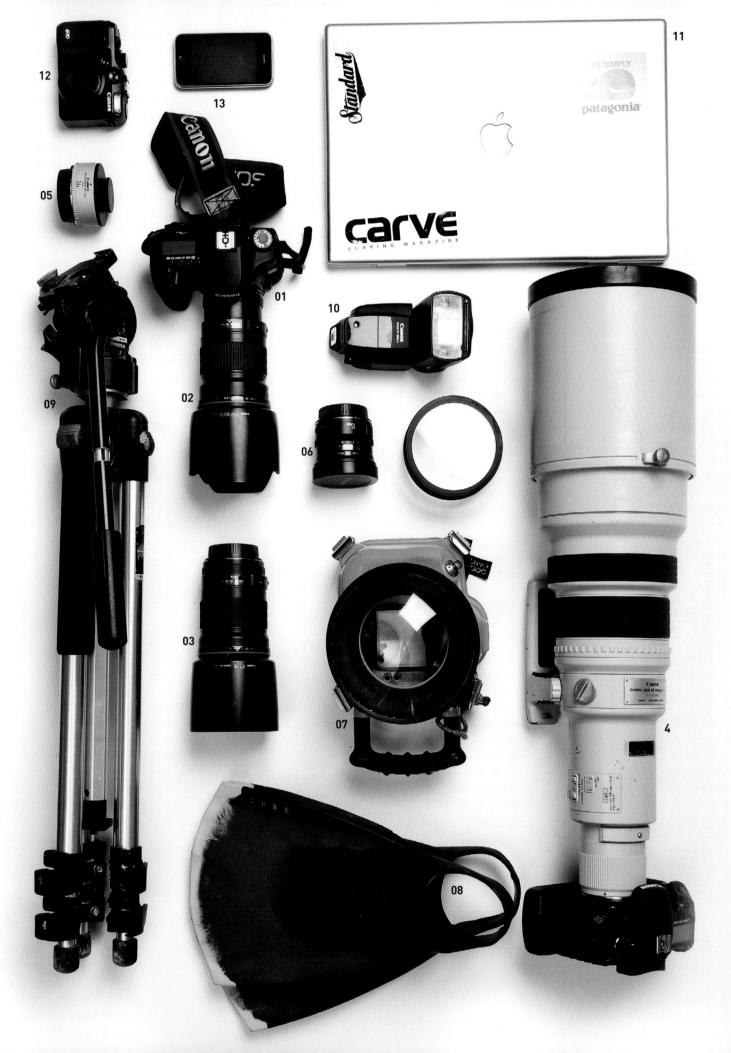

//WORK

A few examples of published work by the photographers featured in this book.

Tim Jones
WWW.TIMJONES.COM.AU

Alan van Gysen
WWW.AVGPHOTO.CO.ZA

Scott Aichner
WWW.SCOTTAICHNER.COM
WWW.AFRAMEPHOTO.COM

Steve Sherman
WWW.STEVESHERMANIMAGES.COM

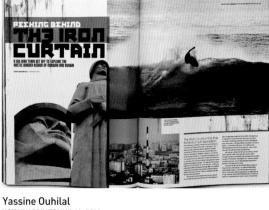

Yassine Ouhilal
WWW.YASSINEOUHILAL.COM

Tungsten (Erick and Ian Regnard)
WWW.TUNGSTEN.NET.AU

Mickey Smith
WWW.MICKEYSMITH.CO.UK
WWW.THEDEADAREDYINGOFTHIRST.BLOGSPOT.COM

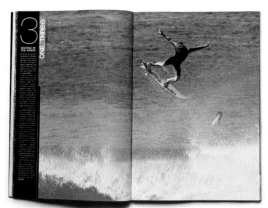

Roger Sharp
WWW.CARVEMAG.COM

Anthony Walsh
WWW.ANTHONYPAULWALSH.BLOGSPOT.COM
WWW.VIMEO.COM/ANTHONYWALSH

Clark Little
WWW.CLARKLITTLEPHOTOGRAPHY.COM

Tim McKenna
WWW.TIMMCKENNAPHOTOGRAPHY.COM

DJ Struntz
WWW.DJSTRUNTZPHOTO.COM

Will Bailey
WWW.WILLBAILEYPHOTOGRAPHY.BLOGSPOT.COM

Lucia Griggi
WWW.LUCIADANIELLAGRIGGI.CO.UK

Simon Williams
WWW.SWILLY.COM.AU

//INDEX